ITALIAN OLD MASTER DRAWINGS

From the Collection of Jeffrey E. Horvitz

ITALIAN OLD MASTER DRAWINGS

From the Collection of Jeffrey E. Horvitz

Linda Wolk-Simon

Samuel P. Harn Museum of Art
University of Florida
Gainesville, Florida

1 9 9 1

EXHIBITION ITINERARY

Samuel P. Harn Museum of Art, University of Florida
Gainesville, Florida
July 12-September 8, 1991

Spencer Museum of Art, The University of Kansas
Lawrence, Kansas
October 6-November 17, 1991

The Minneapolis Institute of Arts
Minneapolis, Minnesota
December 14, 1991-February 16, 1992

Fogg Art Museum, Harvard University
Cambridge, Massachusetts
August 15-October 11, 1992

The Taft Museum
Cincinnati, Ohio
November 19, 1992-January 10, 1993

The Montréal Museum of Fine Arts
Montréal, Québec
January 29-March 21, 1993

Edited by Brenda Gilchrist
Catalogue design by Meredith Davis
Photography of Horvitz collection by John Knaub
Type set by Marathon Typography Service, Inc.
The catalogue has been set in Palatino type
and printed on 80# Karma text paper
Edition of 3,000
Printed by Storter Printing Company, Gainesville, FL

Provenances of the drawings reflect available information at the time of publication.

Library of Congress Cataloging-in-Publication Data
Wolk-Simon, Linda
 Italian old master drawings from the collection of Jeffrey E. Horvitz / Linda Wolk-Simon.
 p. cm.
 Catalog of exhibition held at the Samuel P. Harn Museum of Art, University of Florida, Gainesville. July 12-Sept. 8, 1991 and other museums.
 Includes bibliographical references and index.
 ISBN 0-9629384-0-8
 1. Drawing, Italian—Exhibitions. 2. Horvitz, Jeffrey E.—Art collections—Exhibitions. 3. Drawing—Private collections—United States—Exhibition. I. Samuel P. Harn Museum of Art. II. Title.
NC255.W6 1991 91-19914
741.945'074'73—dc20 CIP

The paper in this catalogue meets the guidelines for permanence and durability of the Committee on Production Guidelines for Book Longevity of the Council on Library Resources.

ISBN 0-9629384-0-8

TABLE OF CONTENTS

FOREWORD

Making a serious personal collection of art is not for the fainthearted. Collecting for oneself for pure pleasure, with no regard for the opinion of others, would seem at first to offer an environment of unbridled indulgence, unlike museum collecting, which is done in the glare of public opinion with donated money and must be as critically correct as professionals can manage. Many of the same factors, however, rule the private collector as the museum, and the most independently minded individual buyer soon discovers a network of issues affecting choice that includes not just price and beauty, but also condition, rarity, importance, and, in many cases, resale potential. Mistakes can be costly, so poring over books and catalogues, studying museum collections, and consulting with scholars, curators, and dealers are all part of developing the necessary skills for the chase.

Undertaking to collect art is a gradual process: a purchase is made here or there, a direction soon emerges, a specific goal comes to mind. Collecting often occurs among the busiest people, who somehow find the time to build significant collections. Jeffrey Horvitz is an example of the deeply engaged businessman who breaks his professional routine to search out and acquire major works of art, instantly recognizing what he wants against a cumulative background of intense study and careful observation of many objects. He possesses an extraordinary memory for details, figures, and dates, and demonstrates an outstanding eye for quality: in the relatively short time of seven years he has amassed distinguished collections of paintings, drawings, and sculpture, including such rich subsets as this group of Italian drawings.

Jeffrey Horvitz views his Italian drawings as a collection in transition, growing and changing with his increased experience and improving as the right examples become available. While he may regard this collection as not complete, it is already impressive in both size and quality, in its representation of rare artists, and in its consistently strong examples.

Jeffrey Horvitz, born in 1950, holds masters' degrees in sociology and psychology. Formerly a dealer in modern art and a real estate executive, he is now a private investor. As an art dealer a decade ago, he formulated the personal method he uses to guide his choices today. Employing the Venn diagram theory, he visualizes a set of three circles: in the first is art he likes; in the second, art that scholars, connoisseurs, dealers, and other opinionmakers in the field think is of high quality; and in the third, art that is reasonably priced. He tries to buy only things that fall within the intersection of these three circles.

He observes that he started buying drawings because they were the most immediately

yet subtly appealing among all the art objects he wished to own. They also presented him at the time with the widest range of choices for the allocation of his resources. He acknowledges having a particular fondness for the directness and physicality of drawings—the bite of the paper, the marks and even mistakes that reveal the artist's thought process. While he also claims that he prefers drawings that are "finished," i.e., thoroughly realized and fully executed, he includes delightful exceptions such as the extraordinary Guercino sketch *Head of a Monk*. Whether he collects Italian or French drawings, Old Master paintings, or twentieth-century art, he does not intend, in his words, "to build a stamp collection"—to seek to fill perceived gaps and to make seamless continuities merely for the sake of it. Instead, he will buy several works by an artist he likes, always surprised when he is expected to be interested only in artists whose works he doesn't already have. The vigorous pace of his collecting activity is reflected in the fact that his drawing collections alone now approach two hundred works.

The scope of this selection, spanning three centuries, while by no means a chronological survey of styles and movements, conveys the enormous variety and invention in Italian art of this era. First-rate examples by recognized artists, many of which have distinguished provenances and are well-known to the field, exist alongside masterpieces by lesser known figures, rare discoveries that reflect the significant accomplishments of the collector.

Jeffrey Horvitz's generous sharing of these exquisite works has given the Harn Museum the opportunity to organize the exhibition *Italian Old Master Drawings From the Collection of Jeffrey E. Horvitz* and to publish this catalogue. Major undertakings for a museum open less than a year, they have challenged us to provide the scholarship and research necessary to affirm or reconsider attributions and to identify the subjects and related works in the first public exposure of this collection.

In 1987, when I asked Jeffrey Horvitz for the loan of a part of his collections for an exhibition tour, he suggested his Italian drawings. Since then, many people have participated in the development and refinement of the exhibition, and I have numerous colleagues and friends to thank for their contributions to the success of this effort.

In the earliest stages, we received the generous advice and recommendations of Charles Ryskamp, director, The Frick Collection, New York, and Everett Fahy, John Pope-Hennessy Chairman of the Department of European Paintings, The Metropolitan Museum of Art, New York. Suzanne Folds McCullagh, curator of Earlier Prints and Drawings, The Art Institute of Chicago, was extremely helpful throughout the planning stages. We owe a great debt to Diane De Grazia, curator of Southern Baroque Painting, National Gallery of Art, Washington, D.C., for her recommendation of Linda Wolk-Simon, who became our consulting scholar and the author of our catalogue.

We are grateful for the cooperation of the directors and staffs of the museums participating in the tour: Andrea S. Norris, director, and Doug Tilghman, assistant director,

Spencer Museum of Art, University of Kansas; Evan Maurer, director, and Beth Desnick, administrator of Exhibitions, Minneapolis Institute of Arts; James Cuno, director, Marjorie Cohn, acting director, Edgar Peters Bowron, former director, and William Robinson, Ian Woodner Curator of Drawings, Fogg Art Museum, Harvard University; Ruth K. Meyer, director, and David Torbet Johnson, assistant director/registrar, Taft Museum, Cincinnati; and Pierre Thébèrge, director, and Micheline Moisan, curator of Prints and Drawings, Montréal Museum of Fine Arts.

At the University of Florida, we were fortunate to have many resources to support us in such a complex undertaking, and we wish to thank the following: John Knaub, Office of Instructional Resources, who photographed the collection and who patiently and skillfully obtained the most faithful renderings; Karen Stone, associate general counsel, who assisted with keen interest in all our agreements and contracts; and Daniel Arrington, coordinator of management analysis, and Michael Harris, assistant vice-president, Planning and Budgeting, who helped in the computer conversion of the catalogue copy to make it compatible for the typesetters.

While all members of the Harn Museum staff were actively involved in the exhibition's success, some made particularly notable contributions to its development. Larry David Perkins, curator of Collections, was helpful in the early stages of planning, with the itinerary, with advising on the structure of the catalogue, and with framing the collection for travel; Kerry Oliver-Smith, coordinator of Programs, dedicated her staff to producing exciting educational programs and accompanying materials for the exhibition; Blair Sands, assistant registrar, coordinated all the photography and registration details; and Bradley Smith, chief preparator, and Timothy Joiner, assistant preparator, expertly matted and framed the collection in its uniform travel frames, designed and installed the exhibition at our museum, and prepared the exhibition for travel. Charlotte Simmons, business manager, was consistently helpful throughout the complicated details of managing the project. My secretary, LeJene Normann, lent her cheerful support and excellent skills to many phases of the project, including travel arrangements, manuscript typing, and coordinating years of intensive communication.

We would like to thank in particular Anne Schroder, curator of Exhibitions, who joined the staff late in the development of the Italian drawings project, but devoted a substantial part of her time to finalizing the tour plans, arranging dates, and planning the installation of the exhibition.

We also want to express deep appreciation to Meredith Davis, coordinator of Visual Design in the School of Design, North Carolina State University, Raleigh, for the catalogue design. She has been instrumental in developing the Harn Museum's publications program from its inception. Through her design work, she has created a standard of excellence for the museum's catalogues and educational materials.

To Margaret Bass Bridges, museum registrar, we owe the greatest debt of gratitude for

her contributions to the exhibition and catalogue. From its inception, Peggy accepted responsibility for the entire development of the show, long before our new building was finished and while we were still a tiny staff with no clerical support. She arranged the transport of the collection, made all contractual arrangements, worked closely with the collector and the photographers, secured provenance materials, coordinated the itinerary, controlled the budget, and supervised the design, content, and editing of the catalogue. Although it was her first full-scale original exhibition, she carried this assignment out with consummate skill, smooth organization, unruffled composure, and graceful good humor.

We had the extraordinary good fortune to secure the requisite expertise in Italian drawings in the distinguished person of Linda Wolk-Simon, assistant curator, Robert Lehman Collection, Metropolitan Museum of Art. She has given us a brilliant study of the collection through her individual entries on the drawings and was invaluable in assisting with the full range of issues concerning the exhibition, including making the final selections, choosing the color reproductions, and advising on the catalogue format. Her insights and observations are at the very heart of the project, and our association with her over the past two years has been extremely rewarding.

Our greatest thanks are reserved for Jeffrey Horvitz, who generously allowed us access to his collection and to his records, and who was so supportive throughout the development of the exhibition. He agreed from the start that the highest scholarly standards and correctness of attributions should be the guiding principles for this exhibition, regardless of the consequences. This openmindedness made the project a joy for scholars and staff, and his unfailing courtesy and patience sustained us through the arduous process. Although he obtained the drawings from a wide variety of sources, Jeffrey Horvitz credits a substantial part of his collection's quality to three dealers who are also his friends: Marianne Roland Michel, Jean-Pierre Selz, and especially, for the Italian drawings, Jean-Luc Baroni.

We are extremely appreciative of the generous support of the administration of the University of Florida—in particular, president John V. Lombardi, provost Andrew A. Sorensen, and vice-provost Gene W. Hemp. We extend to the members of the Harn Alliance our warm thanks for providing funding for all our programs.

To our Founders, who pursued the ambitious idea of an art museum at the University of Florida, this exhibition is dedicated, as a symbol of what is possible when individuals and institutions work together toward a dream.

■

Budd Harris Bishop
Director
Samuel P. Harn Museum of Art

AUTHOR'S ACKNOWLEDGMENTS

This catalogue came into being through the dedicated energies of a number of colleagues and collaborators. Budd Harris Bishop, director of the Samuel P. Harn Museum, conceived this project and oversaw its progress at each stage. I am indebted to him and the staff of the museum for their cheerful assistance, particularly Blair Sands, who tenaciously pursued photographs from around the world, Stacy Martorella, who compiled the bibliography, and Larry Perkins. Special thanks are due to Peggy Bass Bridges, who ably and gracefully coordinated every facet of this catalogue and without whose indefatigable spirit it would not have been realized.

For their efforts, I am also grateful to Meredith Davis, who designed the catalogue, John Knaub, who photographed all the drawings, and, especially, Brenda Gilchrist, who edited the manuscript with a keen eye and gentle hand.

Jean-Luc Baroni and Stephen Ongpin kindly provided information on a number of the drawings discussed in the catalogue. I also wish to thank Diane De Grazia, to whom I owe my participation in this project. William Griswold conferred with me throughout the entire course of the writing of the catalogue; his knowledge and insight, always generously shared, have considerably improved its content, and it has been my great good fortune to have him as a colleague. As always, my husband, Joseph Simon, has been an unstinting contributor and participant from beginning to end. Finally, I would like to express my gratitude to Jeffrey Horvitz for his gracious support of this undertaking and for providing the enviable opportunity to work on a singularly distinguished collection of Italian Old Master drawings.

■

Linda Wolk-Simon

CATALOGUE

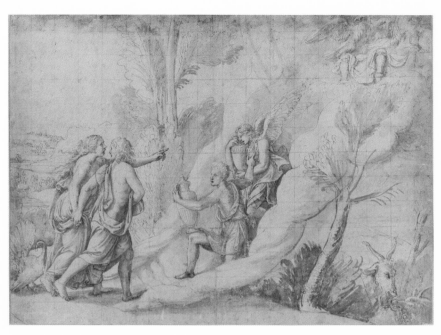

1

GIULIO ROMANO (Rome 1499-Mantua 1546)

1. *Jupiter and Juno Take Possession of the*
Throne of Heaven
Black chalk, pen and brown ink, brown wash, squared in
black chalk, 39.4 x 55.2 cm. (15 1/2 x 21 11/16 in.).

Provenance: Sir Thomas Lawrence (Lugt 2334); [Wood-
burn]; Lord Francis Egerton, first earl of Ellesmere; sale,
London, Christie's, December 9, 1980, no. 17, repr.;
[Arnold-Livie, 1982, no. 13, repr.]; [Colnaghi, London,
1984, no. 2, repr.].

A youthful Jupiter and Juno, hands clasped, prepare to as-
cend a stairway of cloud to take possession of the Olympian heaven. Jupiter's throne,
eagle, and lightning bolt await them at the summit, while two vase-bearing attendants,
a winged victory and an athletic male acolyte, greet the god and goddess and direct
their progress. Juno's peacock stands at her side, and behind her, a receding, distant
landscape is glimpsed. Two goats graze at the lower right, this detail perhaps a refer-
ence to the infancy of Jupiter, who was suckled by the goat Amalthea (Ovid *Fasti*
5.121.24).

This drawing by Giulio Romano, notable for its particularly distinguished provenance,
is a *modello* for a painting now at Hampton Court (fig. 1a).[1] Executed by his workshop
after Giulio's drawing, the painting is part of a series, originally consisting of sixteen to
eighteen panels, depicting scenes from the lives of the Olympian deities.[2] Although it is
not mentioned in contemporary documents, seventeenth-century inventories indicate
that this series originated in Mantua, where Giulio Romano worked in the service of the
Gonzaga court from 1524 until his death in 1546. The original setting of these panels, as
well as the identity of the patron, is unknown; the paintings may have been commis-
sioned by Giulio's major employer and benefactor, Federico Gonzaga, who appropri-
ated the imagery of Jupiter for various aspects of the decoration of the Palazzo Te and
the Palazzo Ducale in Mantua. A date of ca. 1537 has been suggested for a drawing
connected with another panel in the series;[3] our study should be dated to the same
period.

The Horvitz sheet is a representative example of the type of drawing Giulio Romano
most frequently produced in Mantua. Active as an architect, designer of tapestries and
table service, and overseer of public buildings, the artist was also responsible for the
entire interior embellishment of the Palazzo Te and later, of a suite of apartments in the
Palazzo Ducale, both of which included fresco and stucco decoration. He maintained a

1

large if nebulous workshop to assist him in this enterprise, but had little time or energy to devote to the actual painting of the designs he invented. To accommodate these constraints, Giulio adopted the working manner practiced by Raphael, providing composition drawings to his assistants which they employed to translate his designs into paint. Similar drawings by the artist include the *modello* for the *Boar Hunt* medallion in the Sala dei Venti in the Palazzo Te;[4] the study of a *Shepherd and a Wolf* for the Giardino Segreto of the Palazzo Te,[5] and the *modello* for the *Infancy of Augustus* in the Camerino dei Cesari of the Palazzo Ducale.[6]

Like the present study, these composition drawings by Giulio are, as a rule, executed in pen and ink with wash. A hard contour line is combined with transparent brown wash applied in broad pools to indicate the play of light and shadow on the forms, and details of anatomy and costume are treated in a rather cursory fashion. Traces of black chalk underdrawing occasionally appear, and many of these studies, the present example included, are squared for transfer, indicating that they served as *modelli*. The majority of these drawings from Giulio's hand are fully finished inventions rather than *pensieri*— designs that afforded his *garzoni* no latitude to interpret his intentions, merely the guidelines to execute them.

Motifs and forms favored by Giulio Romano punctuate the *Jupiter and Juno modello*. Characteristic of his pictorial vocabulary are the twisting, serpentine posture of both Jupiter and the male acolyte[7] and Juno's elaborately coifed hair with windswept tresses. The cloud-stair motif was reused by the artist in the *Judgment of Paris* in the Sala di Troia in the Palazzo Ducale, while the airy landscape receding to a distant horizon occurs in such early works as the *Deësis (Christ in Glory with Saints)* in the Galleria Nazionale, Parma.

■

1a. Giulio Romano and workshop, *Jupiter and Juno Taking Possession of the Throne of Heaven,* Royal Collection, Hampton Court Palace

1 On the painting, see Shearman, 1983, no. 123, pl. 111; Hartt, 1959, vol. 1, pp. 214-15; vol. 2, fig. 462. On the Ellesmere Collection of drawings by Giulio Romano, see *Catalogue of The Ellesmere Collection*, part II, Sotheby's, London, 1972. (The present drawing was not included in this sale.)

2 Shearman, 1983, under no. 125.

3 *Neptune Taking Possession of the Sea*, Musée des Beaux-Arts, Dijon, inv. CA 807. See the entry by Konrad Oberhuber in Mantua, 1989, p. 427, repr. The painting to which this drawing relates is lost.

4 Albertina, Vienna, inv. 317 [SR 384]; see Mantua, 1989, pp. 354-55, repr.

5 Teylers Museum, Haarlem, inv. Ax52; see Mantua, 1989, p. 363, repr.

6 Royal Library, Windsor Castle, inv. 0308; see Mantua, 1989, p. 401, repr.

7 The latter compares closely with the gesturing youth at the lower left in the *Stoning of St. Stephen* in S. Stefano, Genoa (Mantua, 1989, p. 76, repr.).

■

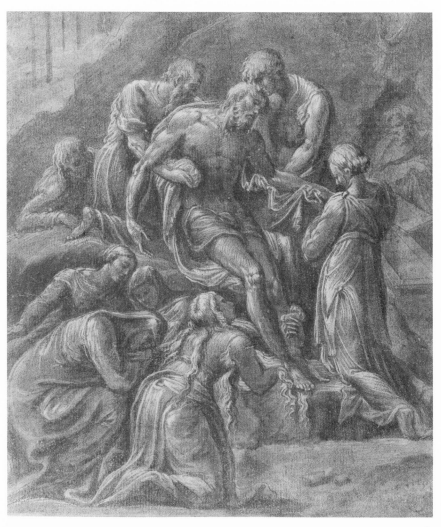

2

Follower of P O L I D O R O D A C A R A V A G G I O
(Caravaggio ca. 1499–Messina ca. 1534 or ca. 1543)

2. *The Entombment of Christ*

Pen and brown ink, brown wash, heightened with
white, over traces of black chalk,
22.0 x 19.4 cm. (8 5/8 x 7 5/8 in.).

Provenance: Unidentified collector's marks on recto and
verso (not in Lugt); [Colnaghi, New York, May 1984,
no. 2].

The body of Christ, draped in a winding cloth, is supported by two male bearers, one bearded and the other of a more youthful aspect. The Virgin Mary, identified by her veiled head, appears at the lower left, collapsed in a posture of grief. She is attended by two female mourners. To the right of the Virgin kneels Mary Magdalene, who embraces Christ's feet and swaths his wounds with her long tresses in a gesture of penitence. Another female mourner, her back turned toward the viewer, supports the left hand of Christ with the edge of the *corporale*. Two more figures who participate as witnesses but do not actively engage in the drama complete the scene—a youthful male who peers out behind the bearer at the left and a cloaked, bearded spectator who stands behind the open tomb glimpsed at the right edge of the composition. Aside from Christ, the Virgin, and Mary Magdalene, the identities of the figures who populate the composition are somewhat unclear owing to a lack of identifying attributes. The female attendants should presumably be recognized as the Three Marys who witnessed the Crucifixion and later discovered the empty sepulchre after the Resurrection. The bearded man who supports Christ is in all likelihood Nicodemus, in which case the other bearded witness would be Joseph of Arimathea, who gave his tomb for the burial of Christ. The youthful bearer is probably John the Evangelist. That the locus of the drama is Mount Calvary is established by the bases of the three crosses visible at the upper left.

The composition recorded in the Horvitz sheet is the invention of Polidoro da Caravaggio, whose authorship is established in a presumed autograph drawing in a private collection of which our study would appear to be a faithful replica.[1] The artist treated the related themes of the Lamentation, Deposition, Transporting of the Body, and Entombment of Christ—all of which describe with some accuracy the subject of the present sheet—in many studies throughout his career and in a number of paintings as well. The latter group includes the *Deposition* now in the Museo Nazionale di Capodimonte, Naples, one of Polidoro's most powerful and dramatic works.[2] While some of the drawings by the artist that treat these consecutive episodes of the Passion are clearly con-

5

nected with paintings,[3] others appear to be graphic elaborations of a theme that evidently engaged Polidoro's artistic imagination throughout his career, but were not necessarily conceived as designs for commissioned works. The invention recorded in our sheet falls into the latter category. It is closely related in subject matter and composition to a drawing by Polidoro in the Musée du Louvre, Paris, of the *Pietà*[4]—the upright and central position of the body of Christ in both designs is particularly close—but like the Paris sheet, cannot be clearly connected with a finished painting. Both compositions descend from earlier treatments of the theme by the artist: another drawing in the Louvre representing the Entombment,[5] and a study in the Musée Condé, Chantilly, for an altar wall that includes the Lamentation as the central element.[6] All these studies in turn anticipate a later invention—the Naples *Deposition*. Connections between drawings, and with paintings, by Polidoro are thus fluid and ambiguous rather than direct and literal.

Questions of authorship further complicate an investigation of the Horvitz sheet. Autograph variants of the same composition are not unknown in Polidoro's graphic oeuvre,[7] but our drawing is sufficiently different in style from the version cited above to render unlikely the possibility that both are by the same hand. Moreover, the sheet demonstrates certain characteristics of a copy, notably the flattening out of forms around the contours. This is particularly the case with the kneeling female figure at the right, whose right shoulder and hip adhere to the surface plane of the sheet rather than curve convincingly in space. Other passages, such as the body of Christ, whose muscular torso collapses with the weight of death, are more deftly handled, however. And certain morphological details, such as the slanted, shadowed eye and straight, sloping nose of the Magdalene, are consistent with Polidoro's style. Finally, the extensive use of white heightening and its application in the form of hatched strokes is familiar from autograph drawings by Polidoro, a fact that suggests the hand of an artist well conversant with his graphic manner.

While not by Polidoro da Caravaggio, the Horvitz *Entombment of Christ* is, in the opinion of the present author, the work of a close follower of the artist. That the drawing from which it appears to derive was executed after he left Rome in 1527 and was taken, presumably by Polidoro himself, to Messina,[8] indicates that the author of our study was one of his disciples in this provincial capital. For the moment, the identity of this competent draftsman remains a mystery.

■

1 On this drawing, see Leone de Castris, 1988, p. 81, no. VI.4. As noted in the catalogue, this sheet, which dates ca. 1527–28 and was therefore executed in Naples, has a Messina provenance. This circumstance would seem to indicate that the artist took his drawings with him when he removed to Messina. It was through such means that Polidoro's earlier inventions became known in the south and continued to exercise a profound influence on his provincial followers even after the artist's death.

The autograph status of the variant published by Leone de Castris in my opinion is not entirely certain. It is possible that this sheet, too, is an early copy of a lost invention by Polidoro.

2 On this painting, see ibid., pp. 78–79, no. VI.1, repr.

3 This is the case, for example, with the study for a *Lamentation* in the British Museum, London (inv. 1944-7-8-16), which was executed in connection with the lost antipendium from the Martelli altar in S. Agostino, Rome. See Pouncey and Gere, 1962, no. 202 and pl. 170; and Ravelli, 1978, no. 26, repr. The drawing is in poor condition but it appears to be autograph.

4 Inv. 6070; see Ravelli, 1978, no. 95. For a discussion of this drawing and its relation to the composition recorded in our sheet, see Leone de Castris, 1988, pp. 80–81, no. VI.3.

5 Inv. 592; see Ravelli, 1978, no. 43, repr.; and Paris, 1983, no. 107.

6 Inv. 95; see Ravelli, 1978, no. 91, repr. This drawing has been tentatively connected with the Chapel of Fra Mariano in S. Silvestro al Quirinale, Rome, decorated by Polidoro and his collaborator Maturino around 1525. Also related to this group of drawings is a study by Polidoro of the *Lamentation*, datable to the artist's Roman period, which is currently on the art market (Paris, Drouot-Richelieu, sale no. 2, January 24, 1991, no. 64, repr.). Stephen Ongpin kindly brought this drawing to my attention.

7 A case in point is an invention from the artist's Roman period depicting *Christ Carried to the Tomb*, of which at least two autograph versions exist, one in the Louvre and one in the Fogg Art Museum, Harvard University. On the Louvre sheet, see Paris, 1983, no. 107; on the Fogg variant and its connection with the Louvre drawing, see Ravelli, 1988, p. 11 and figs. 7 and 8. I do not accept Ravelli's attribution of the Louvre version to Perino del Vaga, and believe the traditional ascription to Polidoro is correct.

8 See note 1 above.

■

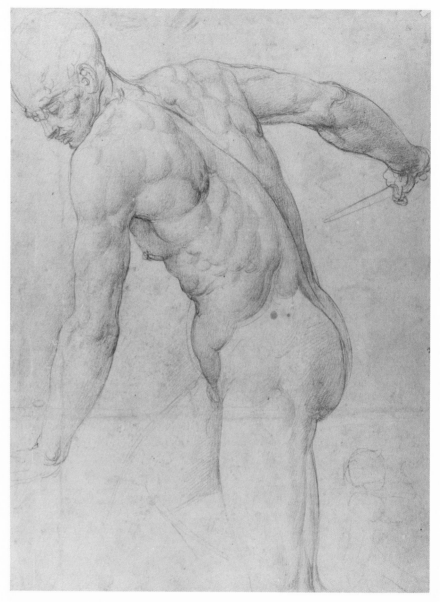

3

3. *Study of a Nude Man Holding a Dagger*

Black chalk, retouched in pen and brown ink at upper
left and center, probably by a later hand,
32.8 x 24.4 cm. (12 7/8 x 9 5/8 in.).
Inscribed in brown ink on verso of old backing:
Michael Angelo:.

Provenance: Furst Johann von und zu Liechtenstein,
Vienna (as Daniele da Volterra); [Colnaghi, London,
1953, no. 17, as Daniele da Volterra]; [Harrop, London,
April 4, 1968]; Timothy Clifford; [Colnaghi].

T his drawing, executed in black chalk, depicts a standing
nude man seen from the side. He rests his left hand on a ledge or some other support
and extends a dagger in his right hand as though preparing to attack an intended
victim. A second figure in a reclining posture is summarily sketched in the lower right
corner.

The artist seems in this study to have been primarily interested in the nude form. While
the muscles and sinews of the straining figure's torso are carefully delineated in exact
detail, with a fidelity and accuracy that suggest a live model, the legs, left hand, and
cranium are treated in a more cursory fashion.[1] A vigorous and controlled hatching
imparts to the figure relief and plasticity. The precise, solid modeling and insistent
contour that characterize the sheet exemplify the sixteenth-century Italian tradition of
disegno.

Although the use of black chalk and the particular handling of the medium, as well as
the subject matter, of the Horvitz sheet would seem to suggest a central Italian artist,
this drawing is by the Venetian painter and printmaker Battista Franco.[2] A paradigmatic
example of the artist's chalk drawing style, it may be compared with a black chalk study
of a standing nude in The Metropolitan Museum of Art, New York, that similarly attests
to the artist's interest in the heroic male form.[3] Suggestive affinities in both style and
subject matter may also be observed in a sheet of studies by Franco in the Rijksmuseum,
Amsterdam (fig. 3a).[4] Executed in black and red chalk, the latter depicts a series of male
nudes. Like the figure in the Horvitz sheet, these are essentially half-length, the artist
again being concerned foremost with the muscular torsos, and their postures similarly
suggest a battle scene. It is possible that the two drawings are contemporary and were
executed in connection with the same commission, although neither can be directly
associated with a known painting or print by Franco.

9

The Horvitz drawing is a revealing testament of Battista Franco's artistic sensibility: he was perhaps the most faithful "romanista" of any Venetian artist of the sixteenth century and a devoted follower of Michelangelo.[5] In our study, the artist treats a subject favored by Michelangelo, particularly in the first decades of his career—the heroic, idealized male nude. He also employs the medium preferred by Michelangelo in many of his single figure studies.[6] Moreover, in its emphasis on the muscular posture of the figure, this study recalls many of Michelangelo's own drawings. Even Franco's handling of the chalk and the particular graphic technique, specifically the incisive outline and the sculptural cross-hatching employed to create form, reveal analogies with the graphic style of the older master. A comparison of the Horvitz sheet with a group of black chalk figure studies executed in connection with the *Battle of Cascina* serves to demonstrate the extent to which Franco approximated the graphic style of Michelangelo.[7] And as an inscription on the verso of our drawing, *Michael Angelo*, and the earlier attribution to Michelangelo's follower Daniele da Volterra both confirm, affinities with that artist have long been observed.

The function of this study is unknown. The pose of the figure and the presence of the dagger in his hand suggest to the present author three possible subjects: a scene of martyrdom, the *Massacre of the Innocents*,[8] and *Tarquin and Lucretia*.[9] Battista Franco executed a painting of the latter subject during a sojourn in Florence, according to Vasari, but this work does not survive.[10] The present sheet may relate to this lost painting, or it may simply be one of the numerous drawings by the artist that were carried out as autonomous graphic demonstrations with no particular end or final invention in mind.[11] Indeed, as Vasari remarked, Battista Franco was "ostinato in una certa openione che hanno molti, i quali si fanno a credere che il disegno basti a chi vuol dipignere."[12] In either case, the Horvitz drawing is a revealing and characteristic work by an artist who was more distinguished as a draftsman than a painter.

■

10

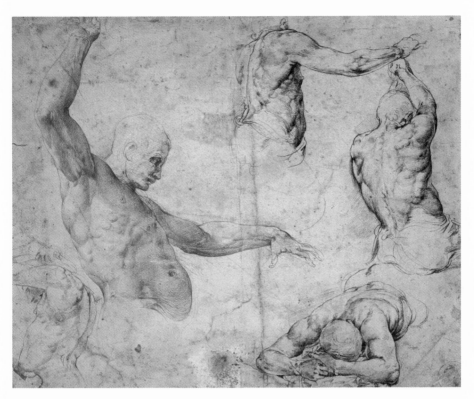

3a. Battista Franco, *Sheet of Studies*, Amsterdam, Rijksmuseum

1

1 Vasari's remark that Battista Franco's fresco of the *Capture and Imprisonment of St. John the Baptist* in the Oratory of S. Giovanni Decollato suffered because the artist lavished too much attention on the graphic preparation of the composition and on such minute details as the muscles of his figures is particularly telling in relation to this drawing. (Vasari-Milanesi, 1906, vol. 6, p. 580.)

2 On Battista Franco, see the entry by Ettore Merkel in Venice, 1981, p. 202.

3 Inv. 62.119.10. On this drawing, which has been connected with the figure of Christ in an engraving of the *Flagellation* designed by Franco, see Bean and Turčić, 1982, no. 84, repr.

4 Inv. 1948:367; see Frerichs, 1981, no. 66 and fig. 79.

5 This point is stressed by Vasari in his *Vita* of Franco, which begins with the tale that the artist decided at age twenty to remove to Rome where he "resolved to seek no other model to study and imitate than the drawings, paintings, and sculpture of Michelangelo." (Vasari-Milanesi, 1906, vol. 6, p. 571.) Instances of the artist executing copies after Michelangelo's works are noted by Vasari throughout his *Vita* of Franco. Michelangelo's influence is evidenced in Franco's panel depicting the *Battle of Montemurlo*, among other works, in which Michelangelo's celebrated *Ganymede* is literally and precisely quoted in the center of the composition (Palazzo Pitti, Florence; on this painting, see Florence, 1980, no. 504, repr.).

6 For a discussion of Michelangelo's use of black chalk, see Hirst, 1988, pp. 6–7.

7 The Horvitz sheet may be compared in particular with the studies in the Teylers Museum, Haarlem (inv. A18 recto and A19 recto), and the Albertina, Vienna (inv. SR 157 verso). These drawings by Michelangelo represent single nude male figures and are executed in black chalk. (See Hartt, 1970, nos. 42-44, repr.) A particularly compelling comparison may be made with the Albertina study, which depicts a muscular nude torso seen from the rear gripping a weapon.

8 Franco's figure is similar to one of the soldiers in Daniele da Volterra's *Massacre of the Innocents* in the Uffizi, Florence. For an illustration of this work, see Pugliatti, 1984, fig. 106.

9 It has also been suggested (Andrews, 1969, no. 37) that the drawing may be a study of a Sacrifice of Abraham. It should be noted, however, that the figure of Abraham in a print of this subject by Franco (B.XIV, 118) does not conform to the posture of the figure in our drawing, his arm instead raised high in the air over his head. Such a gesture is frequent in representations of this subject, since the patriarch's raised arm presented itself more readily to the intervening angel.

10 Vasari-Milanesi, 1906, vol. 6, p. 574: "... una tela, dove fece con molta fatica e diligenza Lucrezia Romana violata da Tarquinio." A drawing by Franco of this subject is in the British Museum, London (inv. 5236-117). See Gere and Pouncey, 1983, no. 116 and pl. 127. The pose of Tarquin in the British Museum sheet is similar to that of the figure in our drawing.

1 2

11 A general correspondence may be observed between the figure in the Horvitz sheet and a sword-bearing soldier executing a prisoner in a study by Franco for a ceiling painting. Formerly at Chatsworth, the drawing is now in The Pierpont Morgan Library, New York (inv. 1984.30). For an illustration, see *Old Master Drawings from Chatsworth*, Christie's, London, 1984, no. 14, repr. The episode in question is labeled number 5 on the sheet in Franco's hand. Our drawing may have been executed in connection with this invention, but it is more likely that the artist merely used a study already in his possession if the two are indeed related.

12 Vasari-Milanesi, 1906, vol. 6, p. 572. (Franco was obstinate in being of the opinion, shared by many, that drawing is enough for those who would paint.)

■

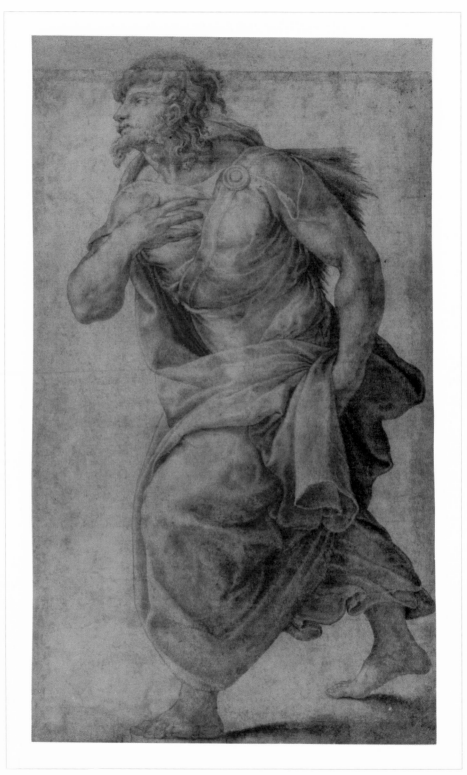

4. *Study for an Apostle in the "Pentecost" of the*
Markgrafen Chapel in S. Maria dell'Anima, Rome
Black chalk, top edge of sheet made up,
43.3 x 25.6 cm. (17 1/8 x 10 1/16 in.).

Provenance: F. Abbot; [Yvonne Tan Bunzl, London,
1984, no. 9].

A barefooted man with beard and curling tendrils of hair is
dressed in a flowing drapery, which he catches at his hip with his left hand. Striding
forward and gazing to the left with his lips slightly parted, he gestures toward his chest
with a gracefully crooked right hand. The identical figure occurs in the guise of an
apostle at the far right of Salviati's fresco in the semidome of the Markgrafen Chapel in
S. Maria dell'Anima, Rome, representing the *Pentecost*; the present drawing appears to
be a previously unrecognized preparatory study for that composition.[1]

Despite the fresco's poor state, an undeniable connection with the Horvitz sheet exists.
The figure in the drawing is lit from the left as is the apostle in the fresco, who is bathed
in the divine radiance of the dove of the Holy Spirit. Similarities in costume include
such details as the bared right arm, the flowing cloak, and the leather band strapped
diagonally across the apostle's chest held in place with a metal clasp. The attitude and
posture of the figure in our drawing are explicated by the subject of the fresco: the
apostle gazes with wonder and responds to the apparition of the dove of the Holy
Spirit. His bewildered expression and rhetorical gesture of disbelief are appropriate to
the narrative content of the Pentecost, when the gift of tongues was bestowed on Christ's
disciples.

The first phase of the fresco cycle in the Markgrafen Chapel was carried out between
1541, following Salviati's return from a two-year sojourn in Venice, and 1543, when the
artist temporarily abandoned Rome for his native Florence. Since it occupies the upper-
most zone of the chapel, the *Pentecost* was presumably the first part of the decoration to
be carried out in keeping with the traditional practice of executing a mural painting
beginning with the highest part of the wall. In any event, all sources concur that it was
unquestionably executed during the first campaign. Accordingly, the Horvitz drawing
can be assigned to the period 1541–42.[2]

Executed in black chalk with an emphasis on the forceful, relieflike quality of the figure,
the *Study for an Apostle* demonstrates affinities both in subject matter and technique with
such drawings by Salviati as a kneeling, draped male figure in the Pennsylvania Acad-

1 5

emy of the Fine Arts, Philadelphia;[3] a head of a bearded man in the Musée du Louvre, Paris;[4] a similar sheet in The Pierpont Morgan Library, New York;[5] and a draped female figure in the Frits Lugt Collection, Fondation Custodia, Paris.[6] A number of red chalk drawings by the artist, such as a study of a male nude torso seen from the rear in the Biblioteca Reale, Turin,[7] also belong to this category of Salviati's graphic production. In their bold, sculptural hatching, indicative of a preeminent concern for describing the plasticity of forms, these drawings testify to Salviati's training in the Florentine tradition of *disegno* and his enduring preoccupation throughout his career with the human figure.[8]

■

1 On Salviati's frescoes in the Markgrafen Chapel, see Nova, 1981, pp. 355–72; and Geiger, 1985, pp. 181–94. The connection between this drawing and the S. Maria dell'Anima fresco was kindly pointed out to me by David Ekserdjian.

2 On this dating of the Markgrafen Chapel frescoes and the *Pentecost* as the first fresco to be executed, see Nova, 1981, p. 356; and Geiger, 1985, p. 182.

3 Inv. 79; see Olszewski, 1979, no. 27, repr.

4 Inv. 9063; see Monbeig Goguel, 1972, no. 150, repr.

5 Inv. I, 6B; see Bean and Stampfle, 1965, no. 102, repr.

6 Inv. 2518. Executed around 1548–49, this drawing is connected with Salviati's fresco of *The Beheading of John the Baptist* in the Cappella del Palio of the Palazzo della Cancelleria, Rome. See Byam Shaw, 1983, vol. 1, no. 29; vol. 3, pl. 40.

7 Inv. 15649b D.C. On this drawing and related studies, see the entry by Catherine Monbeig Goguel in Turin, 1990, no. 49a, repr.

8 The latter point has recently been emphasized by Monbeig Goguel in Turin, 1990, under no. 49a.

■

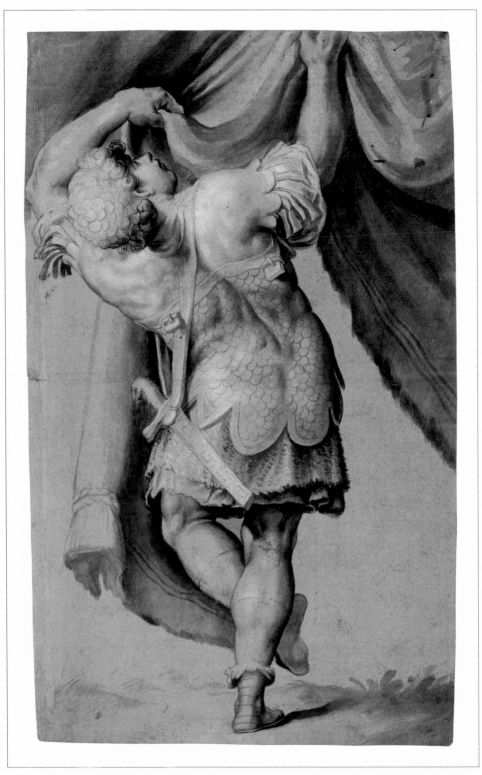

5. *Study of a Standing Soldier Lifting a Curtain*
Brush and brown and gray wash, heightened with
white, on yellowish paper,
43.1 x 26.7 cm. (16 15/16 x 10 1/2 in.).
Inscribed in pen and brown ink on verso:
Franc.ᶜᵒ Salviati.

Provenance: [Colnaghi, London, June–July 1985, no. 2,
repr.].

A soldier dressed in elaborate and somewhat fanciful Roman military costume looks upward as he lifts a curtain with his raised arms. Seen from the rear, he stands with his legs crossed and his torso twisted in the artificially graceful "serpentine" posture favored by mannerist artists. Despite his bulging musculature, the figure evinces a curiously weightless aspect. Assuming a balletic pose with his weight poised on one foot, he casts only a slip of a shadow on the vaguely delineated grassy turf.

Francesco Salviati executed a group of drawings to which this sheet relates in both style and technique. These include studies for a running soldier with a raised sword in the Statens Museum for Kunst, Copenhagen;[1] a reclining female figure with an open book and a scroll in the Musée du Louvre, Paris;[2] the ancient hero Jason in the British Museum, London (fig. 5a);[3] and a seated soldier in the Biblioteca Ambrosiana, Milan.[4] These drawings have all been dated to the 1550s, the period to which our study must also belong. Of the artist's major works, the figure in the Horvitz study demonstrates the closest affinities with the inflated, twisting, broad-hipped St. Andrew in the Oratory of S. Giovanni Decollato, Rome, which was executed in 1550,[5] and a standing soldier in the Sala delle Fasti Farnese in the Palazzo Farnese, painted between 1550 and 1554.

Like the group of similar drawings referred to above, the function of our study is uncertain, and the sheet does not appear to be related to any of the artist's frescoes, tapestry designs, or easel paintings. Discussing the Ambrosiana study of a seated soldier, Alessandro Nova has suggested that these drawings were probably not executed in connection with a specific commission, but rather were intended as models to be employed in various compositions when appropriate.[6] Since a number of Salviati's major mural cycles, notably the frescoes in the Palazzo Sacchetti and the Palazzo Farnese in Rome and the Sala dell'Udienza in Florence, include soldiers, it is conceivable that the artist indeed maintained a repertoire of such stock figures. Moreover, a large number of drawings by Salviati representing soldiers, executed in various techniques and likewise impossible to associate definitively with any of his major commissions, exist—

a fact that would seem to support this hypothesis.

It is also possible that our drawing represents an idea for a fresco cycle that was super-seded by another design. The type of figure represented in the sheet was conceivably intended to flank a narrative scene, around which he would have drawn an illusionistic curtain, or to be seen as the central image of a short wall in a grand *salone*. A similar figure in fact appears in such a position in the Sala Paolina in Castel S. Angelo, Rome.[7] Designed by Pellegrino Tibaldi, who completed the decoration after the death of Perino del Vaga in 1547, this detail may have inspired Salviati's figure.[8] Finally, it is also conceivable that the present drawing was designed as a finished work in its own right, a suggestion consistent with its highly finished quality.

The Horvitz drawing reveals Salviati's particular flair for fanciful and infinitely varied details of costume of which Vasari took note.[9] His delicate handling of wash and the strong contrast between the figure and the background created through the liberal application of white heightening invest this sheet with something of the effect of an ancient cameo.[10] Salviati's early training as a goldsmith and his ongoing activity as a designer of precious objects inform the highly refined quality of our sheet and the group of drawings to which it is related.[11]

■

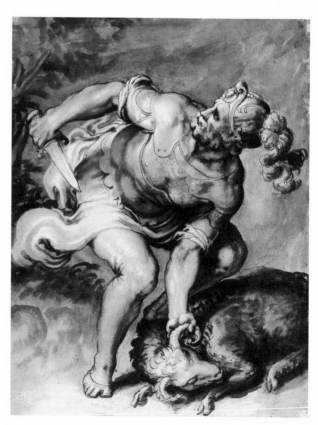

5a. Francesco Salviati, *Jason*, London, British Museum

2 0

1 Inv. Ital. Mag. XIX, 33; see Gere, 1971b, p. 82 and pl. 10.

2 Inv. 1657; see Monbeig Goguel, 1972, no. 157, repr.

3 Inv. 1946-7-13-53; see Monbeig Goguel, 1971, p. 84 and pl. 21; and Turner, 1986, no. 128, repr.

4 Cod. F. 262 Inf. no. 39. See the entry by Alessandro Nova in Notre Dame, 1984, no. 53, repr.

5 On this fresco, see Hirst, 1967, pp. 34–36.

6 Nova in Notre Dame, 1984, under no. 53.

7 For an illustration of the Castel S. Angelo fresco, see Gaudioso, 1981, vol. 1, p. 172, fig. 112; this detail is illustrated in color on the back cover of vol. 2.

8 That Tibaldi exercised an influence in this period on the older Salviati has been pointed out by Alessandro Nova with regard to the muscular standing saints in the Markgrafen Chapel. (Nova, 1981, p. 364 and note 27.) Our drawing is further evidence of this influence.

9 "...Clothing his figures in new styles of dress, he was fanciful in the variety of headdresses, footgear, and every other kind of ornament." (Vasari-Milanesi, 1906, vol. 7, p. 41; translation by Nova in Notre Dame, 1984, under no. 53.)

10 This point has been made by Monbeig Goguel, 1972, p. 133, under no. 156, in a discussion of the above cited related drawing in the Louvre.

11 On Salviati's designs for goldsmith work, see Dillon, 1989, pp. 45–49.

■

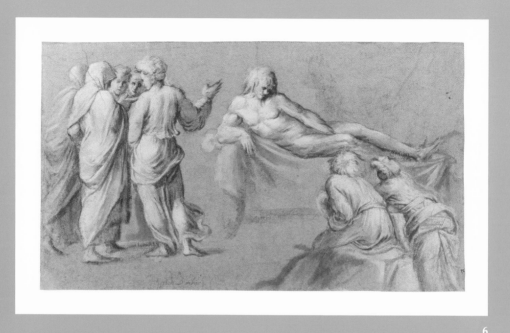

6

6. *Groups of Figures and a Reclining Male Nude*
Pen and brown ink, brown wash, heightened with white,
over black chalk, on blue paper,
23.2 x 40.9 cm. (9 1/8 x 16 1/16 in.).
Inscribed at bottom of sheet: *Raphael D'Urbino.*

Provenance: Sir Peter Lely (Lugt 2092); Nicholas Lanier;
[Colnaghi, London, 1990].

A youthful nude male reclines on a draped bed, behind which two lightly sketched figures stand. At the lower right two figures seen from the rear, one seated and one leaning over a ledge or other support, regard the reclining nude. A group of five standing figures, two women with veiled heads and three men, converse at the left, two of them gesturing toward the scene at the right.

This sheet, implausibly ascribed at one time to Raphael as the inscription indicates, is a distinctive and paradigmatic drawing by the sixteenth-century Bolognese artist Biagio Pupini.[1] A painter of modest abilities, Pupini possessed considerable facility as a drafts-man, and a great number of his drawings survive. His graphic oeuvre consists largely of drawings in which densely applied white heightening is the primary medium, a prac-tice exemplified by the present sheet. This technique, as well as Pupini's lithe, elongated figures cloaked in nervous, animated draperies and disposed in friezelike groupings, bespeak the strong influence of Polidoro da Caravaggio, to whom many of Pupini's drawings have at one time been ascribed. The Horvitz drawing is highly "Polidoresque" in character: the two figures seen from the rear at the right recall a similar pair in a drawing by Polidoro in the Uffizi, Florence;[2] and the more prominent of the two veiled female figures from the standing group finds an almost exact prototype in a study by that artist in the Kunsthalle, Hamburg.[3] Both of these drawings by Polidoro exhibit a liberal use of white heightening in a manner analogous to Pupini's similar handling.

In addition to the Roman influence of Polidoro da Caravaggio, whose drawings he must have seen during a presumed trip to the Eternal City about 1524, Pupini's graphic style manifests a distinctly Emilian character, shaped foremost by the example of Girolamo da Carpi, and also by Parmigianino. The influence of the former, with whom the artist was associated for a time, as Vasari reports,[4] is evident particularly in Pupini's figure types. A case in point is the standing, gesturing male figure at the left of our drawing, whose elongated and slightly twisting serpentine torso and proportionally small head conform to the canon adopted by Girolamo in many of his figure drawings.[5] While less direct, Parmigianino's impact should perhaps be discerned in the graceful, elegant, and

willowy figures who populate Pupini's compositions.[6] It has even been suggested that Pupini was attempting to emulate not only the drawing style of Parmigianino, but also the effect achieved in chiaroscuro woodcuts based on his designs in such drawings as the present example where white heightening is densely employed.[7]

The subject of the Horvitz drawing is enigmatic; indeed, it is not clear if the sheet depicts a single narrative episode in the conventional sense or if it is a group of unrelated studies. The reclining nude figure is perhaps an artist's model in a studio being drawn by the two figures who study him, but since their action is unclear and ambiguous this may only be surmised. The figures on the left are engaged in some sort of discourse, but whether or not their topic is the reclining figure is equally obscure. It is possible that the figures are all copies after works by other artists or antique reliefs, or even a single relief, of the type that Pupini must have seen in Rome, but this suggestion, too, is speculative since no specific sources for any of the details have been identified. The nude male reclining on a bed of vaguely Roman design recalls the figure of David disposed in a similar posture in one of the lost *basamenti* frescoes in the Vatican Logge, executed by Raphael's workshop around 1518-19.[8] Pupini is known to have copied the Logge frescoes,[9] and it is not impossible that our study was inspired by a Raphaelesque model, as the otherwise inexplicable old attribution to Raphael may indicate. Yet this connection, too, remains conjectural.

The rather disjunctive character of the figures, who seem to form three distinct groups rather than a single, cohesive composition, would seem to favor the point of view that the drawing is a sheet of studies of the type that Pupini produced in some number. Visually appealing but lacking any element of invention, his drawings corroborate Vasari's assessment that Pupini was "più pratica nell'arte che eccellente."[10]

Another version of this drawing, which in my opinion is probably a copy after the present sheet, is currently on the New York art market.[11]

■

1 On Biagio Pupini, see the essay by Anna Maria Fioravanti Baraldi in *Pittura Bolognese*, 1986, pp. 185-208. See also De Grazia, 1984, p. 308.

2 Inv. 500 P; see Ravelli, 1978, no. 19, repr. The drawing in question depicts two figures in a landscape contemplating Roman ruins.

3 Inv. 21446; see Ravelli, 1978, no. 20, repr. The subject of this drawing is the Raising of Lazarus in a landscape.

4 Vasari refers to their collaboration in his joint *Vita* of Girolamo da Carpi and Garafolo; Vasari-Milanesi, 1906, vol. 6. p. 473.

5 Among the many drawings by Girolamo da Carpi that could be cited in this connection, comparison may be made with a double-sided sheet in the Staatliche Graphische Sammlung, Munich (inv. 3086), depicting a draped female figure. The figure on the verso in particular exhibits the unnaturally elongated torso that Pupini also frequently adopted. On the Munich drawing, see Harprath, 1977, no. 19, repr. On Girolamo da Carpi's influence on his collaborator Pupini, see Canedy, 1970, pp. 86-94; and De Grazia, 1984, pp. 309-10.

6 The influence of Parmigianino on Pupini has been discussed by Canedy, 1970, p. 93.

7 Ibid.; De Grazia, 1984, p. 308.

8 This is the lost *basamento* from the eleventh bay, whose subject was *Bathsheba Beseeching David on Behalf of Solomon*. The composition is known through an engraving by Pietro Santi Bartoli; see Dacos, 1986, pl. 143a.

9 A drawing after the *Judgment of Solomon* fresco in the twelfth bay in The Metropolitan Museum of Art (inv. 10.45.5) has been ascribed to Pupini. See Bean and Turčić, 1982, no. 207, repr.

 Vasari, who speaks only briefly and disparagingly of Pupini, refers to the artist's recourse to Raphael but in a derogatory way, commenting that he and his Bolognese contemporary Bagnacavallo were essentially unaccomplished, and that they erred in believing that paraphrasing Raphael was enough to render them good artists. Their success in Bologna, he continues, was only owing to the fact that no one in the city knew anything about art; for this reason, the artists were esteemed by their compatriots as "the best masters in Italy." (Vasari-Milanesi, 1906, vol. 5, p. 177.)

10 Ibid.

11 Sotheby's, January 8, 1991, no. 27, repr.

■

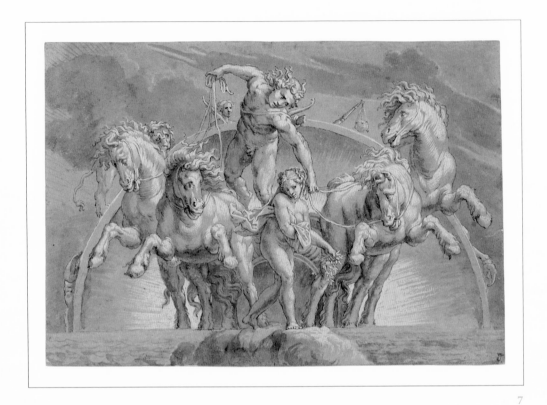

**7. *Apollo Driving the Chariot of the Sun,
Preceded by Aurora Scattering Flowers***
Pen and brown ink, gray-brown wash, heightened with
white, 21.4 x 31.1 cm. (8 3/8 x 12 3/16 in.).

Provenance: Marquis C. de Valori (Lugt 2500);
[Colnaghi, London, July 1986, no. 3].

Apollo, god of the sun, commands his chariot as it is led
through the sky by a team of four rearing horses. Populated by a number of the zodiacal
signs, among them Leo and Sagittarius, the arch behind him represents the heavens
through which the sun passes. Aurora, goddess of the dawn and, according to Greek
myth, sister of the sun god, walks before the chariot scattering flowers in its path.

The present sheet is one of five related drawings by Lelio Orsi dealing with this subject.[1]
These studies have recently been connected with the decoration of the Torre dell'Orologio
of the Piazza del Duomo in Reggio Emilia, now lost, which was commissioned from the
artist in November 1544.[2] That this is indeed their original function is testified by an
anonymous seventeenth-century painting in the Civica Pinacoteca Fontanesi, Reggio
Emilia, which shows the Torre dell'Orologio embellished with a fresco of *Apollo Driving
His Chariot* clearly recognizable as the composition recorded in Orsi's drawings (fig. 7a).
Further confirmation is provided in a study from this group preserved at Windsor
Castle which includes to the left and right of Apollo's horses the coat of arms of the city
of Reggio, an appropriate heraldic emblem for a decoration intended for the major
public square of the commune.

A series of four drawings by the artist in the Musée du Louvre, Paris, illustrating
allegories of the seasons may represent an earlier, more elaborate idea for the Torre
dell'Orologio commission.[3] In these drawings, each of the seasons is personified by
Apollo guiding the chariot of the sun accompanied by an appropriate god or goddess
(e.g., Ceres in the Allegory of Summer) and the three zodiacal signs associated with
each of the four times of year. The original commission possibly called for the artist to
decorate all four sides of the great tower, with one season represented on each of the
four faces. Such an allegory of time and the cycles of the months would have been a
fitting iconographic conceit for a clock tower.

If this series was intended for the Torre dell'Orologio, the scheme ultimately adopted
was more modest in scope, comprising a single fresco ornamenting the main face of the
tower. This less ambitious program was at once more economical and more practical,

given the limited visibility of the other three faces of the tower. The four allegories of the seasons projected in the Louvre drawings were conflated into a single allegory of the day: the figure of Apollo, god of the sun, who appeared in the four seasons compositions was retained, but the seasonal deities were replaced by Aurora, goddess of the dawn, who led the chariot of the sun to the heavens each morning, thus initiating the cycle of the day. Like the four seasons, this condensed allegory of time would have been a fitting image for the clock tower overlooking the central piazza of the city.

The style of the Horvitz sheet is typical of Lelio Orsi's manner as a draftsman. Particularly notable is the dense and meticulous application of white heightening, which serves not only to invest forms with a sense of relief, but also to suggest a bright, radiant light. Indeed, in this study, light assumes an existence independent of form, the artist keenly interested in its formal, pictorial qualities. Drawings by Orsi executed in a similar style include a study of the *Trinity with Pagan Deities*;[4] in both sheets, forms are outlined with a thin, incisive pen line and modeled with white heightening applied as bold hatching.

While the nervous, straining energy of the horses in this study of *Apollo Driving the Chariot of the Sun* finds parallels in the art of Orsi's Bolognese contemporary Pellegrino Tibaldi, the muscular nude form of Apollo recalls Michelangelo. An echo of Correggio is seen in the delicate features and rounded contours of Aurora, who finds a close counterpart in the figure of St. Catherine of Alexandria in Orsi's *Martyrdom of St. Catherine*,[5] executed between 1565 and 1569. Like many of his paintings, this study thus reflects a concern for synthesizing elements of a central Italian style, particularly the example of Michelangelo whose influence intensified after Orsi's trip to Rome in the mid-1550s, with aspects of sixteenth-century Emilian artistic culture.[6] Precisely this characteristic was noted by the great eighteenth-century French collector and connoisseur Mariette, who wrote that in his drawings Orsi "joint au goût terrible de Michel-Ange les graces aimables du Corrège."[7]

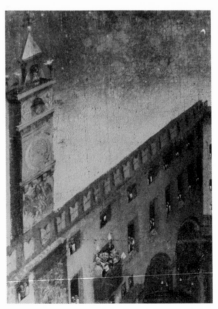

28

1 The related drawings are in the Royal Library, Windsor Castle (inv. 0224); the Biblioteca Ambrosiana, Milan (inv. F 269); the Musée du Louvre (inv. 10378); and an American private collection. See Reggio Emilia, 1987, nos. 14–18, repr. These in turn belong to a larger group of drawings by or after Orsi dealing with related subjects, such as a sheet in the Frits Lugt Collection, Fondation Custodia, Paris (inv. 1976-T.37) depicting the *Chariot of Apollo at the Forge of Vulcan,* which may have originally numbered some twenty sheets. (See Byam Shaw, 1983, vol. 1, no. 395; vol. 3, pl. 448, for a discussion of this series.) In my opinion, a sheet in the National Gallery of Scotland, Edinburgh (inv. D 3162) that has been connected with this series is a copy after Orsi and therefore not part of the autograph group. On this drawing, see Andrews, 1968, vol. 1, p. 82; vol. 2, fig. 577.

2 Reggio Emilia, 1987, pp. 58 and 60.

3 Invs. 3640, 10379, 10380, and 10381; Reggio Emilia, 1987, nos. 10, 13, 11, and 12, respectively, repr.

4 Private Collection, Paris. For an illustration, see Reggio Emilia, 1987, no. 139 and color plates.

5 Galleria Estense, Modena; Reggio Emilia, 1987, no. 142, repr.

6 On this aspect of Orsi's artistic practice, see Washington, New York, and Bologna, 1986, p. 150.

7 Mariette, 1851–60, vol. 4, p. 63.

■

Left:

7a. Anonymous seventeenth-century artist, *Religious Festival in the Piazza del Duomo* (detail showing clock tower with fresco of Apollo by Lelio Orsi), Reggio Emilia, Civica Pinacoteca Fontanesi

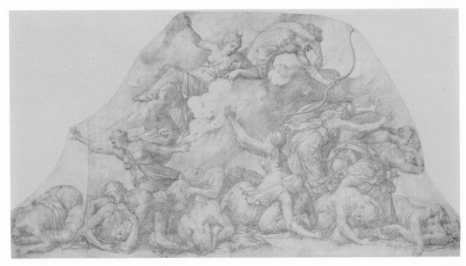

8

8. *Diana and Apollo Killing the Children of Niobe*
Red chalk, lightly squared in black chalk; partly
silhouetted; left edge made up of attached sheet,
36.1 x 67.6 cm. (14 3/16 x 26 9/16 in.).

Provenance: Brentano-Birckenstock Collection; sale,
New York, Sotheby's, January 13, 1989, no. 111, repr.

F rom a bank of clouds, Apollo, holding his bow, and Diana,
wearing a crescent moon crown and gripping an arrow, wage an assault on the un-
armed Niobids. Niobe is seen at the center with her arms raised toward Diana in a
gesture imploring mercy, one of her dead offspring slung across her lap. Other dead
children litter the ground. Three females attempt to flee, two on the right covering their
heads in an effort to protect themselves from the arrow Apollo aims at them. The
subject of the drawing is taken from Ovid's *Metamorphosis* (6.204-312). Apollo and Diana
avenge their mother, Leto, who was ridiculed by Niobe for having only two children
while she boasted fourteen. Niobe serves as an example of pride humbled, her misfor-
tune caused by her arrogant belief that she was superior to the gods.

Painter, architect, and antiquarian, Pirro Ligorio is a quintessential exemplar of the
sophisticated, archaeologizing, *all'antica* culture of Renaissance Rome.[1] Active in the city
for much of his career, the artist first distinguished himself with his facade decorations
in the manner of Polidoro da Caravaggio, whose classicizing, monochrome frescoes of
ancient subjects were accorded the same esteem as ancient relief sculpture, and with his
numerous drawings after the antique. While only a single fresco from Ligorio's long
tenure in Rome survives,[2] his drawings of this period exist in some number, and serve
to testify to the artist's keen interest in and responsiveness to the *maniera antica*.

The Horvitz sheet is a revealing case in point. Forms are rendered in a solid, sculptural
manner with hard, incisive contour lines. Ligorio's graphic style in this drawing ap-
proximates relief sculpture, a quality that is reinforced by the dense composition and
compression of the figures against the surface in a manner analogous to ancient sar-
cophagi.[3] It is possible that this study is one of the copies after ancient sculpture the
artist is known to have produced, of which other examples survive.[4] No precise proto-
type for this composition has yet been identified, however.[5] Whatever its source, the
sheet evinces many of Ligorio's distinctive stylistic traits—the figure types that loosely
recall the artistic idiom of Giulio Romano; the limp, floppy hands connected to de-
formed wrists; and the "insipidly regular profiles" of the faces, particularly that of
Niobe, which recur frequently in his drawings.[6]

In addition to the obvious influence of the antique, the Horvitz sheet reflects Ligorio's responsiveness to Michelangelo. This is evident in the heroic, muscular nude forms and in the powerful modeling that imparts to the figures a strong relieflike character. The same features characterize a black chalk drawing by Ligorio in the Musée du Louvre, Paris, of figures carrying grain that is perhaps his most Michelangelesque graphic invention.[7] Present in Rome when the *Last Judgment* in the Sistine Chapel was unveiled, Ligorio, like other artists of his generation, was profoundly aware of Michelangelo's haunting genius and attempted to emulate his manner.

His antiquarian interests always outweighing his energies as a painter, Ligorio executed many drawings after the antique that were not preparatory studies but independent graphic exercises, a number of these produced in connection with his planned magnum opus on Roman antiquities. Some of his drawings involve religious subject matter, but the majority deal with secular, classical imagery and reflect his enduring preoccupation with the antique. Both in terms of its style and subject matter, our drawing clearly falls into the latter category and, like many studies by the artist, it cannot be decisively related to a known work or commission. The composition was reproduced in reverse in an engraving by Philips Galle published in 1557 (fig. 8a),[8] but it is uncertain whether the design was originally conceived for a print; the fact that it is executed in red chalk rather than pen and ink, and that its inventor was unknown to the engraver, would seem to render this hypothesis unlikely. More probably, the sheet was executed in connection with one of Ligorio's lost Roman facade decorations. The relieflike quality of the design is consistent with this function: Roman facade paintings of this period as a rule were executed in monochrome and were meant to simulate ancient reliefs. Moreover, the precise subject matter of the present drawing was earlier taken up by Polidoro da Caravaggio in a narrative frieze from the lost facade decoration of the Palazzo Milesi, Rome.[9] A well-known and influential precedent, and a model that appears to have influenced Ligorio's own treatment of the theme,[10] thus existed for depicting Diana and Apollo killing the children of Niobe on a painted facade. And the dating of the Horvitz sheet to Ligorio's early career, suggested by its close stylistic affinities with other drawings assigned to this period such as a study of two draped figures formerly in the Wrangham Collection,[11] would accord with the hypothesis that our drawing was executed in connection with a lost facade decoration, as Ligorio's activity in this field was confined to his early years in Rome. Certainly the drawing embodies the same spirit as the artist's facade decorations, which Baglione describes as rich in invention and evocative of the magnificence of ancient Rome.

Ligorio's composition may have provided the inspiration for a plaquette by the sculptor Guglielmo della Porta. Part of a series dedicated to the myths of Ovid, the relief depicting the *Massacre of the Children of Niobe* includes a number of figures who recall their counterparts in this design.[12]

■

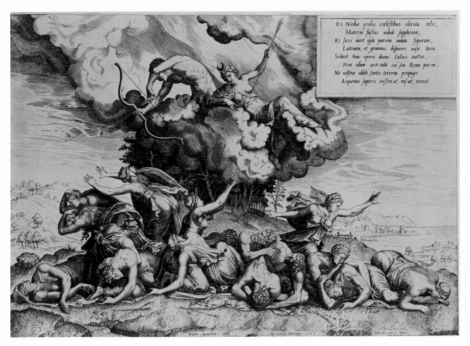

8a. Philips Galle after Pirro Ligorio, *The Death of the Niobids*,
New York, The Metropolitan Museum of Art

1 On Ligorio, particularly his antiquarian interests, see Mandow-sky and Mitchell, 1963. For a summary of his career, see Gere and Pouncey, 1983, p. 113.

2 This is Ligorio's fresco in the Oratory of S. Giovanni Decollato depicting the *Dance of Salome,* for which see Weisz, 1984, pp. 47-50. Like the works of other artists who practiced in this genre, Ligorio's facade decorations no longer exist; these were mentioned by Baglione, 1649, pp. 9-11. In addition to the *Dance of Salome,* a grisaille fresco in the Oratory depicting an ancient sacrifice has been plausibly ascribed to Ligorio by Gere, 1971a, p. 239.

3 For a discussion of this aspect of Ligorio's graphic style, see Gere, 1971a, p. 245.

4 See, for example, two drawings of battle scenes by Ligorio in the British Museum that are free copies after reliefs on the Arch of Constantine; Gere and Pouncey, 1983, nos. 201-2.

5 An ancient sarcophagus relief depicting the Death of the Niobids was known in Rome since the fifteenth century and was widely copied in the cinquecento, but our drawing does not appear to be based on this source. On the Niobe sarcopha-gus, now in Wilton House, Wiltshire, and Renaissance copies after this model, see Bober and Rubinstein, 1986, pp. 139-40, no. 107.

6 These characterizations of Ligorio's graphic style were advanced by Gere, 1971a, pp. 243-44.

7 Inv. 9695; see Chicago, 1979, no. 26, repr.

8 The inscription on the bottom of the print, which was published by Hieronymous Cock, erroneously credits Giulio Romano, a well known artist whose name was often incorrectly assigned to reproductive prints not based on his designs, with its invention. This inscription also provides a *terminus ante quem* for Ligorio's design of 1557. It is possible that the missing left edge of the present sheet originally included the landscape shown in the print.

9 Numerous copies after this facade, one of Polidoro's most celebrated inventions, record the appearance of the Niobe frieze. See Ravelli, 1978, nos. 670-764. Ligorio's Apollo is quite close to Polidoro's Diana in the Massacre of the Children of Niobe scene; see ibid., fig. 758.

10 In addition to the ironic quotation of Polidoro's Diana for his Apollo, the fleeing figure with outstretched arms at the right of Ligorio's design is a virtual quotation of a similar fleeing figure in Polidoro's Niobe frieze (see ibid., figs. 763-64). And Ligorio's dense, compact frieze of figures closely recalls Polidoro's precedent.

11 Gere, 1971a, pp. 242-43 and pl. 6a. The forceful, sculptural hatching is identical in the two sheets, and the profile of the seated figure is an exact replica in reverse of the face of Niobe in the Horvitz study. The ex-Wrangham drawing is a character-istic representative of what Gere has defined as Ligorio's early style as a draftsman.

12 On this plaquette, see Cannata, 1982, no. 72.

■

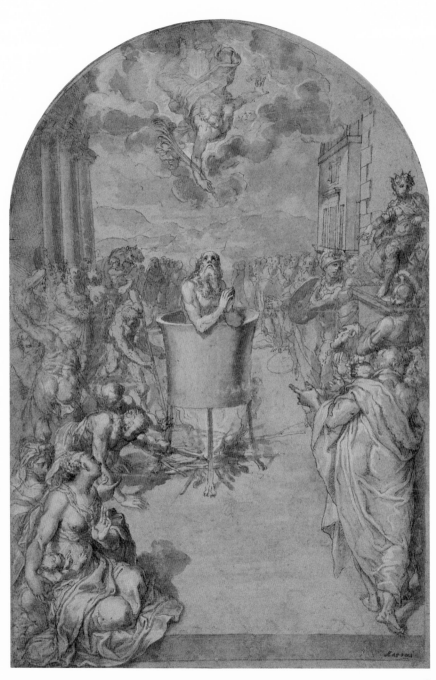

36

9. *St. John the Evangelist Immersed in a Caldron of Boiling Oil*

Pen and brown ink, brown wash, heightened with white, over black chalk, on gray-green paper; repaired at upper left, 40.8 x 27.3 cm. (16 x 10 3/4 in.).
Inscribed in pen and brown ink at lower right: *Barocci.*

Provenance: Sale, Paris, Nouveau Drouot, Salle 7, October 10-11, 1983, no. 79 bis, repr., attributed to Trometta; [Anna Maria Edelstein, London, June 1985].

The drawing depicts a scene from the life of St. John the Evangelist. The particular episode is narrated in the *Golden Legend*, a popular and widely influential thirteenth-century compendium of apocrypha concerning saints' lives. According to this source, the Evangelist was thrown into a caldron of boiling oil on the command of the emperor Domition, who ordered his martyrdom during a period of Christian persecution. The saint miraculously survived the ordeal, as well as a later poisoning, and eventually died a natural death on the island of Patmos where he composed the Book of Revelation.

In our sheet, the bearded figure of St. John the Evangelist appears in the center of the composition, submerged in the caldron of oil and looking heavenward in supplication. Two of his tormentors tend the fire below the caldron, one adding wood to the pyre and the other stoking the flames. An assembly of onlookers, twisting and gesturing in rhetorical postures of agitation, witness the scene. The emperor Domition, enthroned on a plinth and flanked by soldiers impassively standing by, is at the right. A generalized cityscape described by the orthogonally receding facades behind the figures provides the locus for the drama, this setting reminiscent of contemporary designs for stage sets by artists like Baldassare Peruzzi and Sebastiano Serlio. In the upper zone of the composition, a large angel descends from heaven extending the palm branch of martyrdom.

The Horvitz drawing is a *modello* for an altarpiece by Marco Pino, an important but relatively unstudied mid-sixteenth-century central Italian artist, painted for the chapel of St. John the Evangelist in the church of Ss. Apostoli in Rome. Commissioned in August 1568, this work no longer exists, but the contract for it survives. This document stipulates that the altarpiece represent "quando San Giovanni Evangelista fu messo nel caldara d'olio bollente," that it be executed in oil, and that the artist complete it by the feast of the Nativity (December 25) the following year.[1] The early seventeenth-century biographer Giovanni Baglione mentions the painting, citing both its subject matter and

its location in the church: "nella chiesa de' Ss. Apostoli de' Frati conventuali di S. Francesco una tavola sopra l'altare a man manca, entrovi la storia di S. Gio. Evangelista messo nella caldaia di olio bollente con molte figure intorno, a olio con buona maniera, e con gran diligenza concluse."[2] Given the precise correspondence with both the 1568 contract and Baglione's description, it can scarcely be doubted that our drawing is connected with this lost altarpiece by Marco Pino; indeed, it is a valuable record of a work whose appearance is otherwise undocumented.

Characteristic of the artist are the combination of media and the extravagantly posturing figures cloaked in ample, flowing draperies evident in the present sheet. The twisting figure seen from the rear, who stands at the lower right, appears to have been a particularly favorite invention, recurring, for example, as a Magus in the *Adoration of the Magi* in the Museo Nazionale di Capodimonte, Naples, executed in 1571,[3] and a gesturing soldier in the *Meeting of Alexander the Great with the High Priest Ammone* in the Sala Paolina in Castel S. Angelo, Rome, painted in 1546.[4] A similarly posturing figure, in this instance seen frontally, reappears at the right of a study in the Los Angeles County Museum of Art representing the *Battle of Anghiari.*[5] Among the artist's drawings, our sheet may be compared stylistically with a *Holy Family,* and a *modello* for the *Birth of the Virgin* altarpiece in Ss. Severino e Sossio, Naples, both in the Musée du Louvre, Paris.[6]

Like many of his drawings, this study reveals the disparate influences that shaped Marco Pino's style as a draftsman.[7] The loose, fluid line with which the figures in the background are delineated signals the artist's debt to his Sienese master, Domenico Beccafumi, while the muscular, twisting, and almost contorted postures of the figures recall Pellegrino Tibaldi, with whom Marco Pino collaborated in Rome in the 1540s. Affinities with certain drawings by Federico Barocci may also be observed;[8] along with other drawings by the artist,[9] the Horvitz sheet was once ascribed to Barocci, as an annotation in the lower right corner records. Finally, the influence of Taddeo Zuccaro should also be noted: the descending angel in Marco Pino's composition is evidently based on the figure of Christ in the *Conversion of St. Paul* in the Frangipani Chapel, S. Marcello al Corso, Rome, begun by Taddeo in 1556,[10] and the figure types as well as the handling of the present sheet reveal affinities with a number of drawings by that artist.[11]

A study by Marco Pino of a group of angelic figures floating on clouds within an arched field that recently appeared on the market, executed in the identical technique as our drawing, possibly relates to the same lost altarpiece from Ss. Apostoli.[12]

■

1 The contract is transcribed in Zannini, 1974, pp. 83-84. ("Saint John the Evangelist immersed in a caldron of boiling oil.")

2 Baglione, 1649, p.31. ("In the church of Ss. Apostoli of the conventual Franciscans, an altarpiece above the altar on the left side, in which is represented St. John the Evangelist immersed in the caldron of boiling oil surrounded by many figures, in oil, of graceful style and rendered with great diligence.")

3 For this painting, which was originally in the church of Ss. Severino e Sossio, see Causa, 1957, pl. 10; and Previtali, 1978, pp. 56-57, and fig. 75.

4 On this fresco and the related drawing by Marco Pino, see Gaudioso, 1981, vol. 1, pp. 35-36 and p. 165, fig. 100; vol. 2, no. 86.

5 See Feinblatt, 1976, no. 28, repr.

6 For an illustration of the *Holy Family*, see Gere, 1971b, pl. 25 and p. 84. For an illustration of the *Birth of the Virgin*, see Monbeig Goguel, 1971, fig. 12 and p. 89. Both drawings are executed in a similar technique to the Horvitz sheet. The composition of the latter includes the steplike base and arched top seen in our drawing.

7 On Marco Pino, see Gere and Pouncey, 1983, pp. 141-42; the entry by Giovanni Previtali in Siena, 1980, p. 18; and the essay by Roberto Bartalini in Siena, 1990, pp. 384-91.

8 See, for example, the study for a *Kneeling Draped Male Figure* in the Biblioteca Ambrosiana, Milan; Notre Dame, 1984, no. 57, repr.

9 For example, the study of a *Holy Family* in the Louvre referred to above (note 6) bore an earlier attribution to Barocci.

10 On this painting, see Gere, 1969, p. 72. A drawing for the upper zone of Taddeo's altarpiece, which includes this figure, is in the Frits Lugt Collection, Fondation Custodia, Paris. See Byam Shaw, 1983, vol. 1, no. 136; vol. 3, pl. 159.

11 See, for example, a drawing of ca. 1559/60 depicting four muses (Musée du Louvre, inv. 2816 recto), which is a study for the detached fresco from the destroyed *casino* of the Palazzo Bufalo, Rome; Gere, 1969, no. 170 and pl. 110. The drawing by Marco Pino referred to in note 12 below as a possible preparatory study for *St. John the Evangelist Immersed in a Caldron of Boiling Oil* demonstrates particularly striking parallels of style, medium, and subject matter with a study by Taddeo of a group of angels in the collection of Professor Richard Krautheimer, datable to the early 1550s; see Gere, 1969, no. 145 and pl. 81.

12 Sotheby's, Monaco, June 20, 1987, no. 15, repr. William Griswold kindly brought this drawing to my attention and pointed out the similarity to the descending angel in the Horvitz sheet.

■

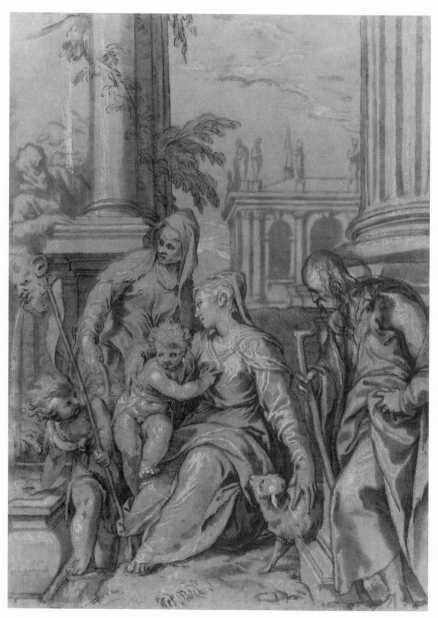

10

PAOLO FARINATI (Verona 1524-Verona 1606)

10. *The Holy Family*
Pen and brown ink, brown wash, heightened with white,
45.0 x 33.3 cm. (17 5/8 x 13 1/16 in.).
Inscribed at lower left: *Paolo Farinati.*

Provenance: [Jean-Pierre Selz, Paris].

S eated on a grassy ground, the Madonna embraces the Christ Child with her right arm and holds a lamb, symbol of his future sacrifice, with her left hand. She is surrounded by Joseph, standing at the right with a walking stick; the young St. John the Baptist, holding a tall cross at the left; and Elizabeth, mother of the Baptist, behind her. A male figure leans over the tall podium at the left, gazing at the Holy Family; his identity is unclear, but he may be Zacharias, Elizabeth's husband. The outdoor setting is dominated by imposing classical architectural forms—a massive, fluted column behind Joseph, a colonnade behind Elizabeth, and a basilicalike structure in the background. A large *pentimento* is evident in the figure of St. Joseph, whose head was initially inclined to his left, away from the Christ Child.

A contemporary of Paolo Veronese, who greatly influenced him, Paolo Farinati was a leading artistic personality in Verona in the sixteenth century.[1] Although he was a prominent painter in his day, and was active as an architect, sculptor, and printmaker, Farinati is best known as a draftsman.[2] Rapid sketches from the artist's hand exist, but more familiar are his highly finished drawings. His graphic style, which remained strikingly consistent throughout his career, is characterized by continuous, delicate, and calligraphic contour lines; the extensive use of white heightening to suggest the rounded volume of forms and their smooth, almost polished surfaces; and a hard, even hatching applied in short strokes to create shadow. These traits, all evident in the present sheet, distinguish any number of drawings by Farinati, for example, *The Labors of Hercules* in the Staatsgalerie, Stuttgart;[3] *A Seated Hermit Saint with a Book* in the Musée du Louvre, Paris;[4] *Alexander the Great in Persian Costume* in the Royal Library, Windsor Castle;[5] and *The Virgin and Child Adored by Saints* in The Pierpont Morgan Library, New York.[6] As such drawings attest, Farinati's artistic sensibility differed from that of his Venetian contemporaries in being "plastic" rather than "pictorial":[7] his style as a draftsman owes more to Giulio Romano and the central Italian tradition of *disegno* than to the fluid manner of Titian and Veronese.

The Horvitz drawing is a revealing document of Farinati's artistic personality. Echoing the theatrical settings of Veronese's monumental narrative compositions, the massive architectural forms of the backdrop reflect Farinati's own activity as an architect. The

4 1

satyr-head water spout at the left, for instance, a whimsical ornament that has no relevance to the subject of the Holy Family, seems to have migrated from Farinati's portal of the Palazzo Verità in Verona, one of his few extant architectural designs.[8] The Palladian temple in the background, reminiscent of the Basilica in Vicenza, further signals the artist's particular interest in architecture.

A prolific draftsman, Farinati compiled volumes of his own drawings, many kept as *ricordi* of his inventions which he would reprise in his late works. Other studies were produced as designs for etchings. Finally, Farinati also executed a large number of finished drawings as independent works in their own right. A type of "presentation drawing," these finished inventions were presumably intended as gifts and perhaps even dispersed on the open market.[9] Predictably, a good number of studies from his hand cannot be connected with prints or paintings. Such is the case with the Horvitz *Holy Family*, whose finished character suggests that it is an independent invention rather than a preparatory study. While the sheet may have been executed as a design for an etching similar to the *Madonna and Child with St. John the Baptist in a Landscape* ascribed to Farinati,[10] such a function remains hypothetical since no print based on this image is known.

Owing to their stylistic consistency, Farinati's drawings are difficult to date. This is particularly true in the case of sheets that, like the present example, cannot be connected with a painting and for which no external chronological signpost thus exists. Drawings from his early period tend to be executed in a looser and more sketchy style, while those dating after ca. 1590 exhibit a hardness and lack of spontaneity.[11] Of these two poles, the Horvitz *Holy Family*, with its controlled line and application of heightening, is closest to Farinati's late style, and a date of ca. 1590 may be proposed.

■

1 On Farinati, see the essay by Terence Mullaly in Verona, 1974, pp. 85-88. On his activity as a printmaker, see Marini, 1980, pp. 277-81. On Farinati as an architect, see the discussion by Lionello Puppi in *Architettura a Verona*, 1988, vol. 2, pp. 206-10. On sixteenth-century Veronese art in general, see Sergio Marinelli, "La pittura a Verona nel Cinquecento," in *Pittura in Italia*, 1987, pp. 117-24; and Marinelli, 1988; for Farinati, see esp. pp. 341-52.

2 The seventeenth-century biographer Carlo Ridolfi describes Farinati as a prolific and gifted draftsman whose drawings were avidly collected (Ridolfi, 1648, vol. 2, pp. 127, 132). He also relates that Farinati was talented as a sculptor and architect (ibid., p. 133).

3 Inv. 1665; see De Grazia Bohlin, 1982, pl. 6. The drawing is a study for a fresco in the Palazzo Giuliari, Verona.

4 Inv. 4847; for this drawing, which is from Vasari's *Libro*, see Ragghianti Collobi, 1974, vol. 1, p. 137; vol. 2, pl. 419.

5 Inv. 5000; see Popham and Wilde, 1949, no. 305 and fig. 64.

6 Inv. IV, 79B; see Bean and Stampfle, 1965, no. 118, repr. This drawing is a *modello* for the *Pala dei Fogazza* in the Museo di Castelvecchio, Verona, executed in 1592.

7 Farinati's manner has been so characterized by Rosand, 1966, p. 421. On this point, see also De Grazia Bohlin, 1982, pp. 359-60.

8 *Architettura a Verona*, 1988, vol. 1, p. 166.

9 Ridolfi, 1648, vol. 2, p. 132, reports knowing of and having seen large collections of Farinati's drawings. On the albums compiled by the artist himself, see De Grazia Bohlin, 1982, p. 360. The large corpus of finished drawings by Farinati is perhaps accounted for by the fact that the artist produced such sheets for sale, as proposed by A. E. Popham in Popham and Wilde, 1949, p. 217.

10 On this etching, see Marini, 1980, no. XI, 48. In addition to the similar subject matter, the pose of the Madonna and Child in the drawing are essentially the same as in the print but in reverse. Ridolfi, 1648, vol. 2, p. 132, specifically mentions that many of Farinati's drawings were reproduced in prints.

11 For this characterization of Farinati's graphic style, see De Grazia Bohlin, 1982, pp. 360-61.

■

11

11. *Christ on Calvary and the Disrobing of Christ*
Pen and brown ink, brown wash, over traces of black
chalk, 26.1 x 34.3 cm. (10 1/4 x 13 7/16 in.).
Inscribed in graphite in modern hand at lower right: *Ten*
(cut off at right).

Provenance: Sale, Bern, Galerie Kornfeld, June 22–24,
1983, no. 37, repr.; [Colnaghi].

C hrist stands at the far right, identified by the aureole of
light radiating from his head. The cross on which he will be crucified lies on the ground
at his feet, projecting forward at a steeply foreshortened angle. A crowd of soldiers, two
on horseback and others bearing upright lances, converge on him; two seize him and
remove his garment. In the center of the composition, a figure digs a hole in which the
cross will be elevated. A scene from the Passion of Christ, this subject is unusual and
does not rank among the canonical episodes.

This characteristic drawing by Luca Cambiaso presents the artist's idiosyncratic and
immediately recognizable graphic style. Little emphasis is given to the locus of the
drama, which is only summarily indicated and completely uncharacterized. Attention is
focused instead on the figures, who are rendered as blocklike forms with featureless,
square faces. Broad patches of wash employed to suggest volume and contour enhance
the angular aspect of the forms. Typical of Cambiaso's manner as a draftsman, and
familiar from countless other drawings from his hand, the figures in the Horvitz sheet
are reminiscent of the small wooden models used by artists to the present day. Indeed, it
is possible that Cambiaso employed such wooden figures when he conceived his com-
positions, a practice known to have been adopted by Raphael and Fra Bartolommeo
among other sixteenth-century painters. In no other artist's work, however, are the
chunky contours of these models retained to the degree witnessed in Luca Cambiaso's
drawings.

Although the present study cannot be connected with a known painting or commission,
the theme of the Passion of Christ occurs frequently in both Cambiaso's paintings and
his drawings. These include a number of representations of *Christ at the Column;*[1] the
Flagellation;[2] *Christ Crowned with Thorns;*[3] *Ecce Homo;*[4] *Christ Carrying the Cross;*[5] and
Christ Nailed to the Cross,[6] as well as another representation of *Christ Stripped of His
Garments.*[7] Most closely related to our drawing is the version of *Christ Nailed to the Cross*
in the Manning Collection. Not only is the style close—the same blocklike, faceless
forms, including a soldier on horseback, populate a nondescript setting in both draw-

ings—but the subject of the Manning sheet represents the subsequent moment to that of our drawing in the narrative sequence that concludes with the Crucifixion.

Despite the figures' lack of emotional characterization, the Horvitz drawing ranks among Cambiaso's more dramatic graphic inventions. The torturers of Christ are made the more brutal for their facelessness, while an element of pathos is imparted by Christ's attitude—submissive, yet radiantly triumphant in accepting his fate. The dark pools of wash applied to create murky shadows invest the scene with a nocturnal aspect that heightens its dramatic content: Cambiaso's interest in nocturnal lighting, amply attested in many of his paintings, is here reflected in his graphic style.[8]

■

1 Paintings of this subject by the artist are in S. Pietro ad Vincula, Sestri Levante (Suida Manning and Suida, 1958, fig. 386); the Brera, Milan (ibid., fig. 408); the Palazzo Bianco, Genoa (ibid., fig. 409); and a private collection (ibid., fig. 417). Another drawing of this subject by a follower of Cambiaso is in the Art Museum, Princeton University. See Gibbons, 1977, no. 106, repr., as school of Luca Cambiaso.

2 Drawings are in the Albertina, Vienna (Suida Manning and Suida, 1958, fig. 388); and the Uffizi, Florence (2 versions, ibid., figs. 404–5).

3 Uffizi (Suida Manning and Suida, 1958, fig. 414).

4 These include a painting in the Escorial, Spain, and a drawing in the Manning Collection, New York; see ibid., figs. 401 and 413.

5 Drawings of this subject are in the Uffizi (ibid., fig. 387); and the Art Museum, Princeton University, inv. 48-622; Gibbons, 1977, no. 84, repr.

6 Drawings are in the Uffizi (Suida Manning and Suida, 1958, fig. 390); the Manning Collection, New York (ibid., fig. 396); the National Gallery of Scotland, Edinburgh (inv. D3141; Andrews, 1968, vol. 1, p. 26; vol. 2, fig. 206); and the Museum of Fine Arts, Boston (inv. 1958.1163; Macandrew, 1983, no. 11, repr.).

7 Colnaghi, London, 1985, no. 6, repr. The composition of this drawing, which was brought to my attention by William Griswold, is similar to that of the Horvitz study except that the position of the soldiers on horseback is reversed, and Christ appears near the center of the sheet.

8 On this aspect of Cambiaso's style, see Suida Manning, 1952, pp. 197-220.

■

12

12. *Putti Dancing*

Pen and brown ink, brown wash,
27.2 x 42.3 cm. (10 11/16 x 16 5/8 in.).
Inscribed at bottom: *Cambiaso* (cut off at lower edge).

Provenance: Sale, London, Sotheby's, December 10, 1979,
no. 229, repr.; [Spencer A. Samuels Gallery, New York].

E ight nude putti hold hands and dance in a ring. The space in which they frolic is nondescript, defined only by the series of rapid, horizontal hatched lines vaguely suggesting an earthen ground. The figures are executed in Luca Cambiaso's distinctive style, their chunky forms rendered with a hard outline. Light veils of wash are applied to give volume and definition to the anatomical forms, which are otherwise cursorily described, the emphasis on contour rather than modeling.

A number of drawings exist by Cambiaso representing *giuochi dei putti* (putti playing). These include two closely related sheets of seven putti dancing in a ring, one in the Uffizi, Florence,[1] and the other in a Genoese private collection;[2] drawings of the *lotta dei putti* (putti fighting) in the Palazzo Rosso, Genoa,[3] the Ratjen Collection, Vaduz, Liechtenstein,[4] and the Staatsgalerie, Stuttgart;[5] and a study of eight putti dancing in a ring around a dog in the Art Museum, Princeton University.[6] A painting by the artist from a Genoese private collection treats a similar theme: two putti recline, one holding a laurel wreath and the other a palm branch.[7]

None of these "putti" compositions can be securely associated with a known painting. The seventeenth-century biographer Raffaello Soprani records that Luca Cambiaso executed in Genoa a painted facade near the church of S. Domenico, now lost, which had as its subject gods, nymphs, and "putti fra loro scherzanti."[8] Our sheet, and the related drawings noted here, may have been produced in connection with this work or a similar commission, or they may simply have been independent inventions executed in a light and playful vein. The *giuochi dei putti* was a popular theme in sixteenth-century Italian art, taken up, for example, by Raphael's collaborator Giovanni da Udine in a series of tapestries commissioned by Pope Leo X.[9] Another instance of this subject originating in Raphael's circle is an engraving by Marcantonio Raimondi depicting the *Dance of the Cupids*.[10] The similarities in both subject matter and composition suggest that Marcantonio's print may have been the source for the present drawing.

While consistent with the manner of Cambiaso, this sheet, it should be pointed out, is possibly the work of a close follower of the artist, as the somewhat labored line of the figures' features and contours suggests.

■

1 Inv. no. 137600; see Suida Manning and Suida, 1958, p. 188 and fig. 457.

2 See Genoa, 1956, no. 81, repr. (This drawing may be a copy after the version in the Uffizi.)

3 Genoa, 1956, no. 79.

4 Inv. R 14; see Munich, 1977, no. 54, repr.

5 Inv. no. 6226.

6 Inv. 48-642; see Gibbons, 1977, no. 91, repr.; and New York, 1967, no. 17.

7 Genoa, 1956, no. 7, repr.

8 Soprani, 1768, vol. 1, p. 79.

9 On the *Giuochi dei putti* tapestries, see Quednau, 1981, pp. 349–58. These lost tapestries are known through a series of engravings by the Master of the Die, for which see the entries by Rolf Quednau in *Raffaello in Vaticano*, 1984, nos. 135a–d, repr.

10 B.XIV, 177. For a discussion of this print, see Shoemaker and Broun, 1981, no. 39.

■

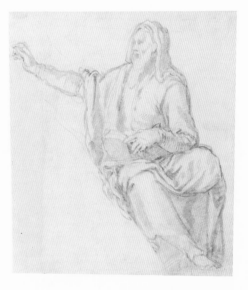

13

14

13. *King David*

Red chalk; upper right corner made up,
26.2 x 18.6 cm. (10 5/16 x 7 5/16 in.).
Verso: Seated figure.

14. *A Prophet (Jeremiah?)*

Red chalk; left margin below figure's outstretched arm
made up, 26.2 x 23.1 cm. (10 5/16 x 9 1/16 in.).
Verso: Seated figure.

Provenance: An album probably acquired by
Christopher Race Mansel Talbot (1803-1890), Margam
Castle, Port Talbot, Wales; [Colnaghi, New York, May
1989, nos. 2 and 3, repr.].

Delineated in the curved space of spandrels framing an
arch are two Old Testament figures. King David, identified by his crown and the large
harp on which he rests his right hand, appears in the left spandrel. He is paired in the
right spandrel with a bearded prophet with veiled head who holds an open book in his
lap and raises his right hand in a gesture suggesting the act of writing. Given the lack of
specific attributes, the identity of this figure is uncertain, but his garb clearly signals his
status as an Old Testament prophet.

These drawings, which may originally have formed a single sheet, can be connected
with some certainty with a fresco of the *Annunciation* executed in 1566 by Federico
Zuccaro in the Jesuit church of S. Maria Annunziata in Rome.[1] This work no longer
exists, the church having been destroyed in 1626 during the building of S. Ignazio, but
its appearance is recorded in a detailed composition study by Federico,[2] as well as an
exact and faithful engraving by Cornelius Cort, published in 1571 (fig. 13a).[3] In the
center of a large lunette, the artist portrayed the Annunciation. God the Father, the Holy
Ghost, and a choir of angels fill the upper tier of the composition; six Old Testament
prophets, three on either side of the central scene, complete the lower zone. The span-
drels framing the lunette are the domain of Adam and Eve, perpetrators of the Original
Sin redeemed by Christ, whose Incarnation is witnessed below.

Each prophet in the lower zone of the *Annunciation* is identified by a tablet bearing an
inscription with his prophecy announcing the birth of Christ. Two of the prophets
distinctly resemble those in the present sheets: David, the crowned figure at the left
playing the harp and accompanied by a tablet inscribed with a verse from Psalms, and

Jeremiah, the standing bearded figure with veiled head at the right holding his tablet. The only figure so attired in the lost fresco, Jeremiah may reasonably be recognized as the prophet in our drawing on the basis of this similarity.[4]

The prophets in the print do not conform precisely to the corresponding figures in the present drawings. In addition to the obvious differences in pose, the latter were clearly conceived as spandrel figures, initially projected for the space framing the main scene filled by Adam and Eve in the final composition. The Horvitz studies thus represent an earlier design by Federico for the S. Maria Annunziata commission. That the artist had originally conceived a more conventional and straightforward treatment of the subject of the Annunciation is testified by a drawing in the Uffizi, Florence, identified as a first idea for the lost fresco.[5] Presumably, the prophets in our studies were initially projected for the spaces above this Annunciation, an arrangement recalling Perino del Vaga's prophets in the entrance arch of the Pucci Chapel in SS. Trinità dei Monti, Rome.[6] As in Perino's scheme, these figures would have assumed the role of heralds and precursors of the Age of Grace, initiated in the scene of the Annunciation below, who foretold the coming of Christ in their prophecies. In the final composition, Federico abandoned this conventional iconographic scheme in favor of a more dense, arcane, and symbol-laden imagery.

Executed around 1565 and therefore dating to the early period of Federico's career, these drawings reflect the strong influence of the artist's brother, Taddeo Zuccaro, with whom he collaborated until the latter's untimely death in 1566. This is evident not only in the use of red chalk, which Taddeo favored over black chalk and which Federico would cease to use alone in his later drawings of this type where black and red chalk are invariably combined, but also in the concern for describing the figures' volumes and their movements in space. As in his contemporary red chalk drawings dating from the mid-1560s, such as a study for a group of figures in the *Conversion of the Magdalen* fresco in the Grimani Chapel in S. Francesco della Vigna, Venice,[7] Federico attempts in the present studies to approximate that aspect of Taddeo's graphic manner that finds its most brilliant expression in such drawings as the study of a man seen from behind in the National Gallery of Art, Washington.[8]

In addition to those noted above, other drawings by Federico Zuccaro connected with the lost *Annunciation* include studies for a group of three prophets in the National-museum, Stockholm,[9] and the Uffizi;[10] and for angels in the clouds in the Musée du Louvre, Paris,[11] the National Gallery of Art,[12] and the London art market.[13]

∎

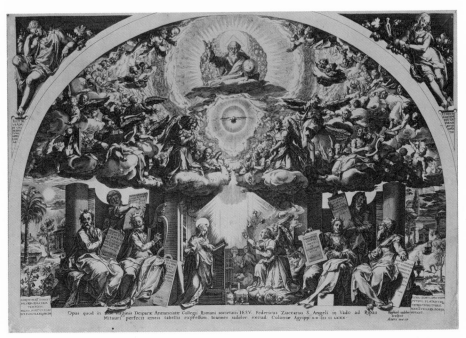

13a. Cornelius Cort after Federico Zuccaro, *The Annunciation,* New York, The Metropolitan Museum of Art

1 On this lost work, see Körte, 1932, pp. 518-29, esp. pp. 522ff.; Mundy, 1989, under no. 62.

2 Musée du Louvre, Paris, inv. 4539. On this drawing, which comes from Vasari's *Libro de' disegni*, see Ragghianti Collobi, 1974, vol. 1, p. 148; vol. 2, fig. 451.

3 A previously unidentified sixteenth-century copy after this composition attributed to Domenico Sacchetta is in the Pinacoteca, Fano.

4 It is also possible that this figure is the prophet Isaiah, who is more frequently paired with David in typological cycles representing scenes from the life of the Virgin Mary.

5 Inv. 818S; see Körte, 1932, fig. 5; see also Gere, 1966, no. 49, fig. 37.

6 Parma Armani, 1986, fig. 47. Federico and his brother, Taddeo, had completed the Pucci Chapel decoration in the early 1560s, shortly before Federico executed the lost Annuncation, and it is not unlikely that Perino's entrance arch provided the immediate prototype for his prophets.

7 Sotheby's, New York, January 11, 1990, no. 42, repr.

8 Inv. 1972.4.2; see Mundy, 1989, no. 11, repr.

9 Körte, 1932, fig. 6.

10 Inv. 8386F; noted by Gere, 1966, p. 38, under no. 49.

11 Körte, 1932, fig. 7.

12 Inv. 1971.23.1; Mundy, 1989, no. 62, repr.

13 Sotheby's, New York, January 11, 1990, no. 43, repr; Yvonne Tan Bunzl, *Master Drawings*, December 1990, nos. 8 and 9, repr. A drawing of angels in the National Gallery of Scotland (inv. D 2900; Andrews, 1968, vol. 1, p. 132; vol. 2, fig. 884) cited by Mundy (1989, under no. 62) in connection with this lost work is in my opinion a copy after Federico Zuccaro.

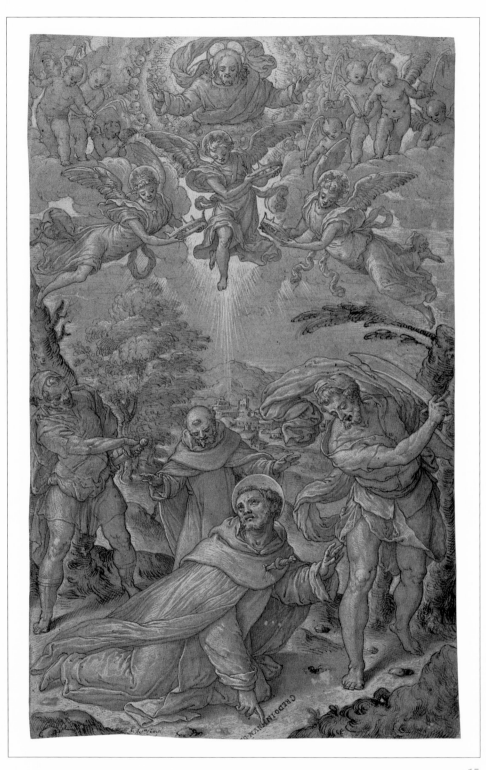

Niccolò Martinelli,
called I L T R O M E T T A (Pesaro ca. 1540-Rome 1611)

15. *The Death of St. Peter Martyr*

Pen and brown ink, brown wash, heightened with white,
over traces of black chalk, on gray-green paper,
37.4 x 23.6 cm. (14 11/16 x 9 1/4 in.).
Inscribed in brown ink at lower left center: *scuola di Ant.o Campi.*

Provenance: "Borghese (Sagredo?) Album" (inscribed in
pen and brown ink on old mount, *S. L. N° 2*; on verso
S. L. N° 28); Michel Gaud; Michel Gaud sale, Monaco,
Sotheby's, June 20, 1987, no. 87, repr.

S t. Peter Martyr, cloaked in a Dominican habit, falls to his
knees, his breast pierced by a dagger. He raises his left hand in vain defense against the
imminent assault of his executioners, and with his right hand writes the apostle's creed
in blood on the ground before him. Although cut off by the bottom edge of the sheet,
the first words are neatly inscribed and clearly legible: *Credo in vnvm d.* Two sword-
bearing torturers flank the saint, whose companion, similarly garbed in a Dominican
habit, stands between them, his hands extended in horror as he witnesses the martyr-
dom. A cityscape bordered by mountains is glimpsed in the distance. In the heavens
above appear three angels bearing martyrs' crowns, a choir of nude putti each clutching
palm branches of martyrdom, and the half-length, blessing figure of Christ in glory to
whom the saint directs his gaze.

A follower of Taddeo Zuccaro about whom relatively little is known, Trometta was
active in Rome in the second half of the sixteenth century. His personality as a drafts-
man has been distinguished and characterized by John Gere,[1] who established a corpus
of over forty drawings that may be credibly assigned to the artist. The present sheet
evinces all the readily recognizable morphological features described by Gere as typical
of Trometta's graphic style: "little curls, small, pointed chins, and wide apart, vacuously
ecstatic eyes."[2] The figure type in our drawing, distinguished by exaggerated, elongated
proportions, bulky legs, and disproportionately tiny heads all bearing Trometta's pinched
features, is also consistent with the artist's manner as a draftsman. Finally, the particu-
lar medium of the Horvitz sheet—pen and ink with brown wash liberally heightened
with white—and the use of a bluish paper, further reinforce the attribution of this sheet
to Trometta, whose authorship is unarguable.

Aside from the frescoes in the choir of S. Maria in Aracoeli, Rome, which are generally
regarded as the artist's most important and accomplished effort, few works by Trometta

are known.[3] The Horvitz study cannot be related to a lost painting or a recorded commission, and its original function remains a mystery. The highly finished nature of the drawing, with its careful attention to details of foliage and costume and fully worked-up composition, as well as the particular subject matter, suggest that the sheet may be a *bozzetto* for an altarpiece. Without the existence of documents referring to a painting of this subject by Trometta, however, no fruitful discussion of this question is possible.

Stylistically, the *Death of St. Peter Martyr* relates closely to a drawing by the artist of the *Assumption of the Virgin* in the British Museum, London.[4] Both studies are executed in the same even, unbroken pen line. The bearded, kneeling apostle at the lower left of the *Assumption* bears a striking resemblance to the similarly bearded executioner at the right of our drawing, and the outstretched, rhetorically waving hands with delicate fingers of the standing apostles are precisely like the hands of Peter Martyr and his companion in the Horvitz sheet. The artist also adopts a two-tiered vertical format for each composition. The subject matter of the present drawing was treated by Trometta in another sheet in the Staatliche Graphische Sammlung, Munich,[5] which Gere dates to the later years of the artist's career. The function of that sketch, the composition and style of which are more tentative than the Horvitz study, is likewise unknown, but given the coincidence of subject matter it may conceivably be a first idea for a composition that was superseded by the design recorded in our drawing. Whatever its original purpose, the *Death of St. Peter Martyr* is an important addition to the relatively small graphic oeuvre of this competent if uninspired draftsman.

■

1 Gere, 1963, pp. 3-18.

2 On this point and what follows, see ibid., p. 10.

3 For a summary of Trometta's career and reference to the few
 extant works securely ascribed to the artist, see Gere and
 Pouncey, 1983, p. 174.

4 Gere, 1963, pp. 12-13; Gere and Pouncey, 1983, no. 279, repr.

5 Inv. 7990; see Gere, 1963, pp. 12 and 16, and no. 26, pl. 15b; and
 Harprath, 1977, no. 101. This study is part of an important
 group of drawings by Trometta in the Graphische Sammlung,
 four of which are connected with the frescoes in S. Maria in
 Aracoeli. These reveal the strong influence of Taddeo Zuccaro.

■

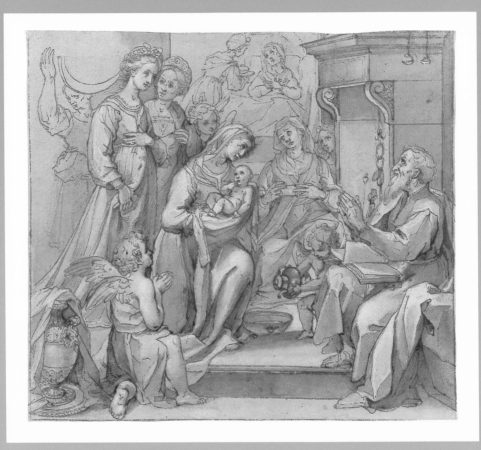

16

16. *The Birth of St. John the Baptist*
Pen and brown ink, brown wash, heightened with white,
over black chalk; sheet trimmed at top,
24.1 x 27.4 cm. (9 1/2 x 10 3/4 in.).
Inscribed in pen and black ink on verso at upper right:
Ventur/ Ventura Salimbeni vero.

Provenance: [Colnaghi, New York, May 1990, no. 20,
repr.].

T he scene takes place in a domestic interior dominated by
a large fireplace and hearth. Surrounded by several female attendants, one of whom
bears a cradle on her head, a kneeling nursemaid holds the newborn John the Baptist.
She gazes at his father, Zacharias, the bearded figure seated at the right with an open
book on his lap, who responds with wonder and clasps his hands in reverence. Two
winged angels participate in the event, one kneeling and the other pouring water into a
basin to prepare the infant's bath. In a bedchamber in the background is St. Elizabeth,
mother of the Baptist, attended by a servant.

A leading Sienese artist of the late sixteenth and early seventeenth century, Ventura
Salimbeni's manner as a draftsman is closely allied to that of his half-brother and fre-
quent collaborator, Francesco Vanni.[1] The present sheet exhibits many elements of
Salimbeni's distinctive graphic style, notably the sinuous, delicate, and slightly angular
line; the relative lack of interior modeling of forms and resulting broad, flat planes; and
the morphological type distinguished by lithe, lilting, round-faced figures with large,
bulging eyes and small, pursed mouths. These features are all evident, for example, in a
study of the *Immaculate Conception* in the Musée du Louvre, Paris, which is wholly
characteristic of Salimbeni's draftsmanship.[2]

The subject matter and composition of the Horvitz sheet find suggestive parallels in
other works by Salimbeni. Among these are a fresco depicting the *Birth of the Virgin* in
the church of the Fontegiusta in Siena,[3] and a drawing of the same subject in the Uffizi,
Florence, which reprises the domestic setting—replete with large fireplace, ewer and
basin, cradle, and distant bedchamber—of our drawing.[4] These works and other con-
temporary Sienese representations of the same theme such as Alessandro Casolani's
altarpiece in S. Domenico, Siena,[5] hark back to Domenico Beccafumi's celebrated *Birth of
the Virgin* now in the Pinacoteca Nazionale, Siena, one of the canonical images of Sienese
art. Like other painters of his generation, Salimbeni was keenly interested in the art of
Beccafumi, whose influence may be discerned in the present drawing not only in the

domestic setting, but in the willowy, graceful figures as well.[6]

Its highly finished character and fully worked-up composition, careful attention to light and shadow, and absence of *pentimenti* invest the *Birth of the Baptist* with the character of a *modello*. No painting of this subject by the artist is known,[7] but the drawing relates iconographically to a group of studies by Salimbeni depicting scenes from the infancy of St. John the Baptist. These include a series of drawings of the *Annunciation to Zacharias*[8] and a sheet illustrating the *Birth of the Baptist*, the same subject as the present drawing.[9] It has been plausibly suggested that two of these designs are connected with the lost lunette frescoes painted by Salimbeni in the Oratory of S. Giovanni Battista della Compagnia della Morte in Siena between 1604 and 1607, which illustrated scenes from the life of the Baptist;[10] our drawing likewise may have been executed in connection with this campaign. Salimbeni also worked for the Compagnia di S. Giovannino in Pantaneto in Siena, from whom he received a commission in 1600 to paint a Feast of Herod;[11] the possibility that the present drawing is connected with an unrealized work for that confraternity, whose dedication to the young St. John the Baptist is of note given the particular subject of the sheet, should also be considered, although this suggestion must remain conjectural.

Another version of this drawing in the City Museum and Art Gallery, Plymouth, possibly a workshop variant, includes two angels above the fireplace at the upper right.[12]

∎

On Salimbeni, see Riedl, 1959, pp. 60-70; Scavizzi, 1959, pp. 115-36; Riedl, 1960, pp. 221-48; and the essay by Donatella Capresi Gambelli in Siena, 1980, pp. 143-48.

1 On Salimbeni, see Riedl, 1959, pp. 60-70; Scavizzi, 1959, pp. 115-36; Riedl, 1960, pp. 221-48; and the essay by Donatella Capresi Gambelli in Siena, 1980, pp. 143-48.

2 Inv. 1992; see Viatte, 1988, no. 394, repr.

3 See Gerszi, 1958, pp. 359-63 and fig. 4.

4 Inv. 835E; see Riedl, 1976, no. 105, repr. Riedl has suggested that this drawing is possibly a study for an altarpiece of this subject by Salimbeni painted for the church of S. Domenico, Ferrara.

5 For Casolani's *Birth of the Virgin*, see Siena, 1980, no. 22, repr. Also relevant in this connection is a *bozzetto* by Rutilio Manetti for an altarpiece in S. Maria dei Servi, Siena, for which see Bagnoli, 1978, no. 82, repr. Manetti's *bozzetto*, which was formerly ascribed to Salimbeni, is closer to Beccafumi's model than is the related altarpiece.

6 On Salimbeni's interest in Beccafumi, evident particularly in works executed around 1600, see Scavizzi, 1959, pp. 122-23.

7 Jean-Luc Baroni has recently informed me that there is an altarpiece of this subject by Salimbeni in the church of S. Maria Corteorlandini, Lucca, dated ca. 1602. I have been unable to see this work or a reproduction and therefore cannot judge its possible relation to our drawing. However, according to the Touring Club Italiano guide of Tuscany, the subject of this painting is the Birth of the Virgin, not the Birth of the Baptist.

8 Drawings of this subject by Salimbeni are preserved in the Biblioteca Comunale, Siena; the Teylers Museum, Haarlem; the Musée du Louvre, Paris; and the Uffizi, Florence. These are discussed by Riedl, 1976, under no. 104.

9 Haarlem, Teylers Museum, inv. Ax38.

10 Meijer and van Tuyll, 1983, no. 19. The authors propose that the two sheets in Haarlem, the compositions of which are both delineated in lunette-shaped fields, are connected with these lost frescoes by Salimbeni.

11 Bagnoli, 1978, p. 55, under no. 3; Capresi Gambelli in Siena, 1980, pp. 146-47.

12 London, 1962, no. 327; noted in Colnaghi, *Master Drawings*, New York, May-June 1990, under no. 20.

■

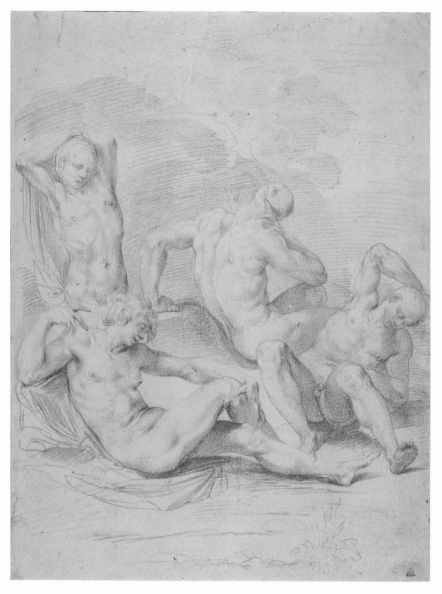

17

Giuseppe Cesari,
called CAVALIERE D'ARPINO (Rome 1568–Rome 1640)

17. *Four Male Nudes in a Landscape*

Red chalk, 30.0 x 23.0 cm. (11 13/16 x 9 in.).
Inscribed in graphite in modern hand on backing:
Giuseppe Cesari called D'Arpino from the Collections of
Marquis de Lagry [sic], *Dimsdale & Lestevenon.*

Provenance: Thomas Dimsdale (Lugt 2426); W. A.
Lestevenon; marquis de Lagoy (Lugt 1710); sale,
London, Sotheby's, July 2, 1984, no. 40, repr.;
[Colnaghi, London].

F our male nude figures are depicted in a loosely rendered landscape. Three of these recline in artfully complicated, twisting postures with limbs gracefully extended, while the fourth stands or kneels at the left with his arms grasped over his head. The setting is described only by the grassy turf at the lower right, the rocklike mound against which the figure in the center leans, and the vague suggestions of sky and foliage in the space above. Despite these generic plein air trappings, no recognizable physical setting is delineated, nor does the study represent an obvious narrative subject. The composition instead has the aspect of an academy drawing, seemingly compiled from individually posed models that do not relate formally or dramatically to one another. The artist's primary concern appears to have been the representation of the male nude form seen in a variety of positions—frontally, from the side, and from the rear—including the difficult foreshortened pose of the figure at the right. The use of live models is suggested by the anatomical accuracy of the muscular torsos and legs and the careful rendering of the play of light on the forms. Close attention has also been paid to cast shadows, which are particularly evident beneath the legs and outstretched feet of the two foreground figures.

This drawing formed a part of the celebrated collection of the marquis de Lagoy in the eighteenth century. It is meticulously described in the manuscript inventory in the following entry: "École Romaine. giuseppe Cesari detto il Cav. d'Arpino. no. 114. Étude de quatre figures nues et couchées qui paroissent destinées pour un tableau du jugement dernier. à la Sanguine. Larg 8 p. 1/2. Haut. 11 p. Collection Lestevenon."[1] Its critical history is of note, since relatively few drawings are so precisely documented in early sources.

Cavaliere d'Arpino produced a number of chalk drawings of nude figures throughout his long career, many of which are studies drawn from live models having an academic

character similar to our sheet.[2] Some of these academies are preparatory studies for paintings, while others appear to be independent exercises. To the former category belongs a black chalk study of a male nude figure on a plinth in the British Museum, London, that relates to a fresco by the artist in the Palazzo dei Conservatori in Rome.[3] In style and handling, this drawing is close to the Horvitz study—both share the same delicate, continuous contours and pronounced vertical hatching—and the reclining nude at the left of our drawing is of the identical physiological type as the figure in the British Museum study. Other drawings by the artist that may be signaled in this connection include a study of a nude man in flight at Rugby School, Warwickshire;[4] a study of a nude soldier in the Musée du Louvre, Paris;[5] and a series of drawings depicting *Hercules and Anteus*.[6] Also closely related to the present study is a black chalk drawing of a single male nude reclining in a landscape in the Graphische Sammlung, Frankfurt (fig. 17a).[7] The figure's pose is essentially the same in reverse as that of the nude at the left of the Horvitz sheet, and the same system of hatching and cross-hatching is employed to create volume and describe anatomy.

Although our drawing does not represent an identifiable subject, the postures of the four figures would be appropriate in a number of narrative contexts. One possibility is that they are studies for sleeping soldiers from a Resurrection. The drawing does not seem to be connected with any such invention by Cavaliere d'Arpino or his workshop, however.[8] Another possibility is that they were envisioned for a Last Judgment, as the marquis de Lagoy noted in his inventory. Indeed, straining nudes in contorted postures appear in a painting by the artist of a closely related subject, *St. Michael Combating the Rebel Angels* now in the Glasgow Art Gallery, but these also do not appear to be based on our drawing.[9] A final possibility is that the figures were intended as fallen soldiers in a battle scene such as Cavaliere d'Arpino's celebrated fresco in the Palazzo dei Conservatori, executed between 1595 and 1599. Again, however, no direct correspondence exists. At present, then, it remains uncertain whether this study was carried out in connection with a lost or never realized work or simply as an independent exercise.

Two of the figures in the Horvitz sheet may derive from earlier sixteenth-century sources: the reclining nude at the left recalls the slouched figure of Noah in Michelangelo's *Drunkenness of Noah* in the Sistine Chapel, while the foreshortened pose of the figure at the right is reminiscent of a black chalk study by Raphael of a sleeping soldier in the British Museum.[10] In their artificially graceful, serpentine postures and apparent recourse to earlier cinquecento models—a common practice in the works of Cavaliere d'Arpino and his followers[11]—the figures in this drawing are highly mannerist inventions. This circumstance suggests a dating to the earlier part of the artist's career, in the 1580s or 1590s.

■

17a. Cavaliere d'Arpino, *Reclining Male Nude*, Frankfurt,
Städelsches Kunstinstitut

1 *Catalogue des dessins qui composent la collection de M^r. de Lagoy*, MS., n.d., p. 29. (Roman School. Giuseppe Cesari, called the Cavaliere d'Arpino, no. 114. Study of four nude, reclining figures who seem intended for a painting of the Last Judgment. Red Chalk.)

Professor Herwarth Röttgen has kindly informed me that he regards the present sheet to be by Bernardino Cesari rather than Giuseppe (written communication), but in my opinion its high quality, and the fact that it was ascribed by the marquis de Lagoy to Cavaliere d'Arpino, favor the traditional attribution.

2 For a general discussion of this point, see Gere and Pouncey, 1983, under no. 28.

3 Ibid., no. 22 and pl. 20.

4 The drawing, executed in red and black chalk and based on a live model, is a study for a fleeing apostle in the *Capture of Christ* in the Borghese Gallery, Rome. See Röttgen, 1973, no. 122, repr.

5 Inv. 2993. This drawing is a study for the battle scene in the Palazzo dei Conservatori, which was executed between 1595 and 1599. See ibid., no. 120.

6 Louvre, inv. 148; Collection of the duke of Devonshire, Chatsworth, inv. 216; École des Beaux-Arts, Paris. The latter two drawings are illustrated in Röttgen, 1973, nos. 99-100, repr.

7 Inv. 4100.

8 Two paintings of this subject by the workshop of Cavaliere d'Arpino, one in the church of S. Folco, Santopadre (see Röttgen, 1973, no. 149, repr.), and the other recently on the art market (Sotheby's, New York, March 11, 1977, no. 77, repr.), include four sleeping or startled soldiers, but in neither work are these figures particularly close to those in our sheet. A red chalk drawing of sleeping soldiers in the Ashmolean Museum, Oxford (Parker, 1972, no. 476, as Polidoro da Caravaggio; Röttgen, 1973, no. 155) that is connected with the Santopadre *Resurrection* demonstrates formal affinities with our drawing in the similar depiction of four unrelated figures in different postures.

9 Röttgen, 1973, no. 11. A small painting on copper of this subject by the artist that recently appeared on the market (Sotheby's, New York, January 22, 1976, no. 52, repr.) similarly includes a group of nude figures in a variety of postures, but this, too, cannot be connected with the present sheet.

10 Inv. 1854-5-13-11; see Pouncey and Gere, 1962, no. 34, pl. 36. This drawing is a preparatory study for an unexecuted *Resurrection* for the Chigi Chapel in S. Maria della Pace, Rome.

11 Among other examples, this practice is attested in a drawing by the artist's brother, Bernardino Cesari, which is a copy after a red chalk drawing by Michelangelo of *Archers Shooting at a Herm* in the Royal Library, Windsor Castle. See Popham and Wilde, 1949, no. 456, fig. 102.

■

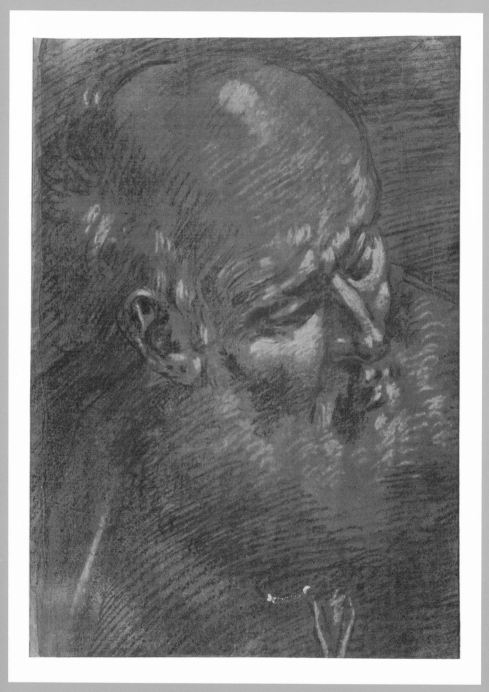

GIACOMO CAVEDONE (Sassuolo 1577–Bologna 1660)

18. *Study for the Head of St. Joseph*
Black chalk, heightened with white, on brown [pre-
pared?] paper; a small area of left margin made up,
38.7 x 27.3 cm. (15 3/16 x 10 3/4 in.).

Provenance: Sale, London, Christie's, July 1, 1986,
no. 83, repr.

A bald-headed, wrinkled, and bearded old man, his eyes
concealed behind lowered lids, gazes contemplatively downward to his left. The figure's
head, which fills most of the sheet, is rendered as though seen at close range—an
analogue of the "almost Caravaggesque physical proximity" that characterizes the paint-
ings of Giacomo Cavedone's mature style.[1] The shoulders and tunic are only summarily
indicated, and the area around the monumental head is filled in with bold hatched lines
that serve to flatten rather than describe space. White heightening densely applied in
the area of the cheekbones, the bridge of the nose, the forehead, the bald pate, the lips,
and elsewhere is used to create a raking light that floods and reflects off the contours of
the face. This is combined with black chalk, which the artist employs to describe the
shadowed recesses of the eye sockets, the temples, and the hollows of the cheeks.
Cavedone exploits the expressive possibilities of this combination of media, producing
a study striking for its immediacy, plastic forcefulness, and dramatic power.[2]

This drawing is a preparatory study for one of Cavedone's most celebrated works, the
Adoration of the Magi in the church of S. Paolo Maggiore, Bologna (fig. 18a).[3] The
particular angle of the head, as well as the individual features, correspond precisely
with the face of Joseph, who stands to the left of the composition behind the seated
Virgin and Child, at whom he gazes over his left shoulder. In this painting, as in our
drawing, the artist demonstrated a particular concern for the physical immediacy of the
figures and for the dramatic contrast of light and dark. The *Adoration of the Magi* and its
pendant, the *Adoration of the Shepherds*, were executed as laterals for the Arrigoni Chapel
in S. Paolo Maggiore. The former is inscribed with the date *1614*; the Horvitz study may
thus be roughly dated to this year as well.

A large number of similar head studies by Cavedone exist, many of these preserved in a
volume at Windsor Castle entitled *Teste di Cavedone*.[4] Most of these drawings, like the
Horvitz sheet, are executed in black and white chalk, although the *Study for the Head of
Nicodemus* in The Metropolitan Museum of Art, New York, was carried out in oil.[5]

Single male heads were a preferred subject of the artist, and our drawing is an entirely characteristic example of this category of his graphic production.

■

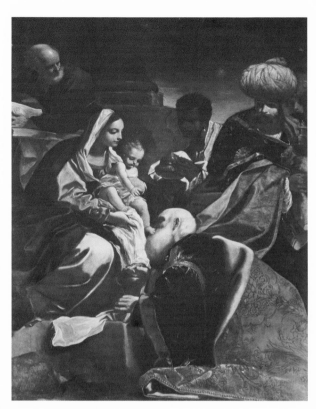

18a. Giacomo Cavedone, *Adoration of the Magi*, Bologna, S. Paolo Maggiore

1 So described by Laura Giles in a discussion of Cavedone's *Adoration* scenes from the church of S. Paolo Maggiore, Bologna, in Washington, New York, and Bologna, 1986, p. 410. On Cavedone, see idem, 1986.

2 Although in generally good condition, the drawing is slightly rubbed, resulting in a somewhat flattened appearance and loss of definition in areas like the jaw line. It is possible that this was caused by having a counterproof pulled from the sheet, a practice perpetrated on other such chalk studies by Cavedone (i.e., Royal Library, Windsor Castle, inv. 5264, a counterproof of inv. 5288; see Kurz, 1955, nos. 88 and 87, respectively).

3 On this painting, see the entry by Giles in Washington, New York, and Bologna, 1986, no. 137, repr.; and Bologna, 1959, no. 40, repr.

4 On the Cavedone head studies at Windsor, see Kurz, 1955, nos. 72-137, pls. 17–22, figs. 19–21.

5 Inv. 1988.140. For an illustration of this drawing, see Kate Ganz Ltd., *Italian Drawings, 1500-1800,* London, 1987, no. 15.

■

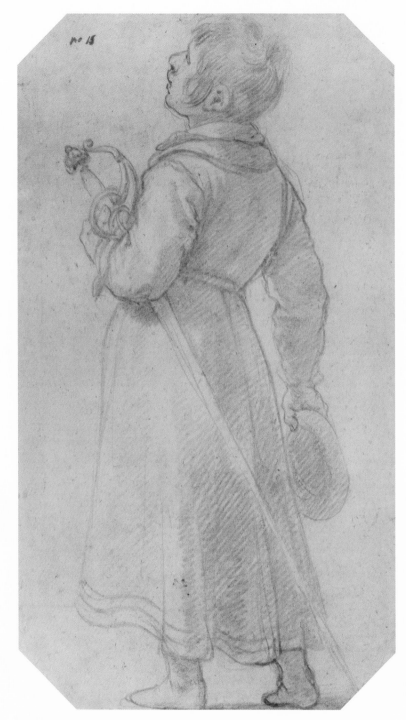

19

76

MATTEO ROSSELLI (Florence 1578-Florence 1650)

19. *A Young Boy Carrying a Sword*
Red chalk, 41.3 x 23.3 cm. (16 1/4 x 9 1/8 in.).
Inscribed in brown ink at upper left: *no 15*; all four
corners cut away.

Provenance: [Colnaghi, London, June-July 1988, no. 23,
repr.].

A youth wearing an ankle-length robe and seen in three-quarter rear profile gazes up to the left. He holds a cap in his right hand and embraces a large sword, whose point rests on the ground behind him, with his left arm. The proportionally large size of the sword indicates that the subject is a boy rather than an adult.

The present drawing is a preparatory study for a fresco in one of the historiated lunettes in the *chiostro grande* of SS. Annunziata in Florence depicting *Pope Alexander IV Approving the Rule of the Servite Order*: the figure appears as an attendant at the far right of the composition. This cycle was carried out by a group of artists, among them Bernardino Poccetti, between 1614 and 1618. Matteo Rosselli was responsible for four of the frescoes. The *Approval of the Servite Rule* to which our drawing relates was singled out for special praise by Pietro da Cortona who, according to the seventeenth-century biographer Filippo Baldinucci, judged it "la migliore che se vedesse in quel luogo."[1]

Like other artists of his generation such as Jacopo da Empoli, Cigoli, and Cristofano Allori, Matteo Rosselli rejected the extreme artifice and stylistic excesses of late mannerism and championed a new naturalism that would become the hallmark of the Florentine baroque.[2] In returning to nature as a source of artistic inspiration, these artists frequently produced figure drawings from life. Rosselli executed a number of these chalk drawings of single figures throughout his career, of which the Horvitz sheet is a characteristic example. That it is based on a live model is suggested by the unidealized, portraitlike quality of the boy's features, and by the accurate description of the interplay of light and shadow with the human form. To this end, the forceful modeling at once defines the contours of the figure and creates the shadow that cloaks the boy's back and right arm, throwing his left side in high relief.

In its naturalism and fidelity to life, as well as the evident preoccupation with the plasticity of the figure, our sheet demonstrates close affinities with a number of drawings by the artist, among them an archer in the Uffizi, Florence;[3] a standing man in the Musée du Louvre, Paris;[4] a reclining male figure in the Gabinetto Nazionale delle Stampe,

Rome;[5] and a nude youth running in the Frits Lugt Collection, Fondation Custodia, Paris.[6] A common use of red chalk and reliance on a live model further unites this group of drawings by Matteo Rosselli.[7]

A pen and ink composition study for Rosselli's SS. Annunziata fresco recently appeared on the market.[8]

■

1 Baldinucci, 1845-47, vol. 4, p. 162.

2 For Matteo Rosselli, see Florence, 1986, vol. 1, pp. 204-9; vol. 2, pp. 219-23; and vol. 3, pp. 158-60. See also Viatte and Monbeig Goguel, 1981, pp. 110-15, under nos. 64-67.

3 Inv. 1063F. On this drawing, which is a preparatory study for Rosselli's *Martyrdom of St. Sebastian* in Impruneta, see Thiem, 1969, p. 149 and pl. 25.

4 Inv. 1558.

5 Inv. F.C. 128827; see Rodinò, 1977, no. 93, repr.

6 Inv. 4624; see Byam Shaw, 1983, vol. 1, no. 60; vol. 3, pl. 73.

7 One of Rosselli's most engaging drawings in this vein is a sheet of studies in the Louvre (inv. 1545) that depicts a group of heads, the figures clearly studied from life and in informal poses.

8 Sotheby's, London, July 7, 1966, no. 109, as circle of Matteo Rosselli. A standing figure holding a sword and looking toward the left appears at the far right in this study, but as a bearded man rather than a young boy.

■

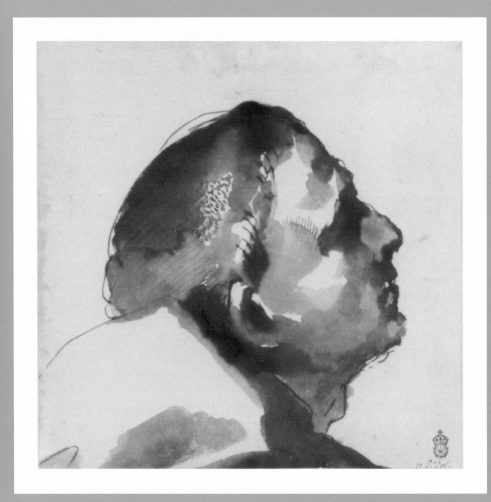

Giovanni Francesco Barbieri,
called G U E R C I N O (Cento 1591-Bologna 1666)

20. *Head of a Monk, Possibly St. Francis*

Pen and brown ink with brown wash,
17.8 x 17.8 cm. (7 x 7 in.).
Inscribed in pen at lower right: *10 P: Dol.*

Provenance: Casa Gennari; Edward Bouverie; earl of
Gainsborough; Archibald G. B. Russell (Lugt 2770a);
John Nicholas Brown; [David Tunick, Inc., New York,
1986].

A male head is seen in right profile. His eye and mouth are subsumed in shadow, while his cheekbone, forehead, upper ear, and cowl are picked out in relief, the untouched areas of the sheet serving as the highlighted passages. This dramatic chiaroscuro effect is achieved through the application of dark brown wash in broad, liquid, and murky pools. The subject of the sheet has traditionally been described as a monk, an identification advanced on the basis of the figure's tonsured head and the voluminous hood that falls over his shoulders. The latter detail suggests the habit of a mendicant, probably a Franciscan, and the figure may perhaps be identified as St. Francis of Assisi or St. Anthony of Padua.[1]

As the inscription at the lower right indicates, this sheet belonged at one time to the large collection of Guercino drawings owned by the artist's descendant Carlo Gennari (1712-1790) in the eighteenth century.[2] The contents of the Casa Gennari collection can be traced directly back to Guercino himself, who retained in his possession the bulk of his extensive number of drawings. Upon his death these were inherited by his nephews Benedetto (1633-1715) and Cesare Gennari (1637-1688), the latter being the grandfather of Carlo Gennari. The majority of the Guercino drawings in the Casa Gennari were bound into albums organized by subject and medium. One of these contained 297 *Dissegni di Penna, et Acquarella di diverse grandezze, rapresentanti diverse Teste, Figure, e Puttini* and may be the volume that originally contained the Horvitz *Head of a Monk.* Drawings from the Casa Gennari that entered the collection of Edward Bouverie in the mid-eighteenth century, the present example among them, were acquired through the Bolognese dealer Franceso Forni, who succeeded in procuring a number of the finest sheets when the contents of the Casa Gennari began to be widely dispersed.

Among the most energetic and prolific draftsmen of the seventeenth century, Guercino produced drawings in pen and ink, his favorite medium, throughout his career.[3] Nicholas Turner has kindly pointed out that the Horvitz study relates stylistically to sheets dating from the 1630s. Parallels may be observed in particular with a number of drawings by Guercino of single male figures represented half-length or bust-length, among

8 1

them studies of a man reading in the Fogg Art Museum, Cambridge, Massachusetts;[4] an old bearded man in the Royal Library, Windsor Castle;[5] St. Joseph holding a staff in the Art Museum, Princeton University;[6] and a bust of a man facing right in The Metropolitan Museum of Art, New York.[7] Our drawing shares with these a kinship in both subject matter and handling. All depict a contemplative, solitary male figure rendered on an intimate scale. The artist focuses on the subject's head and describes the torso in a summary fashion, leaving the surrounding area of the sheet blank in order not to distract from the human form. And in each instance, Guercino's murky, limpid "felicitous touches" of wash[8] are combined with a lively and varied penwork composed of quick, broken, and scribbly contour lines; bold, angular hatching; and, in all but the Metropolitan Museum sheet, passages of stippling to suggest the figure's hair or beard.

Our drawing demonstrates suggestive affinities with the kneeling St. Francis in Guercino's altarpiece of 1639-41 depicting the *Madonna and Child with Ss. Francis and Clare* (Galleria Nazionale, Parma).[9] Although it may represent an early idea for that figure, who is shown with a full beard in the painting, it is equally likely that the drawing was conceived as an independent invention rather than a preparatory study for a specific work. This conjecture is supported by the highly pictorial, poetic character of the sheet, a quality imparted through the exceptionally broad and fluid handling of wash more often seen in the artist's landscape sketches. Indeed, it is in drawings of this type, which greatly influenced Pierfrancesco Mola and anticipate Giambattista Tiepolo in their freedom and spontaneity,[10] that Guercino's genius as a draftsman is most immediately discerned.

■

1 The subject of this drawing has traditionally been identified as St. Lawrence, but the figure's costume and tonsured head clearly identify him as a monk, which the early Christian deacon and martyr St. Lawrence was not.

2 For a discussion of Guercino drawings from the Casa Gennari, see Mahon, 1969, under no. 39; and Mahon and Turner, 1989, pp. xvii-xxi.

3 On Guercino's preferred technique and the predominance of pen drawings in his graphic oeuvre, see Mahon and Turner, 1989, p. xvi.

4 Inv. 1932.233; see Oberhuber, 1979, no. 30, repr.

5 Inv. 2588; Mahon and Turner, 1989, no. 186 and fig. 368. This study, which is in poor condition, is executed on the back of a letter dated 1638.

6 Inv. 40-40; see Bean, 1966b, no. 38, repr.; and Gibbons, 1977, no. 308, repr. The drawing has been dated to the 1630s.

7 Inv. 38.179.4; see Bean, 1979, no. 246, repr.

8 So described by Mahon and Turner, 1989, p. xvii.

9 Mahon, 1968, no. 71, repr.; Salerno, 1988, no. 186, repr. The drawing is not related to any prints by or after Guercino, for which see Bagni, 1988.

10 The importance for Mola and Tiepolo of Guercino's drawings in which wash is liberally applied has been most recently reiterated by Mahon and Turner, 1989, p. xvii.

■

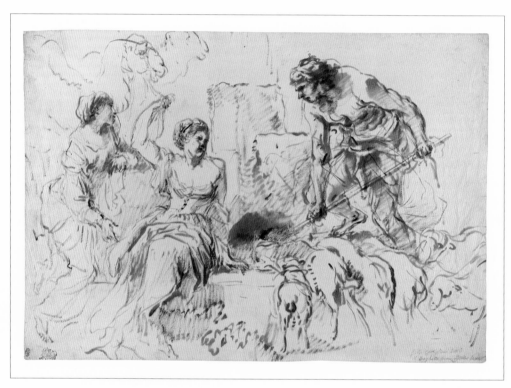

21

21. *Jacob and Rachel at the Well*
Brush and red oil paint,
39.4 x 57.1 cm. (15 1/2 x 22 7/16 in.).
Inscribed in pencil at lower right: *G. B. Castiglioni detto/ il
Greghetto Genovese Leu* [?]; in blue pencil at lower right:
£. 20 (canceled in graphite); on verso at lower right, in
graphite: *100 f*; at upper left center, in red: *M415.*

Provenance: G. Pacini (Lugt 2011); G. Vallardi (Lugt
1223); sale, London, Christie's, July 2, 1985, no. 67A,
repr.; sale, London, Christie's, July 6, 1987, no. 39, repr.

Drawn from the Old Testament, the subject of this drawing
is the Meeting of Jacob and Rachel at the well. Rachel, holding the tethers of two camels
in her upraised right hand and watched over by a female attendant—her maidservant
or perhaps her sister, Leah—is seated on a ledge. She rests her left hand on the well
from which Jacob is engaged in removing the cover stone in order to allow the sheep
belonging to Rachel's father, Laban, to drink. A stone wall rises behind the well be-
tween the central figures.

A prolific and highly innovative draftsman, Giovanni Benedetto Castiglione is best
known for his depictions of pastoral subjects (a predilection he shared with Poussin),
primarily shepherds and their flocks, and scenes from the Old Testament, specifically
the Book of Genesis. The artist's favorite Old Testament theme was the Journey of the
Patriarchs, a genre of which Castiglione made a specialization, as a document of 1635
describing him as the painter of the "viaggi di Giacobbe" testifies.[1]

The subject matter of the present drawing is in effect a compilation of these two pre-
ferred themes. The flock of sheep and the costumes of both Rachel and Jacob, who look
more like a shepherd and shepherdess than biblical protagonists, invest the image with
the aspect of a pastoral scene, while the narrative is drawn from the Old Testament
account of the Patriarch Jacob. This source provided Castiglione with artistic inspiration
throughout his career. The subject of the Horvitz sheet was taken up in a drawing in a
New York private collection.[2] In addition, the artist treated the related biblical episode
of the Journey of Jacob in a group of studies preserved in the Royal Library, Windsor
Castle;[3] a sheet in the Graphische Sammlung, Stuttgart;[4] and in a number of paintings
dating from different periods of his activity.[5] And an etching by Castiglione, *Laban
Searching for Idols Concealed by Rachel*, illustrates an event in the story of Jacob and

Rachel subsequent to that in our drawing.[6] Despite the correspondences in subject matter, the Horvitz sheet is not directly connected with any of these works.

The present sketch displays Castiglione's distinctive technique of drawing directly on the sheet in oil paint, frequently mixed with pigment, with the tip of a brush.[7] As is often remarked, such drawings have something of the quality of an oil sketch, and it is probable that the inspiration for this technique derived from the oil sketches of Rubens and especially van Dyck, which Castiglione would have seen in his native Genoa.[8] A similar technique was also employed by his compatriot Bernardo Strozzi and by Castiglione's master, Giovanni Andrea Ferrari,[9] but the virtuoso handling and painterly quality of Castiglione's drawings owes more to the northern masters than to his Genoese contemporaries.

Executed with a summary, sketchy, and free brushwork, our sheet compares stylistically with such drawings by the artist as an *Adoration of the Shepherds* in the Woodner Collection, New York;[10] a *Holy Family with Angels* in the Musée du Louvre, Paris;[11] and a *Sacrifice of Noah* in the British Museum, London,[12] all of which date ca. 1660. A date for the present study in the later 1650s or 1660s, the last phase of the artist's activity, is suggested by the especially loose and fluid style, and by the immateriality of forms that contrasts with the more solidly rendered figures of his oil sketches of the 1640s.[13] Like the other brush drawings that Castiglione produced in large number from the 1640s onward, the Horvitz sheet would have been created as an independent, finished work, and not as a preparatory design for a painting.[14]

■

1 Cited in Newcome Schleier, 1985, under no. 68.

2 See Percy, 1971, no. 96, repr. Percy reports that a drawing by Castiglione of the same subject is at Windsor Castle, but this information appears to be incorrect since the inventory number cited (3900) is a drawing of a different subject, and no study by Castiglione of *Jacob and Rachel at the Well* is recorded by Blunt, 1953.

3 Blunt, 1953, nos. 94-96, 165.

4 Inv. C 1922/120; see Stuttgart, 1984, no. 144, repr.

5 Among Castiglione's extant versions of this theme are paintings preserved in the Borghese Gallery, Rome; the Gemäldegalerie, Dresden; the Museo del Prado, Madrid; and a New York private collection. See Genoa, 1990, no. 5, where the Borghese version is discussed at length.

6 B.XXI, 4. On this etching, see Bellini, 1985, pp. 16-18; and Sopher, 1978, no. 134, repr. Two drawings by Castiglione of this subject are in the Royal Library, Windsor Castle; Blunt, 1953, nos. 97 and 206.

7 For a discussion of this technique and its sources, see Blunt, 1953, p. 8; Newcome Schleier, 1985, under no. 68; and Percy, 1971, pp. 23-24; 38-39.

8 The example of van Dyck was particularly important; the young Castiglione worked in his studio in the 1620s when van Dyck was active in Genoa.

9 Newcome Schleier, 1985, under no. 68.

10 New York, 1990, no. 37, repr.

11 Inv. 9452; see Newcome Schleier, 1985, no. 73.

12 Inv. 1887, 6.13.75; see Turner, 1980, no. 56, repr.

13 Percy, 1971, p. 43, discusses the differences between Castiglione's oil drawings of the 1640s, which she characterizes as "almost like small paintings" in their highly finished, elaborate quality, and those of his later period, which are looser and more summary.

14 For a discussion of this point, see ibid., p. 39.

■

22

LUCA GIORDANO (Naples 1632-Naples 1705)

22. *The Death of St. Joseph*
Red chalk, 64.8 x 44.2 cm. (25 7/16 x 17 3/8 in.).

Provenance: [Jean-Pierre Selz, Paris, 1988].

T he bearded, wizened Joseph lies on a bed, his torso nude and the rest of his body covered by a sheet clutched to his chest. He is surrounded by three standing figures—St. Michael at the right, clad in a soldier's uniform and helmet, who rests his right foot on a vanquished devil and grasps a sword hilt in his right hand; the Virgin Mary, who stands behind the bier and raises her hands in supplication; and Christ, at the left, who gazes at his mother and extends his left hand heavenward. A winged angel, depicted from the rear, kneels before Joseph's bed, and two other angels and a cherub appear in the heavenly zone at the upper right. Two other attendants complete the scene, one glimpsed below the upraised arm of Christ, the other to the left of St. Michael. In contrast to the rest of the figures, who are rendered in a highly finished and detailed manner, these last two are hastily sketched in outline form.

This drawing is a preparatory study for a painting of the same subject by Luca Giordano executed for the Church of S. Maria del Carmine in Ascoli Piceno and now in the Pinacoteca Civica (fig. 22a).[1] This work, which is not mentioned in any early sources, is signed by the artist and bears the date 1677.[2] Our drawing, then, is roughly datable to the same year. The unusual subject, rarely treated in Italian art before the eighteenth century, is drawn from the apocryphal book of Joseph the Carpenter. This source relates that the saint died at the age of 111 in the presence of the Virgin, Christ, and two angels who descended from heaven. Luca Giordano's composition faithfully conforms to this text, although the presence of St. Michael, not explicated by the narrative account, was presumably dictated by the patron and the original setting for which the painting was intended.

Although this sheet is not marked for transfer, it appears to be a *modello* for the Ascoli Piceno altarpiece. The two correspond in virtually every detail with the exception in the painting of the clouds and putti that appear in the upper left corner (the space left blank in the drawing) and the additional attendant figure glimpsed beside the Virgin's right shoulder. The highly finished aspect of our study is not unusual in Luca Giordano's graphic oeuvre, and parallels may be observed in a number of other red chalk drawings by the artist. These include a sheet in Cologne representing *St. John Baptizing;*[3] a study of *Christ Driving the Money Changers from the Temple;*[4] and a *Flagellation,*[5] the latter two of which recently appeared on the art market. Like the Horvitz sheet, which evinces a precisely analogous handling, these drawings all exhibit an even, controlled, but softly modulated hatching, and reinforced contours.

89

Their close relation might be construed as an indication that our drawing is a copy after the Ascoli Piceno painting, but the stylistic affinities with autograph drawings by the artist argue against this interpretation. That the altarpiece was located in a provincial center and was entirely ignored in early sources also disabuses the notion that it would have been subject to the type of study or attention to have generated such copies. It is possible, however, that the Horvitz drawing is not a *modello* but a *ricordo*—a graphic record made by the artist of a painting dispatched to a remote location. This circumstance would account for its finished nature, the omission of secondary details like the clouds that fill the upper left of the picture, and the absence of exploratory line or *pentimenti*. In support of this suggestion, it should be noted that precisely the same handling and technique that characterize the present sheet are also witnessed in other copy drawings by the artist.[6]

22a. Luca Giordano, *The Death of St. Joseph*, Ascoli Piceno, Pinacoteca Civica

1 See Ferrari and Scavizzi, 1966, vol. 2, p. 92; vol. 3, fig. 149.

2 Signed and dated at the lower left: *Jordanus F. 1677.*

3 Wallraf-Richartz Museum, inv. 607724.

4 Sotheby's, London, July 6, 1987, no. 65, repr. The drawing, which relates to a lost painting of the same subject, was executed around 1657-60 (see Ferrari and Scavizzi, 1966, vol. 2, p. 370).

5 See *Master Drawings presented by Adolphe Stein at the Douwes Fine Art Gallery*, London, June-July 1988, no. 29, repr.

6 A close stylistic comparison may be made with a red chalk drawing in the British Museum, London, representing the *Dream of Jacob*, which is a copy after a detail of a fresco by Raphael in the vault of the Stanza d'Eliodoro in the Vatican. On this drawing, see Vitzhum, 1970, pl. 24 and p. 84.

■

23

23. *The Holy Family*

Red chalk over traces of black chalk; sheet extended on
three sides to rework part of the composition that
includes female figure seated at lower right and two
standing male saints at right,
40.7 x 29.0 cm. (16 x 11 3/8 in.).

Provenance: Ulricho Hoepli, Milan; [Colnaghi, London,
July 1988, no. 32, repr.].

T he Virgin Mary holds the infant Christ in her lap and
extends before him a long sash. St. John the Baptist, a lamb at his feet, kneels before her
holding the cross identifying him as the forerunner of Christ. Seated behind him is his
mother, St. Elizabeth, who raises her finger to her lips in a gesture of silence. Elizabeth's
husband, Zacharias, stands between the two women, and Joseph, his identity signaled
by his flowering staff, looks over the Virgin's shoulder at the right. Behind Joseph is an
unidentified bearded male saint, perhaps St. James the Greater, his hands clasped be-
fore his breast. A female figure at the lower right, presumably a nursemaid but possibly
St. Anne, leans against a cradle and holds a swaddling cloth as she gazes back at the
Christ Child. The crumbling wall of a nondescript structure provides the backdrop to
this gathering, which, in its lack of overt religious symbols and emphasis on the domes-
tic intimacy of the assembled figures, seems more like a humble genre scene than a
sacred image. The composition is not without its sacred content, however: the sacrificial
nature of the Christ Child is symbolized by the lamb at the lower left, and the swad-
dling cloth held by the nursemaid is an allusion to the winding cloth, or *corporale*, in
which the dead Christ will be entombed.

Giuseppe Maria Crespi's distinctive graphic style is readily recognizable in the *Holy
Family* study. Of particular note is the high degree of detail and finish and correspond-
ing absence of pentimenti evident in the majority of his known chalk drawings[1]—
qualities prompting the characterization of the artist's draftsmanship as "rather dry"
and evincing a "neat academic fashion" that contrasts dramatically with the loose and
fluid handling of his paintings.[2] Also typical of Crespi's manner as a draftsman is the
"restrained chiaroscuro"[3] of the Horvitz sheet, in which forms are defined by an even,
bold light that highlights the rounded volumes of knees, thighs, and shoulders while
casting drapery folds and other recesses in deep shadow.

Crespi and his workshop executed a number of paintings of the Holy Family that
reprise the composition recorded in the present drawing.[4] Of these, the primary version

is a canvas in the Pushkin Museum, Moscow, executed around 1715-20 (fig. 23a), the variant to which our sheet most closely relates.[5] A number of slight and insignificant differences notwithstanding,[6] the compositions are identical, and it may be posited with reasonable certainty that the Horvitz drawing is a *modello* for the Pushkin *Holy Family*. Many of Crespi's preparatory studies exhibit the same precise relationship to his paintings. A case in point is a red chalk drawing in the Louvre depicting *St. John on Patmos* that corresponds in virtually every detail, save the loss of the Evangelist's beard, with the related painting.[7] And Crespi's *modello* for the pendant of the *Holy Family*, the *Death of St. Joseph* in the Hermitage, Leningrad, shows the identical dry, neat handling of chalk that distinguishes our study.[8] These considerations leave little doubt of the connection between the present drawing and the Pushkin painting.

A leading artistic personality of the late seicento and early settecento in Bologna, Crespi is celebrated for his poignant and touching images of the humble, and occasionally the aristocratic, classes, as well as his intimate religious compositions cloaked in the language of immediate, everyday experience.[9] His sympathetic and moving portrayals of peasants and others of meager circumstances anticipate the genre scenes of Pietro Longhi and Giovanni Battista Piazzetta, for whom Crespi provided an important precedent. Chalk drawings by the artist are relatively rare,[10] and those that reveal his sensibility as a genre painter are limited to the small number of sketches executed in connection with a series of etchings illustrating the foibles of the Bolognese comic heroes Bertoldo, Bertoldino, and Cacasenno.[11] The present study, datable to the period 1715-20 on the basis of its relation to the Leningrad painting, is thus a notable addition to Crespi's small but still emerging graphic oeuvre.[12]

■

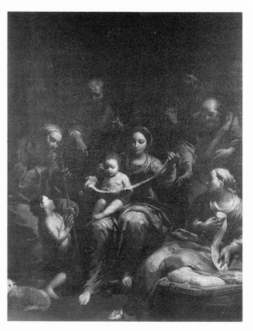

23a. Giuseppe Maria Crespi, *The Holy Family*, Moscow, Pushkin Museum

1 See, for example, a red chalk drawing in the Musée du Louvre, Paris, representing *St. John, Bishop of Amathus, Distributing Alms* (inv. 8215); Bean, 1966a, p. 420 and pl. 34.

2 Ibid., p. 420. On this point, see also Giles, 1989, pp. 223ff.

3 Characterized by Bean, 1966a, p. 419.

4 Eight related paintings of this subject including the primary version in the Pushkin Museum, Moscow, are recorded by Merriman, 1980, nos. 69-76. The author considers three of these to be autograph. Other variants not catalogued by Merriman have appeared on the art market in recent years (Sotheby's, New York, June 11, 1981, no. 76, repr.).

5 Merriman, 1980, no. 69; see also Bologna, 1990, no. 50, repr.

6 Although they are more tightly condensed in the painting than in the drawing, the identical figures appear in precisely the same disposition in both. Differences in the gesture of St. Joseph may be observed, and the loosely described architectural setting also varies slightly. Unlike the drawing, the banderole that the Virgin holds in the Pushkin painting bears a legible inscription, *Ecce Agnus Dei*—Behold the Lamb of God—the words of St. John the Baptist testifying to the sacrificial nature of Christ.

7 Inv. 8216. On the Louvre drawing and the related painting (whereabouts unknown), and a discussion of the precise parallels between the two, see Bean, 1966a, p. 419, fig. 1 and pl. 32.

8 This *modello* is known through a counterproof, apparently retouched by Crespi himself, in the Albertina, Vienna. See ibid., p. 419 and fig. 2.

9 On Crespi's seminal position in the tradition of genre painting in Italy in the eighteenth century, see Spike, 1986. See also the biographical essay by Mira Merriman in Washington, New York, and Bologna, 1986, p. 418.

10 Pen drawings by Crespi are virtually nonexistent, with the possible exception of a sheet in the Detroit Institute of Arts. A pen drawing in the Robert Lehman Collection of The Metropolitan Museum of Art ascribed to Crespi by George Knox in Byam Shaw and Knox, 1987, no. 24, is likely to be by Pier Francesco Mola, as Macandrew, 1988, has suggested. (I am grateful to William Griswold for this reference.)

11 On this series, see Giles, 1989, pp. 222-27; Bologna, 1990, pp. 115-55.

12 According to John Spike, who offers an overview of Crespi as draftsman, ("Giuseppe Maria Crespi, Disegnatore," in Bologna 1990, pp. 157-62; see esp. p. 157) the artist's drawings are not rare, but merely still largely unidentified.

■

DONATO CRETI (Cremona 1671-Bologna 1749)

24. A Sibyl; (Allegory of Wisdom [?])
Pen and brown ink, 25.2 x 17.8 cm. (9 15/16 x 7 in.).

Provenance: Bolognini-Amorini Collection, Bologna;
sale, London, Christie's, July 5, 1983, no. 69 repr.; [Jean-
Pierre Selz, Paris].

A seated woman dressed in a long gown and draped in a flowing cloak supports an open book on her lap. She rests her right arm on a table behind her, her cheek in her hand, and gazes down at the book. At her feet, one of which rests on a tasseled cushion, is a globe. A winged putto at the left leans over the table and dips a quill pen in an inkwell. A vase of flowers sits on the table to the right of the woman; a flaming lamp is suspended at the upper left corner. Extending along the top of the composition is a voluminous drapery pulled back at the upper right to reveal a wall or pier embellished with a bull's-eye pattern and a cherub's head, which bears the inscription, partly concealed behind the vase, *DONA CRET INV*.

As the inscription testifies, this drawing was executed by the Bolognese artist Donato Creti, whose distinctive hand is immediately recognizable in the short, choppy pen strokes and in the tight, angular cross-hatching that defines the drapery folds. This handling, aptly described by Renato Roli as "an almost incisory precision,"[1] recurs in numerous pen drawings by the artist, particularly those that appear to have been conceived as autonomous inventions rather than preparatory studies. In this connection, a drawing of *Tarocchi Players* in a Bolognese collection,[2] and a sketch of *Two Lovers in a Landscape* in the Albertina, Vienna,[3] may be cited. Stylistic as well as compositional parallels link the Horvitz sheet with a drawing in the Pinacoteca Nazionale, Bologna, of two women conversing:[4] Creti's crisp line and dense network of hatching are again evident, and the Bologna sheet depicts a female figure in a similar pose and setting.

Creti produced a number of drawings of female personifications with which our sheet may be loosely connected. Of this group, particular notice should be given to a sketch in the Graphische Sammlung, University of Würzburg, representing a seated woman deployed in a similar posture beside a parapet on which a cupid holds an open book while another draws back a flowing curtain;[5] to a study of the Libyan Sibyl in the Bologna Pinacoteca, where the female figure appears seated on a raised platform holding two tablets in her lap;[6] and to a sketch of a seated, barefoot female figure accompanied by a

vase of flowers in the National Gallery of Scotland.[7] Like the Horvitz sheet, all three drawings are executed in pen and ink and have as their subjects female figures who, in a general sense, personify wisdom.[8] A number of paintings by the artist also deal with similar subject matter. These include a female figure personifying Experience seated beside a flaming lamp beneath a curtain,[9] and a series of four *tondi* representing Virtues.[10] In three of the canvases from this series, the female personification is seated on a stepped platform framed by columns on tall plinths and attended by a putto bearing the Virtue's identifying attributes—details that find compelling parallels in the Horvitz drawing. Not unrelated in this context is the personification of Geometry represented as a female figure surrounded by appropriate attributes that appears in Creti's *Allegorical Tomb of Charles Boyle, John Locke, and Thomas Sydenham*, in the Bologna Pinacoteca.[11]

Despite its suggestive affinities with Creti's drawings and paintings, the subject matter and the function of the Horvitz sheet remain uncertain. The presence of the lamp, book, and flora, as well as the turbanlike headdress of the figure, lead to the inference that she may be a sibyl,[12] although the assembled attributes do not permit a specific identification. Nor may the figure be persuasively associated with any of the obvious Virtues or temperaments typically personified as female figures.[13] It is conceivable that the enigmatic subject was conceived as a personal allegory—a conjecture supported by the prominent inscription recording Creti's authorship—perhaps of artistic inspiration and immortality. As further corroboration of this suggestion, attention should be drawn to a sheet by the artist in the Schloss Fachsenfeld Collection, Staatsgalerie, Stuttgart, which, in addition to obvious stylistic similarities, presents the closest iconographic parallels with the present drawing (fig. 24a).[14] Both depict female figures at a table engaged in reading and writing (this act in our study performed by the attendant putto) and deployed in a setting that includes a large vase of foliage, a bundled curtain, a cushion footrest, and a bull's-eye leaded glass panel. The subject matter of the Stuttgart sheet has been discussed by Christel Thiem, who proposed that the two figures represent Urania, the Celestial Muse, and Clio, the Muse of History, and that the study is an allegory of Imitation and Inspiration—the two poles of artistic practice and a recurring topos in Italian art theory from the sixteenth through the eighteenth centuries.[15] The present drawing seems clearly to be concerned with a similar theme, even if its precise meaning cannot at present be deciphered.

If this interpretation of Creti's drawing is correct, the invention would belong to the tradition of allegorical representations of artistic genius and inspiration that achieved currency in the seicento, notable examples of which include etchings by Pietro Testa, G. B. Castiglione, and Salvator Rosa. In this event, the possibility that our study may have been a design for a similar etching, albeit of a less arcane conceit and content, should be entertained. The hard, regular, and almost fastidious character of the penwork, and the complete lack of the fluid, open, scribbly line that characterizes much of Creti's graphic production, lend support to this proposal, which must, however, be advanced

with some reservation given the limited evidence of the artist's activity in the arena of printmaking. Whatever its function, this engaging allegory is a significant addition to the corpus of drawings that earned Creti the designation from his admiring, slightly older contemporary, Marcantonio Franceschini, "grandissimo dissegnatore."[16]

■

24a. Donato Creti, *Two Women Reading and Writing,* Stuttgart, Staatsgalerie

1 Roli, 1973, p. 28.

2 On this drawing, see ibid., p. 28 and pl. 20.

3 Inv. 34.892, B 302; see Birke, 1979, p. 52 and pl. 53.

4 Bertelà, 1976, no. 62 and fig. 63.

5 Inv. 7448/I20.

6 Inv. 1900; see Bertelà, 1976, no. 65 and fig. 62.

7 Inv. D2930; see Andrews, 1968, vol. 1, p. 44; vol. 2, fig. 319. Although no identification of this figure is proposed, the author notes that both the Libyan and Erythrean Sibyls are occasionally represented with plants such as that which appears in this study.

8 A sheet in the École des Beaux-Arts, Paris, ascribed to Creti of an *Allegory of the Arts* (inv. M2548) may also be cited in this connection. The drawing shows a full-length female figure holding a palette and seated before a ledge on which a cupid stands supporting a canvas. Pieces of sculpture and two drawings lie at her feet, and a flying cupid raises a laurel wreath over her head. The subject and composition relate to the group of drawings discussed here, including the Horvitz study, but the attribution to Creti is in my opinion somewhat tenuous. The sheet may be a copy after the artist.

9 Costantini Collection, Bologna; see Roli, 1967, no. 49 and fig. 32. The painting, executed around 1713, is an autograph variant of the female personification representing Experience in the "Memoria" of Giovan Gerolamo Sbaraglia (ibid., no. 5 and fig. 30).

10 Collezioni Comunali d'Arte, Bologna; ibid., nos. 29-32 and figs. 50-53.

11 Ibid., no. 37 and fig. 71.

12 A recently discovered painting of the *Samian Sibyl* by Guercino (Salerno, 1988, no. 287, repr.) shows the figure in a turban, holding a book, and with an inkwell and quill pen beside her—elements that all find parallels in Creti's image—but other correspondences are lacking and the similarities are not compelling enough to establish with certainty whether this is also the subject of our drawing.

13 Possible candidates include Melancholy, suggested by the contemplative pose but unsupported by conventional symbols like a skull, or Truth, often symbolized by a globe, but as a rule represented by a naked woman. The fact that Creti, according to the eighteenth-century biographer Zanotti, suffered periodic bouts of melancholy may not be irrelevant to a discussion of the subject matter of the Horvitz drawing.

14 Inv. II/680; see Thiem, 1983, no. 68, repr.

15 Ibid., p. 126.

16 Franceschini offered this estimation of Creti in a letter to Prince Johann Adam of Liechtenstein, dated December 13, 1693; see Miller, 1969, p. 307.

■

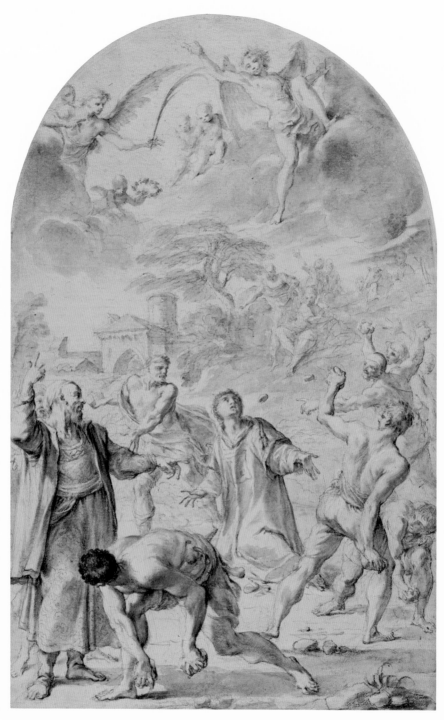

25

AURELIANO MILANI (Bologna 1675-Rome 1749)

25. *The Stoning of St. Stephen*
Black chalk, gray wash, heightened with white,
41.0 x 26.0 cm. (16 1/16 x 10 3/16 in.).

Provenance: [Yvonne Tan Bunzl, London, 1984, no. 37, repr.].

G arbed in a deacon's dalmatic, St. Stephen kneels in the center of a ring of executioners who hurl rocks at him, their brutish aspect communicated by their muscular nude torsos and bare feet. A bearded man in a brocaded tunic, perhaps one of the Sanhedrin whose wrath was aroused by the preaching of the protomartyr, stands at the left, pointing to the drama and raising his right hand in a rhetorical gesture of exclamation. A number of spectators witness the scene from a hillside in the right middle distance. In the arched upper zone of the composition, clouds part to reveal an angelic vision toward which the saint directs his gaze. His martyrdom and ultimate triumph over death are signified by the palm frond and wreath borne by two of the angels.

The present sheet is a study for a lost altarpiece by Aureliano Milani from the church of S. Maria della Purificazione in Bologna, executed shortly before the artist's permanent removal to Rome in 1719 (fig. 25a).[1] The drawing corresponds to the painting in virtually every detail save the absence in the painting of the third torturer behind the helmeted soldier at the right, the wreath-bearing putto at the upper left, and the second Sanhedrin at the far left edge of the composition, and the addition of two helmeted figures behind the saint.

A paradigmatic example of his graphic style, this drawing illustrates Milani's love of compositions populated by muscular, animated figures—a predilection remarked on by the eighteenth-century biographer Giovanni Pietro Zanotti, who observed that "uomini nudi, musculosi, e terribili sono il piacere di questo pittore"[2]—and augmented by unusually detailed landscape backgrounds.[3] Stylistically, the drawing compares closely with a sheet in the National Gallery of Canada, Ottawa, representing *Samson Slaying the Philistines*.[4] Executed in black chalk heightened with white, the same technique employed in the Horvitz sheet, the Ottawa study likewise depicts vigorous, posturing figures set in a detailed landscape. Moreover, both drawings exhibit a certain "additive" character, the carefully posed central figures seemingly based on academic studies of individual models incorporated into a narrative composition and furnished with a landscape backdrop.[5]

Milani's multifigured compositions were inspired by the art of the Carracci, and his emphasis on the individually posed figures that comprise his narratives derives from their figure drawing style, particularly that of Annibale.[6] Although his straining, exaggerated postures seem almost parodies of the drawings produced in the Carracci Academy, Milani's admiration of his artistic forebears was ardent and profound. An acclaimed draftsman in his own day, Milani was accorded a distinguished place in the Bolognese tradition by the biographer Luigi Crespi, who remarked that his drawings "possono andar del pari con quelli di qualunque gran maestro, pel carattere, per la prontezza, per la grandiosità, e per la disinvoltura, con la quale sono toccati, lumeggiati, e macchiati."[7]

Like the lost painting by Milani for which it is a preparatory study, the Horvitz drawing may be dated ca. 1718.

■

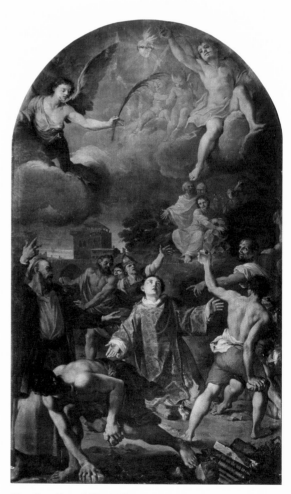

25a. Aureliano Milani, *The Stoning of St. Stephen,* formerly Bologna, S. Maria della Purificazione

1 The painting was destroyed in the course of bombardments of Bologna on September 25, 1943, and June 24, 1944, during World War II. It is referred to in earlier guidebooks of the city: see, for example, Ricci and Zucchini, 1968, p. 128: "S. Maria della Purificazione: *Altar Maggiore*. A destra, il martirio di s. Stefano è opera di A. Milani." On this lost work, see Roli, 1960, no. 10, pp. 190-91, and pl. 61a.

2 Zanotti, 1739, vol. 2, p. 162. The lost painting to which the present drawing relates is mentioned in this source (p. 162).

3 For this characterization of Milani's graphic style, see Cazort and Johnston, 1982, under no. 91.

4 Ibid., no. 91, repr. The authors note that this drawing and the Horvitz sheet are "stylistically identical."

5 This aspect of the *Samson Slaying the Philistines* was noted by ibid., under no. 91. The *Stoning of St. Stephen* is even more additive and disjunctive in character.

6 Milani's assiduous study of the art of the Carracci is repeatedly noted in early sources. See Malvasia, 1769, p. 146; and Zanotti, 1739, vol. 2, p. 160.

7 Malvasia, 1769, p. 147. (Milani's drawings are equal to those of any great master, for their individuality, for their immediacy, for their magnitude, and for the ease of execution with which they are touched, heightened, and shadowed.)

■

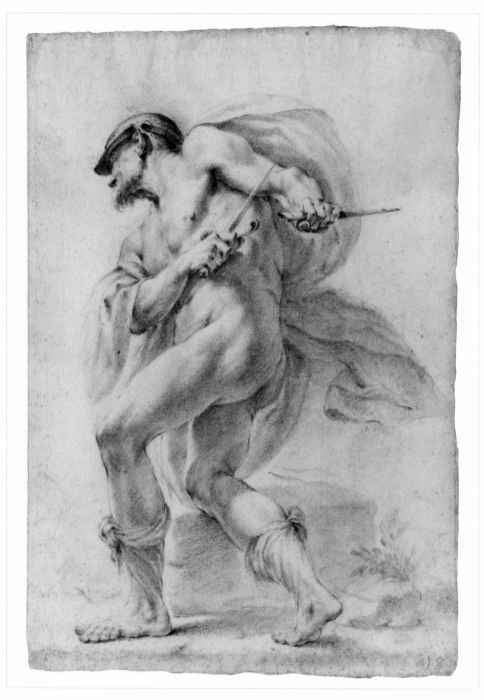

FRANCESCO MONTI (Bologna 1685–Brescia 1768)

26. *Study of a Standing Male Nude Unsheathing a Dagger*
Black chalk, 44.5 x 30.5 cm. (17 1/2 x 12 in.).
Inscribed in graphite at lower right: *18*.

Provenance: [Colnaghi, London, July 1984, no. 33].

A nude male figure, sporting a helmet and cloaked in a billowing drapery, unsheathes a dagger with his right hand. He rests his right knee on a stone slab and twists at the waist in an artfully conceived spiraling posture. A vague suggestion of landscape is imparted by the leafy sprig growing beside a smaller rock at the lower right corner of the sheet.

One of a group of academies by Francesco Monti, this study is characteristic of the artist's manner as a draftsman in both subject matter and style. The handling of the medium exemplifies Monti's "soft chalk style," notable for the smooth modeling of forms, limited use of hatching, complete chalk contour, and careful attention to musculature.[1] Also typical of the artist is the evident predilection, readily witnessed in our drawing, for elaborate, rather contrived postures—an often remarked-on trait that Renato Roli has described as Monti's "neo-mannerism."[2]

Six related drawings by Francesco Monti are preserved in the Pinacoteca Nazionale, Bologna.[3] Like the Horvitz sheet, these are executed in black chalk and drawn from live models. Each depicts a single male nude figure outfitted with a few costume props, such as a drapery, staff, or cap, and isolated in a loosely described landscape setting. The figures all lean, sit, or rest a foot on a stone block in the same fashion as the nude in our drawing. As their helmets indicate, two of the figures from this group are soldiers, and one unsheathes his sword and raises it over his shoulder in a gesture closely akin to that of the soldier in the present study (fig. 26a). It has been suggested that the same model posed for a number of these drawings,[4] and indeed the sharply pronounced nose and chin, scraggly beard, and satyrlike profile of the soldier in the Horvitz sheet may be recognized in at least two of the related studies in Bologna.[5] Finally, it is worth noting that our drawing corresponds precisely in size to the sheets in Bologna,[6] and that, like these, it is inscribed with a number in the lower right corner. These considerations suggest that the drawings were originally part of a sketchbook, and there can be no doubt that the Horvitz study belongs to this group of academies by Monti, to which it is a new and important addition.

The strong influence of Giovanni Battista Piazzetta may be discerned in these nude

figure studies.[7] Monti presumably had a firsthand knowledge of the Venetian artist's black chalk style as the result of their contemporary membership in the 1720s in the Accademia Clementina in Bologna, and their collaboration in the second half of the decade on the well-known series of allegorical paintings of imaginary tombs commissioned by Owen McSwiney for the duke of Richmond, and it seems clear that he assiduously studied Piazzetta's drawings.[8] This circumstance, coupled with the fact that Piazzetta's earliest chalk studies cannot be dated before ca. 1718, suggest that Monti's studies were executed in the 1720s.[9]

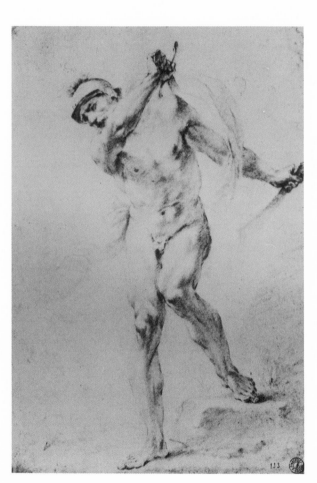

26a. Francesco Monti, *Study of a Male Nude with a Sword*, Bologna, Pinacoteca Nazionale

1 This characterization of Monti's black chalk style was advanced by Cazort Taylor, 1973, pp. 161–63.

2 Roli, 1962, p. 90.

3 Invs. 3780-84 and 4161; see Cazort Taylor, 1973, pls. 28-31; and Bertelà, 1976, no. 70.

 Other academic drawings by Monti exist that do not strictly belong to this group but do relate stylistically, for example, a study depicting *Cain Slaying Abel* in the University of Michigan Museum of Art, Ann Arbor (inv. 1970/2.46), for which see Cazort Taylor, 1974, no. 40, repr.; and Cazort and Johnston, 1982, no. 96, repr.

4 Cazort Taylor, 1973, p. 162.

5 The model who posed for the Horvitz drawing reappears in studies of a standing male nude with a staff and a seated soldier raising his right hand (ibid., pls. 30–31).

6 All the sheets measure roughly 43 x 29 cm.

7 Analogies of both subject matter and handling may be observed, for example, in a black chalk academy by Piazzetta in the Ashmolean Museum, Oxford, depicting a standing male nude holding a staff seen from the rear. On this drawing, see Parker, 1972, no. 1035, pl. 225.

8 Cazort Taylor, 1973, p. 162.

9 An earlier dating for Monti's academies, one that would preclude the possible influence of Piazzetta, has been proposed by Roli, 1979, p. 74.

■

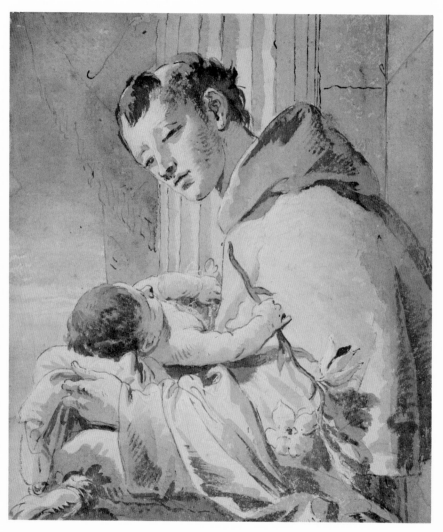

27

GIAMBATTISTA TIEPOLO (Venice 1696–Madrid 1770)

27. *St. Anthony of Padua Holding the Christ Child*
Pen and brown ink, brown wash, heightened with white,
over traces of black chalk,
21.3 x 17.0 cm. (8 3/8 x 6 11/16 in.).

Provenance: [Cailleux, Paris].

S t. Anthony of Padua contemplates the infant Christ, whom
he holds in his arms. The child, depicted at a dramatically foreshortened angle, returns
his gaze and clutches the saint's attribute, a flowering lily, symbol of purity. Obscured
by the flowing sleeve of his habit and the cloth draped over his arm, a ledge supports a
tasseled cushion, visible below St. Anthony's left hand. A fluted column, wall, and
hanging cloth provide the backdrop to the scene. The artist achieves a sense of imme-
diacy through the circumscribed focus on the two tightly interwoven figures, who are
presented at close range, and the half-length format of the composition.

The subject of this drawing relates to a number of devotional works by Giambattista
Tiepolo. The artist represented St. Anthony of Padua with the Christ Child in a canvas
of 1767–69, now in the Museo del Prado, Madrid.[1] A similar intimacy and tenderness
characterize his treatment of a closely allied subject, St. Joseph with the Christ Child,
versions of which exist in the Detroit Institute of Arts,[2] and the church of S. Salvatore in
Bergamo;[3] like the Horvitz drawing, these paintings have as their subject a single male
saint in spiritual communion with the Christ Child. Joseph, Anthony of Padua, and the
infant Christ are represented together in an altarpiece of 1730–35 from the church of S.
Prosdocimo in Padua.[4] Finally, two paintings by Tiepolo—one in the Congregazione di
Carità in Venice,[5] and the other, a smaller version of the subject, in the Fondazione Cini,
Venice [6]—depict St. Anthony with the Virgin and Child. These works illustrate a narra-
tive subject—the saint's vision of the infant Christ—from which the theme taken up in
our drawing is extracted. By omitting the Virgin and all references to the apparitional
nature of the subject, Tiepolo here eschews overt theatricality in favor of restrained
drama, producing a touchingly human characterization of the saint adoring the Christ
Child.[7]

The Horvitz sheet reveals the influence of Giovanni Battista Piazzetta, evident in the
dramatic chiaroscuro, the concern with solidly modeled, sculptured forms, and the
preoccupation with a single, monumental figure in the manner of an academy draw-
ing.[8] Its obvious debt to Piazzetta points to an early date of ca. 1730 for our drawing,
which cannot have been executed later than Tiepolo's frescoes of 1732–33 in the Colleoni
Chapel in Bergamo which are similarly Piazzettesque in character. This date is further

indicated by the clear stylistic analogies between the *St. Anthony of Padua Holding the Christ Child* and a number of drawings produced by the artist between ca. 1725 and 1732 that exhibit the same rich combination of media, elaborate degree of finish, and fully resolved composition. These include two sheets in The Metropolitan Museum of Art, New York, depicting scenes of martyrdom,[9] and a group of loosely related studies divided among various public collections that have been described as "presentation drawings" on the basis of their highly finished aspect.[10] In addition to the comparable handling, iconographic parallels also link the Horvitz study and this group of presentation drawings by Tiepolo, all being exclusively devoted to religious subjects, particularly martyrs and saints.[11]

The function of this sheet can only be surmised. While it is conceivable that the drawing was executed in connection with an unrecorded commission for a private devotional painting, this seems unlikely. More probable is the hypothesis that, like many of Tiepolo's drawings and particularly those that are elaborately finished, it was conceived as an independent work of art. The possibility that the *St. Anthony of Padua Holding the Christ Child* was designed as a model for an etching or engraving should also be considered, however. Though no print of this subject by Giambattista Tiepolo or his son Domenico, who frequently used his father's drawings as models, is known, the fact that many of Tiepolo's so-called presentation drawings of the 1720s were employed for this purpose may indicate that our drawing was intended to serve a similar function.[12] Whatever the case may be, the *St. Anthony* ranks as a distinguished example of a specialized type of drawing produced by Tiepolo during a circumscribed moment of his early career.

■

1 Morassi, 1962, p. 23 and fig. 179. (At the time of that publication, the painting was in a Spanish private collection.) Other than the coincidence of subject matter, our drawing bears no relation to this late work, which some scholars maintain is partly by the hand of Domenico Tiepolo.

2 Ibid., p. 10 and fig. 196.

3 Ibid., p. 4 and fig. 178.

4 Ibid., p. 54 and fig. 148. The painting, which also includes Ss. Francis of Paola, Anne, and Peter of Alcantara, is now in the Galleria dell' Accademia, Venice. See Sciré and Valcanover, 1985, no. 290.

5 Ibid., p. 61.

6 Ibid., p. 62 and fig. 103.

7 St. Anthony and the Christ Child was a favorite theme of Domenico Tiepolo, who produced many drawings of this subject. On this group of studies, see Byam Shaw, 1962, pp. 34–35; and idem, in Byam Shaw and Knox, 1987, under no. 121.

8 On Piazzetta's influence on Tiepolo's early style, see Levey, 1986, pp. 8ff.

9 Invs. 37.165.14 and 37.165.15; see Bean and Griswold, 1990, nos. 187 and 188, repr.

10 On these drawings, see Knox, 1965, pp. 389–97. The group in question includes a *St. Jerome in the Desert* in the Museo Correr, Venice (inv. 4596), and a *St. Anthony Abbot* in the Art Institute of Chicago (inv. 1964.347), both of which are similar in handling to our sheet; ibid., pls. 29 and 28, respectively.

11 Ibid., p. 395.

12 Many of Tiepolo's presentation drawings were engraved by Pietro Monaco in the 1730s and may have been produced specifically for this purpose. On this point, see ibid., pp. 389–97.

■

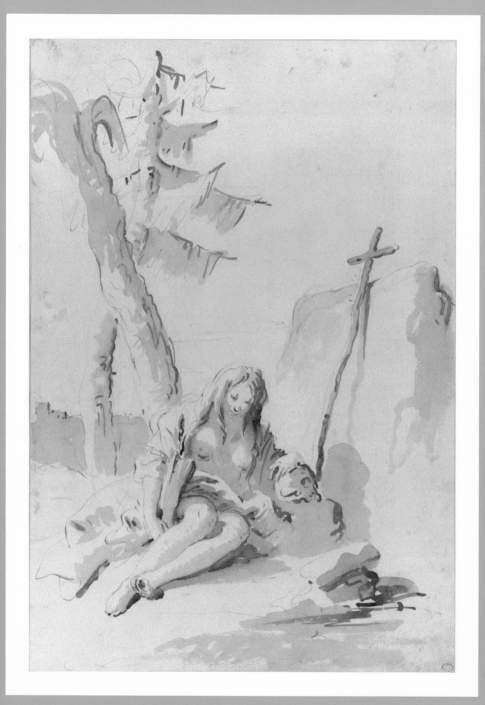

28

28. *The Penitent Magdalene*

Pen and brown ink, brown wash, over black chalk,
43.0 x 29.8 cm. (16 7/8 x 11 11/16 in.).

Provenance: Prince Alexis Orloff; Orloff sale, Paris,
Galerie Georges Petit, April 29-30, 1920, no. 111, repr.;
[Cailleux].

S eated in a rocky landscape, the penitent Magdalene holds a large book with her right arm and rests her left hand on a skull. A tall cross leans on a rock to her left, and behind her rise two trees, evidently a pine and a palm, whose trunks are crossed. The barren setting, skull, and cross, as well as her nudity, denote the saint's penitent aspect, which is further communicated by her downward gaze and contemplative air.

The penitent saint is not an uncommon image in Giambattista Tiepolo's graphic oeuvre, particularly in his early works. The subject of *St. Jerome in the Desert*, for example, was treated in two early drawings, one in the Museo Correr, Venice,[1] and the other in the Museo Civico, Bassano, each of which served as the source for a print.[2] In addition to the analogous subject matter, the Bassano drawing exhibits compositional affinities with our sketch, notably the tall cross to the right behind St. Jerome and the arrangement of trees at the left.

The theme of the penitent Magdalene was taken up in a number of works by Tiepolo in addition to our drawing. Mary Magdalene in the desert is the subject of a sketchy red chalk drawing in the Victoria and Albert Museum, London,[3] and of an early painting, executed around 1723-24, in the Lauro Collection, Naples.[4] As in the Horvitz drawing, the penitent Magdalene in this work has a book and a skull as her principal attributes. However, despite their common subject, our sheet is clearly not connected with the painting, which presents a very different composition—the Magdalene kneels before her book in a rather athletic pose, while behind her appear two large winged angels on a cloud—as well as a more dramatic and spiritually charged treatment of the theme. More relevant for a discussion of *The Penitent Magdalene* is a drawing in the Woodner Collection, New York, depicting the *Assumption of the Magdalene*. Executed in pen and ink with wash, this work shows a closely related subject: the Magdalene spirited by angels from the desert to heaven for her daily spiritual succor, her penitent's skull seen on the ground at the right. Both drawings, it should be noted, originate from the Orloff Album, although the Woodner sheet appears to be later in date.[5]

115

Stylistically, our sheet compares with a number of studies produced by Tiepolo in connection with the ceiling fresco in the *salone* of the Palazzo Clerici, Milan, executed in 1740.[6] The sketchy chalk underdrawing, the soft contours and outline (often rendered with the tip of a brush rather than a pen), and, most distinctively, the broad pools of pale, transparent, golden brown wash that characterize our drawing recur throughout the Palazzo Clerici series, of which the *Seated River God, Nymph with an Oar, and Putto* in The Metropolitan Museum of Art, New York,[7] and the *Zephyrs with a Horse of Apollo* in The Pierpont Morgan Library, New York,[8] are representative examples. Parallels also exist with drawings that may have been executed in connection with Tiepolo's slightly later frescoes in the Palazzo Labia, Venice, such as the study of *Two Women, a Lion, and a Putto on Clouds* in the Metropolitan Museum.[9] Accordingly, the Horvitz *Penitent Magdalene* may be roughly assigned to the period 1740-45. Like many sheets from the Orloff Album—and indeed a good number of drawings produced throughout Tiepolo's career—it seems to be an autonomous invention rather than a preparatory study for a print or painting, hence its more finished quality in comparison with the Palazzo Clerici and Palazzo Labia sketches.

■

1 Inv. 4596.

2 On these drawings, see Knox, 1965, pp. 389-97, esp. 391 and 395; and fig. 10 and pl. 29. On the Bassano drawing and the etching to which it relates, which has also been ascribed to Tiepolo, see Rizzi, 1971, no. 1, the drawing and etching repr.

3 Inv. D.1825.170-1885; Knox, 1975, no. 228r. The subject of this drawing was so identified by Knox in the 1960 edition of this catalogue, but in the second edition, he tentatively suggests that the drawing instead may depict *Rinaldo Abandoning Armida.*

4 Morassi, 1962, p. 32 and fig. 151.

5 On the Woodner *Assumption of the Magdalene*, see New York, 1990, no. 41, repr. The authors of the catalogue date this drawing to the period following Tiepolo's return from Würzburg in 1753, and note the existence of two closely related drawings of the same subject that were also part of the Orloff Collection (Orloff sale, Paris, Galerie Georges Petit, April 29-30, 1920, nos. 112 and 113, repr.). Since the Orloff Album contained drawings from every period of the artist's career, no inference about the date of the Horvitz sheet can be made on the basis of this provenance.

6 For a discussion of this group, now mostly in the Horne Foundation, Florence, The Metropolitan Museum of Art, and The Pierpont Morgan Library, see Bean and Griswold, 1990, under no. 192. Many of the drawings in question may originally have come from a single album and record ideas that were not ultimately executed in fresco. On the Palazzo Clerici decoration, see Levey, 1986, pp. 91-98.

7 Inv. 37.165.32; see Bean and Griswold, 1990, no. 199, repr.

8 Inv. IV, 120; see Knox, 1970, no. 19, repr.

9 Inv. 37.165.37; see Bean and Griswold, 1990, no. 217, repr.

■

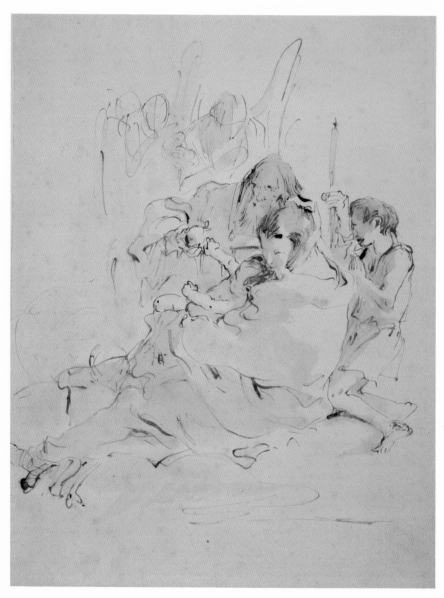

29

29. *The Holy Family with St. John and Angels*
Pen and brown ink, light brown wash,
26.0 x 20.0 cm. (10 1/4 x 7 7/8 in.).

Provenance: Library of the Somasco Convent at S. Maria della Salute, Venice (suppressed 1810); Count Leopoldo Cicognara; Antonio Canova; Monsignor Giovanni Battista Sartori Canova; Francesco Pesaro, Venice; purchased from the latter in 1842 by Colonel Edward Cheney, Badger Hall, Shropshire; Colonel Alfred Capel Cure, Blake Hall, Ongar, Essex; [probably sale, London, Sotheby's, April 29, 1885, lot 1024]; [E. Parsons and Sons, Savile Gallery, 1928]; Richard Owen; [F. A. Drey, London]; Dr. and Mrs. Francis Springell; [Kate de Rothschild-Didier Aaron, 1988].

T he Virgin holds the Christ Child in her arms. Kneeling behind her, his hands clasped in a gesture of reverence, is the young St. John the Baptist. To his right stands St. Joseph, portrayed as an aged, bearded figure. He grasps a walking stick in his left hand and with his right extends an apple toward the Christ Child who playfully reaches for it. Three sketchily rendered forms, apparently winged angels, occupy the space beyond the Holy Family.

The present sheet is one of some seventy-five representations of the subject of the Holy Family originating from the Owen-Savile Album of Tiepolo drawings. This album can be traced back to Giambattista Tiepolo himself, who gave it to the monastic library of the Somasco Convent at S. Maria della Salute in 1762 before his departure from Venice for Madrid.[1] At least sixteen additional variants of the theme not connected with the album are known, the Holy Family ranking among the artist's favorite and most frequently treated subjects.

The Horvitz *Holy Family* is a paradigmatic example of Tiepolo's most appealing graphic style. Here, as in the related versions of the subject, forms are rendered with an open, fluid, and sketchy line. Large areas of delicate, translucent wash suggest volume and shadow. The scribbly, almost shorthand, virtuoso technique imparts to the scene an engaging immediacy, while the tight compression of the figures into a pyramidal composition endows it with an immutable aspect befitting the sacred subject. This combination of intimacy and monumentality is typical of Tiepolo's Holy Family series, as comparison with closely related drawings in the Robert Lehman Collection of the Metro-

politan Museum, New York (fig. 29a),[2] the Art Institute of Chicago,[3] and the Frits Lugt Collection, Fondation Custodia, Paris, serves to illustrate.[4] Like our sheet, the Lehman and Lugt drawings, and possibly the Chicago sheet as well, come from the Owen-Savile Album.

Tiepolo's Holy Family sketches, including the present example, were executed in the later 1750s.[5] These drawings do not relate to paintings by the artist, rather they seem to have been conceived as independent inventions in their own right. As George Knox has remarked in a discussion of the series, these designs "float on the page like exquisite arabesques, and together represent the most magnificently sustained testimony to Giambattista's graphic inventiveness."[6]

■

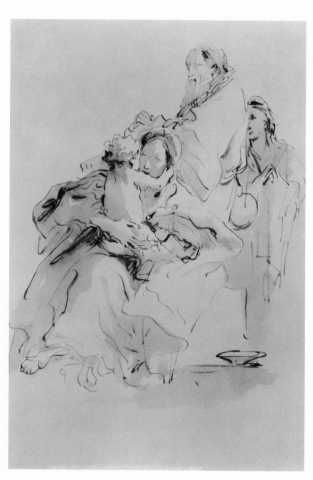

29a. Giambattista Tiepolo, *Holy Family with St. John the Baptist*, New York, The Metropolitan Museum of Art, Robert Lehman Collection

1 On this album, see the discussion by Knox, 1975, pp. 3–9; Byam Shaw and Knox, 1987, under no. 78; and Byam Shaw, 1983, vol. 1, under no. 278.

2 Inv. 1975.1.441; see Byam Shaw and Knox, 1987, no. 93, repr. Another closely related *Holy Family* composition by Tiepolo is in the same collection (inv. 1975.1.442; see Byam Shaw and Knox, 1987, no. 94, repr.).

3 Inv. 168.311; see Joachim and McCullagh, 1979, no. 120 and pl. 128.

4 Inv. 3504; Byam Shaw, 1983, vol. 1, no. 278; vol. 3, pl. 323.

5 Knox, 1975, p. 29.

6 George Knox in Byam Shaw and Knox, 1987, under no. 93.

■

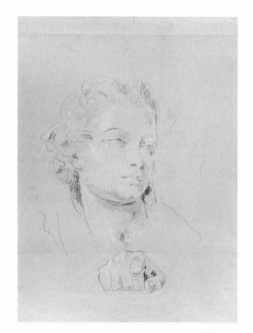

30 recto

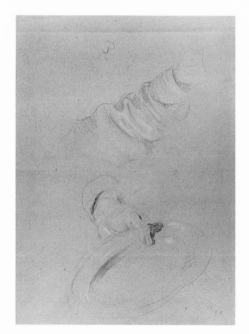

30 verso

GIAMBATTISTA TIEPOLO (Venice 1696-Madrid 1770) or
DOMENICO TIEPOLO (Venice 1727-Venice 1804)

30. *Head of a Young Woman, with a Closed Hand Below*
Verso: *A Raised Arm and a Hand Holding a Dish*
Black chalk, heightened with white, on gray-green paper, 45.0 x 32.2 cm. (17 11/16 x 13 in.).
Inscribed on verso in black chalk at lower right: *GB.*

Provenance: [Colnaghi, London, June-July 1988, no. 36, recto and verso repr.].

E xecuted as isolated and unconnected details, the studies on this double-sided sheet all relate to a painting by Giambattista Tiepolo executed around 1743 representing the *Banquet of Cleopatra*, now in the National Gallery of Victoria, Melbourne (fig. 30a):[1] the head of the woman on the recto is that of the figure of Cleopatra in the painting, whose outstretched left arm is the subject of the uppermost sketch on the verso; the hand on the recto belongs to Lucius Plancus, the bearded figure seated at the right of the table; and the hand and plate on the verso connect with the figure of a servant standing behind Cleopatra. In each case, the sketch on our sheet corresponds precisely to the related detail in the painting.

Questions of authorship immediately arise with chalk drawings of this type—sheets in which specific details of monumental, multifigured painted compositions, such as heads, limbs, or elements of costume, are precisely recorded—originating from the Tiepolo *équipe*.[2] Earlier scholarship tended to assign these drawings *en bloc* to the workshop, and primarily to Giambattista's son Domenico Tiepolo, but a number have recently been ascribed to Giambattista by George Knox, who regards them as working drawings for frescoes and easel paintings.[3] A case in point is a double-sided chalk drawing in a German private collection connected with the Cleopatra frescoes in the Palazzo Labia, Venice, executed in 1544. Depicting details of the jewels and ornaments worn by the main protagonists exactly as they appear in the *Meeting of Anthony and Cleopatra*, the recto has been claimed by Knox as a preparatory study by Giambattista rather than a copy after the fresco by Domenico, to whom the sheet had formerly been ascribed.[4]

Knox's view has not been widely accepted, however, and other scholars, following the opinion of James Byam Shaw, believe that the preparation of such cartoonlike studies is inconsistent with Giambattista's working method and that the bulk of these drawings are copies after his paintings made by his sons Domenico and, later, Lorenzo during their apprenticeships, either as studio exercises, workshop records, or designs for etch-

123

ings.[5] While Knox does ascribe a considerable number of the chalk drawings to Domenico, he argues that, in many instances, these are copies made from Giambattista's own working drawings rather than after the paintings themselves,[6] a point of view that posits *a priori* the one-time existence of such chalk drawings by Giambattista even if these no longer survive. That Domenico closely emulated his father's drawing style in this medium further confounds the thorny issue of attribution of Tiepolo chalk drawings.

The present sheet constitutes a particularly ambiguous case. The painting to which it relates was under way by 1743 and possibly as early as 1740,[7] that is, at the very beginning of, if not before, Domenico's apprenticeship in his father's shop. It had left the artist's studio by March 1744, when Giambattista Tiepolo received payment for the picture.[8] Thus, if the Horvitz drawing is the work of Domenico, it would be one of his earliest exercises of this type. Moreover, if it is a copy after the Melbourne *Banquet of Cleopatra*, it would be the only such known record or copy drawing connected with that painting. This would be a rather anomalous circumstance, since the numbers of similar chalk drawings connected with other large-scale paintings by Giambattista that were the subject of such chalk drawings, whatever their function, are more extensive.[9]

Despite the lack of consensus for this point of view, Knox's admonition that "drawings associated with the work of Giambattista have a *prima facie* right to be regarded as original studies by him, and should be so regarded unless there is clear evidence to the contrary,"[10] deserves to be weighed and cautions against a precipitous dismissal of our sheet as a copy by Domenico. The old inscription on the verso, *GB*, which records an early attribution to Giambattista, must also be taken into account when considering the question of the drawing's authorship.[11]

Bearing these caveats in mind, it is nonetheless the opinion of the present author that our sheet is likely to be by the young Domenico. The rapid, sketchy quality of the chalk suggests not virtuosity, as is the case with autograph drawings of this type by Giambattista, but a tentativeness, even timidity, indicative instead of the hand of a young artist. Moreover, it hardly seems likely that Giambattista Tiepolo would have felt the need to study in detail a minor passage of the Cleopatra composition such as the empty platter recorded on the verso. The hand clutching this implement is awkwardly rendered, with the thumb illogically joined to the palm more in the manner of a finger—another indication that the sketch is the work of a pupil attempting to learn the mastery of form by studying an available model. Lacking the forcefulness and incisive quality characteristic of Giambattista's handling of chalk—witnessed, for example, in his series of drawings after portrait busts by the Venetian sixteenth-century sculptor Alessandro Vittoria[12]—the sheet of studies exhibits a delicacy of line and less plastic, almost ornamental, treatment of forms that signal a different artistic sensibility.

If it is the work of Domenico Tiepolo, as suggested here, the Horvitz sheet can be securely regarded as one of the earliest drawings in the graphic oeuvre of this prolific and engaging draftsman.

■

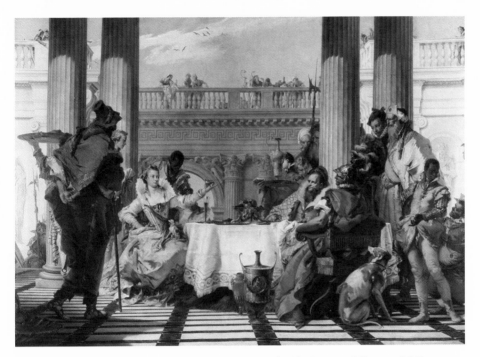

30a. Giambattista Tiepolo, *The Banquet of Cleopatra*, Melbourne, National Gallery of Victoria

1 On this painting, see Morassi, 1955, p. 21 and fig. 28; Morassi, 1962, p. 23; and Levey, 1986, pp. 130ff. and pl. 118. The drawing clearly relates to the Melbourne painting rather than the so-called *modello* in the Musée Cognac-Jay, Paris; Levey, 1986, pl. 119.

2 The problem of Tiepolo chalk drawings has been studied at length by Knox, 1980.

3 On the inception and use of chalk drawings in Tiepolo's working method, see Knox, 1980, vol. 1, pp. 3ff. The author advances the revisionist thesis that "as each section [of a painting] came under consideration, a series of detailed studies was made of important figures, heads, and even arms and hands if these were important elements in the design, and these are our chalk drawings" (p. 5).

4 Knox, 1971, no. 170, repr. The verso of the drawing records a detail of the Palazzo Labia *Banquet of Cleopatra*. The argument advanced by Knox in support of his attribution of the drawing to Giambattista in my opinion is not persuasive.

5 Byam Shaw, 1962; see esp. chapter 2, pp. 21-30. Byam Shaw has recently recapitulated this point of view in Byam Shaw and Knox, 1987, p. 135.

6 Knox, 1980, vol. 1, pp. xiii-xiv.

7 Levey, 1986, p. 131.

8 Knox, 1975, p. 15; Levey, 1986, p. 131.

9 Two etchings by Domenico from the 1770 edition of the *Raccolta di teste* derive from figures in the Melbourne *Banquet of Cleopatra* and are presumed to be based on drawings by him made after the painting, but these are now lost. See Rizzi, 1971, nos. 208 and 209. In any event, the number of chalk drawings associated with this picture remains small.

10 Knox, 1980, vol. 1, p. xiii.

11 The verso of a chalk drawing in the Frits Lugt Collection, Fondation Custodia, Paris (inv. 9053) is similarly inscribed *GB* [for Giambattista], albeit, apparently, in a different hand. Formerly ascribed to Domenico, this drawing has now been accepted as Giambattista, to whom it was recently attributed by James Byam Shaw. (Byam Shaw, 1983, vol. 1, no. 277, and vol. 3, pls. 326 and 327. The inscription and its meaning are discussed.)

12 Giambattista executed a number of drawings after Vittoria's busts of Giulio Contarini and Palma Giovane, for which see Maison, 1968, pp. 392-94; and Knox and Martin, 1987, pp. 158-63, as well as a drawing after a sculpture by Guido Reni, which he presumably knew through a cast. On the latter see Byam Shaw, 1983, vol. 1, under no. 277.

■

Gesuiti in Venezia

31

128

Giovanni Antonio Canal,
called C A N A L E T T O (Venice 1697–Venice 1768)

31. *The Gesuiti in Venice*
Pen and brown ink, brown and gray wash,
31.5 x 26.0 cm. (12 3/8 x 10 1/4 in.).
Inscribed in pen and brown ink at lower margin:
Giesuiti in Venezia.

Provenance: Pierre-Jean Mariette (Lugt 2097); Mariette
sale, Paris, Basan, November 15, 1775, et seq., part of no.
274, "La Vue de la Place des Jésuites à Venise, où l'Église
s'y voit lattéralement, ornée de plusieurs petites figures,
à la plume, & lavée d'encre de la Chine"; Randon de
Boisset; sale, London, Christie's, June 19, 1840, no. 451;
Dr. H. Wellesley; sale, London, Sotheby's, June 25, 1866,
et seq., no. 684; Thomas Poynder, Hartham Park,
Chippenham, Wiltshire; Sir John Dickson-Poynder, his
nephew, later Lord Islington; sale, London, Christie's,
December 13, 1984, no. 75, repr.

A s the inscription in Canaletto's hand at the bottom of the
sheet indicates, this study depicts the piazza, or *campo*, of the church of the Gesuiti in
Venice. The drawing is a topographically literal record of this Venetian urban space in
the eighteenth century. The church's baroque facade, which dominates the right side of
the composition, is balanced at the left by an open, cloud-streaked sky. Facing the
church is a row of simple exteriors, including the Hospital and the Oratory of the
Crociferi. A polygonal well occupies the center of the open piazza, but it is the imposing
ecclesiastical structure, which casts a deep shadow at the far right, that dominates the
space. Receding orthogonally to a point in the distant background, the converging rows
of facades—dwellings and shops on the left, church on the right—open onto a canal. A
number of diminutive figures in various attitudes perambulate the space. These are the
faceless, anonymous Venetian citizens—in this case, members of the bourgeoisie and
lower classes—who populate Canaletto's compositions, contributing to the panoramic
aspect of the overall scene but evincing no individual characterization.

A prolific draftsman, Canaletto produced numerous drawings of both real and fanciful
or imaginary views—*vedute prese da i luoghi* and *vedute ideate*, as the artist himself called
them[1]—of Venice, Padua, London, Rome, and the rustic Italian countryside dotted with
farmhouses or dominated by crumbling classical ruins. In spirit and subject matter, as
well as the careful attention to and precise rendering of incidental details, these draw-

ings are the graphic counterparts of his paintings. While some of Canaletto's drawings may be securely connected with paintings by the artist, many were executed as independent exercises, and still others as preparatory designs for etchings.

The present sheet has been plausibly connected with a painting by Canaletto depicting the *Campo dei Gesuiti*.[2] Now in an Italian private collection, this canvas was part of a series of twenty-one Venetian views painted between 1730 and 1735.[3] The drawing, which should also be dated to this period, corresponds to the right central section of the painting, although slight differences in the number and disposition of figures and in the profiles of the facades at the left may be observed.

The Horvitz sheet is a distinguished example of one type of *veduta* drawing for which Canaletto is known—the highly finished study, executed in precise, controlled pen line and accented with painterly areas of wash, wherein even minute details are carefully and accurately observed. Drawings of this type coexist in his large graphic oeuvre with those executed in a freer and more spontaneous manner. Among the former type, our study may be compared with a drawing in the Kupferstichkabinett, Berlin, depicting rustic houses in Padua,[4] and a *Lagoon Capriccio* in The Metropolitan Museum of Art, New York,[5] both of which exhibit a comparable handling. These drawings by Canaletto impress above all for their technical skill and virtuosity. The element of invention is not always immediately evident beneath the apparent effortlessness of such individual graphic displays, but seen as a whole, Canaletto's corpus of drawings amply reveals the boundless pictorial imagination that the artist brought to his chosen idiom.[6]

■

1 The frontispiece to a series of Canaletto's *vedute* etchings, composed by the artist himself, so describes the two types of images. On this point, see Parker, 1948, p. 25. As Parker defines it, Canaletto's own version of the quintessential eighteenth-century Venetian subject, the *capriccio*, is essentially a merging of these two distinctive types of *vedute*.

2 Constable-Links, 1989, no. 276.

3 For a discussion of this series, see ibid., under no. 188.

4 Ibid., 1989, no. 691; Baetjer and Links, 1989, no. 105. Like the present drawing, the Berlin sheet is vertical in format and has a band with an inscription at the lower edge.

5 Inv. 43.61; see Baetjer and Links, 1989, no. 121, repr.; Bean and Griswold, 1990, no. 22, repr.

6 For a discussion of these points, see Alessandro Bettagno, "Fantasy and Reality in Canaletto's Drawings," in Baetjer and Links, 1989, pp. 41–51.

■

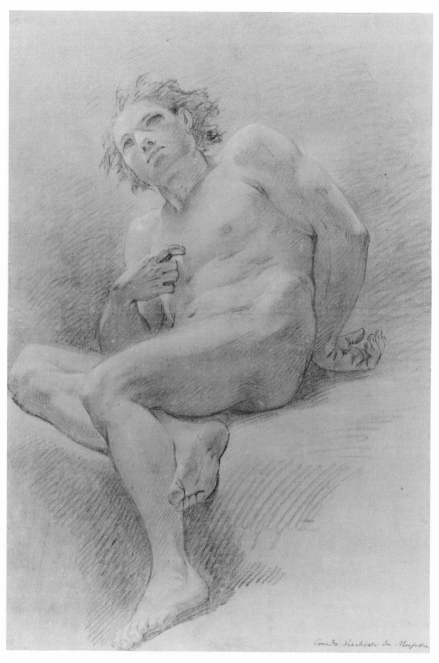

Corrado Giachinto da Morfetta

32

132

32. *A Seated Male Nude; Study for "The Founding of the Trinitarian Order"*

Black chalk, heightened with white on ochre prepared paper, laid down, 54.5 x 37.1 cm. (21 7/16 x 14 9/16 in.). Inscribed in pen and brown ink at lower right: *Corado Giachinto da Morfetta*; in pen and black ink on mount at lower right: *21*; in pen and blue ink at lower right of old mount: *Husen* [?] *Weiss 172.*

Provenance: Unidentified collector's mark on mount (coat of arms in an oval, not in Lugt); [Colnaghi, New York, July 1988, no. 34, repr.].

A monumental, youthful, seated nude male figure gazes up to the left. His right leg is hooked under his left knee and his left arm is bent behind his back. He points to his chest with his right hand. Although he appears seated, only a vague support is indicated, and no spatial setting is rendered; instead the sheet around the figure is filled in with bold hatching. In its focus on a single male nude and the obvious recourse to a live model, the drawing has the character of an academy.

Executed by Corrado Giaquinto, a leading exponent of the Roman rococo who spent much of his career in Naples and was also active in Turin and Madrid, the Horvitz drawing is a preparatory study for an important altarpiece representing *The Founding of the Trinitarian Order* (fig. 32a). The painting, which was commissioned for the high altar of SS. Trinità degli Spagnoli in Rome, was executed by Giaquinto in 1742–43, shortly after the building of the church began.[1] The figure in our study appears in identical form at the lower right of the altarpiece as a bound captive, seated on a rocky ledge before an athletic, striding angel who holds the chain that binds him. His posture explains the model's gesture in the drawing: the captive clutches his chain to his chest as he gazes heavenward imploring divine intervention for his release. Together with the angel, this monumental, twisting nude is the largest figure in the altarpiece. Symbolizing the mission of the Trinitarian Order, which was dedicated to the ransoming and redemption of captives and slaves,[2] he is also the most important iconographically. That the artist attached particular significance to this figure in the overall composition is attested by the Horvitz study, where the musculature of the nude form is carefully transcribed and the nuances of light and shadow deftly captured. Giaquinto evidently regarded this invention with satisfaction because the figure was translated literally in the painting without the slightest modification.

133

Giaquinto produced a group of academies—studies of single, nude figures drawn from life—that are similar in character to the present sheet.[3] He also executed numerous drawings of single figures in connection with his monumental narrative compositions. These include studies of St. Nicholas in the Martin von Wagner Museum, Würzburg;[4] a seated female figure, possibly St. Catherine, in the Museo del Prado, Madrid;[5] a St. Dominick kneeling that recently appeared on the art market;[6] and a nude figure in the Museo Nazionale di San Martino, Naples.[7] The Naples study is particularly close to the present sheet, both in subject matter and handling, exhibiting the same long, even, hatched strokes. Not only the type of drawing, but also the graphic style are typical of Giaquinto's manner as a draftsman. The distinctive facial type of the figure in the Horvitz sheet—the shadowed, slit eyes and broad jaw with the chin seen from below—as well as the hard, reinforced contour lines, and the above-noted predilection for bold, vigorous hatching, recur throughout his graphic oeuvre, these characteristics all seen, for example, in a study for the *Birth of the Virgin*.[8]

In addition to this *Seated Male Nude*, a composition study by Giaquinto for the SS. Trinità degli Spagnoli altarpiece exists.[9] Both may be dated ca. 1742.

32a. Corrado Giaquinto, *The Founding of the Trinitarian Order*, Rome, S.S. Trinità degli Spagnoli

134

1 On this altarpiece, which remains *in situ*, see D'Orsi, 1958, pp. 62–63 and fig. 61.

2 On the founding and mission of the Trinitarian Order, see Jameson, 1866, pp. 257-61. With the Holy Trinity above and two bound captives below, one a Moor seen from the rear behind the angel and the other a Christian, the large nude in the foreground, Giaquinto's altarpiece is an allegorical visualization of the mission of the Trinitarian Order, and also a symbolic depiction of its founding. According to legend, Pope Innocent III experienced a vision in which an angel with two slaves, a Moor and a Christian (symbolic of the order's equal concern for captives of all creeds), appeared to him. This vision led him to approve the foundation of the new order, which he decreed should be called the Order of the Most Holy Trinity for the Redemption of Captives. The figure seen behind the Christian captive is St. John de Matha, founder of the Trinitarians.

3 Five drawings of this type, each depicting a male nude and clearly based on a live model, are in the Spadavecchia Collection in Molfetta. See Amato, 1971, figs. 18–21. These academies have the character of studio exercises and, unlike our drawing, do not appear to be preparatory studies for a painting.

4 Inv. 7435; see Vitzhum, 1970, p. 86 and pl. 36. This drawing is a study for the St. Nicholas cycle in the church of S. Nicola dei Lorensi in Rome, executed in 1746.

5 Inv. F.D. 300; see Perez Sanchez, 1978, no. 78, repr. Executed during the artist's Spanish period (1753–1762), this drawing dates ca. 1760–62.

6 See Colnaghi, London, June–July 1984, no. 37, repr. Like the Horvitz drawing, this study is executed on washed paper.

7 Inv. 20436 recto; see Videtta, 1962–67, part 2, 1965, p. 176 and fig. 23. This study is part of a large corpus of drawings by Giaquinto preserved in the Museo di San Martino, for which see the four-part study by idem, 1962–67.

8 Sotheby's, London, July 4, 1975, no. 147, repr. This drawing is connected with a painting of this subject in the Pisa Cathedral, which dates ca. 1751–52.

9 Colnaghi, London, 1983, no. 36, repr. The drawing is now in a German private collection.

FRANCESCO FONTEBASSO (Venice 1707–Venice 1769)

33. *Two Studies of the Head of a Young Boy*
Black chalk, 42.8 x 28.5 cm. (16 13/16 x 11 3/16 in.).

Provenance: Sale, London, Christie's, July 4, 1984, no. 56, repr.; [Colnaghi].

T he head of a young boy is represented twice on the sheet, in right profile above and three-quarter face below. The two studies portray the same sitter, as the curling hair, full lips, small, slightly receding chin, and straight, sloping nose common to both confirm. The immediacy, informality, and engaging naturalism of these sketches indicate that they were drawn from life.

A compatriot and near contemporary of Giambattista Tiepolo, and a talented purveyor of monumental altarpieces and grand decorative cycles, Francesco Fontebasso is one of the most appealing Venetian draftsmen of the eighteenth century. Like Tiepolo, Fontebasso produced highly finished, pictorially rich composition drawings as works of art in their own right, and also executed throughout his career pen drawings of single figures or groups of figures, many of which are independent graphic exercises not connected with paintings or etchings by the artist.[1] Reflecting the influence of Fontebasso's first master Sebastiano Ricci, these typically exhibit a rather hard line and short, choppy hatching.

Although less numerous than his pen drawings, chalk studies by Fontebasso akin to the present example are also known. These include a closely related sheet with similar studies of the head of a youth seen in three different profiles (fig. 33a),[2] and a sheet of studies of hands.[3] Drawn from life and executed in chalk, these drawings and the Horvitz sheet have similar dimensions, and all appeared on the art market at the same time; it is possible, then, that they are from a common group, possibly a sketchbook or album.

Fontebasso's graphic oeuvre includes a number of drawings of groups of heads, a representative example of which is a sheet in the Musée du Louvre, Paris.[4] Reminiscent of similar "bouquets" of heads by Bolognese artists such as Donato Creti and the Gandolfi,[5] these drawings by Fontebasso, executed primarily in pen and ink, differ from the present example in depicting imaginary or idealized figures, often in fanciful head-dresses, rather than informal portrait heads. In addition, some of the heads in these *studi di teste* appear to be copied from other sources.[6] Our sheet, in contrast, has the character of a life drawing and is possibly a preparatory study. Although it may not at the present time be securely connected with a painting by Fontebasso, it is worth noting

1 3 7

that the two heads find suggestive parallels in a genre painting by the artist of two boys playing, one seen in profile and the other with his head slightly bowed and turned to the right as in our drawing.[7] It is not unlikely that the artist would have executed such preparatory studies from life when painting this type of scene.

33a. Francesco Fontebasso, *Studies of the Head of a Young Boy,* formerly London, art market

1 On Fontebasso as a draftsman, see Byam Shaw, 1954, pp. 317–25. On the artist in general, see Magrini, 1988.

2 Christie's, London, July 4, 1984, no. 55, repr. Misidentified in the catalogue as the head of a young girl, the three studies on this sheet clearly represent a boy, possibly the same subject treated in our drawing.

3 Mia N. Weiner, *Old Master Drawings*, New York, November 1985, repr. (no number). Another sheet by Fontebasso containing similar studies of hands was recently on the art market (Colnaghi, London, 1978, no. 57, repr.).

4 Inv. 18266; see Méjanès, 1983, no. 52, repr. Drawings of this type have appeared at auction in the last few decades (London, Sotheby's, April 9, 1970, no. 47; London, Sotheby's, November 25, 1971, no. 162, repr.).

5 A group of these drawings by Gaetano Gandolfi is in the Fondazione Cini, Venice, and another example by Mauro Gandolfi is in the National Gallery of Canada, Ottawa. See respectively Cazort, 1987, nos. 39–42, repr.; and Washington, 1988, no. 26, repr. For a general discussion of this type of drawing, and its popularity in north Italy in the settecento, see Byam Shaw, 1983, vol. 1, under no. 379.

6 This point has been made with regard to the Louvre drawing mentioned above (note 4); Méjanès, 1983, under no. 52.

7 Magrini, 1988, fig. 86. This painting, present whereabouts unknown, was formerly in a Venetian private collection. Similar types appear in other paintings by the artist, for example, the acolyte in an altarpiece depicting *St. Lorenzo Giustiniani, St. Leonardo, and other Saints* in S. Salvador, Venice (ibid., fig. 24), although no direct relation to the Horvitz drawing exists.

■

34

FRANCESCO GUARDI (Venice 1712-Venice 1793)

34. *Woman Wrestling a Lion*
Pen and brown ink, heightened with white,
17.0 x 12.7 cm. (6 11/16 x 5 in.).
Verso: Sketch of a head.
Inscribed in graphite on verso: *francesco guardi.*

Provenance: Henry Oppenheimer, London; sale,
London, Christie's, July 10, 1936, no. 90a; Bittner; Janos
Scholz; E. V. Thaw; Private Collection, Paris.

A female warrior in a plumed helmet strides toward a rear-
ing lion and grasps his mane. The lion, whose long claws are emphasized, reaches
toward her with his right front paw but is vanquished by her superior strength.

This engaging drawing by Francesco Guardi, datable to the 1780s, epitomizes the ex-
tremely loose and scribbly manner of the artist's late graphic style.[1] Evincing something
of the character of the *macchiette*—small scale, shorthand, and often slight sketches of
stock figures—that Guardi produced throughout his career, the present sheet differs
from these in being an independent invention rather than a design to be adapted for
painted compositions.[2] Drawings of this type, while not unknown in Guardi's graphic
oeuvre, are far outnumbered by his *vedute, capricci,* and *macchiette.* The unusual subject
matter of our study has led to the conjecture that the image is an allegory of Courage.[3] It
is more likely, however, that the sketch is simply a fanciful design with no particular
symbolic meaning.

A closely related sketch by Guardi of the same subject, likewise an independent inven-
tion unrelated to a painting, is in the Janos Scholz Collection at The Pierpont Morgan
Library, New York (fig. 34a).[4] Given its similar theme, a third drawing by the artist, also
in the Morgan Library, which depicts a seated Turk with a leopard, should perhaps be
connected with the two studies of a woman wrestling a lion.[5] The pricked contours of
the seated Turk, which imply that the design was used in a decorative context—possi-
bly a carriage door, wall painting, or furniture suite—as well as the exotic oriental
theme, distinguish it from the other two sheets. But it is worth noting nonetheless that
all three drawings at one time belonged to Janos Scholz, a circumstance suggesting that
they formerly comprised a group which was preserved intact at the time they entered
that collection.

■

34a. Francesco Guardi, *Woman Taming a Lion,* New York, The Pierpont Morgan Library, Janos Scholz Collection

1 The drawing is dated 1780–85 by Morassi, 1975, no. 257, fig. 260.

2 For this definition and characterization of the *macchiette,* see Byam Shaw, 1951, pp. 28–29.

3 Paris, 1971, no. 109.

4 Inv. 1893.35; see Morassi, 1975, no. 258, fig. 259.

5 Janos Scholz Collection, The Pierpont Morgan Library, inv. 1974.33. See Bean and Stampfle, 1971, no. 214, repr.; Morassi, 1975, no. 259, fig. 261.

■

35

35. *A Centaur Lifts a Young Punchinello*

Pen and brown ink, brown and gold wash, over traces of
black chalk, 35.9 x 47.7 cm. (14 1/8 x 18 3/4 in.).
Inscribed in brown ink at upper left: *63*.

Provenance: Sale, London, Sotheby's, July 6, 1920, no. 41;
[Colnaghi]; Richard Owen, Paris; Jean Cailleux, Paris
(according to Gealt); sale, New York, Sotheby's,
January 16, 1985, no. 126.

A centaur, reclining on the ground with his abandoned pipes beside him, grabs a young Punchinello at the waist and lifts him in the air. A young girl and an adult Punchinello, who anxiously extends his outstretched hands in an attempt to rescue his unfortunate relation, witness this encounter. The action is set in a walled garden dominated by a round stone well. A pig sleeping beside a trough at the left, oblivious to the activity taking place behind him, completes the scene.

This sheet forms part of the celebrated series of 104 drawings by Domenico Tiepolo depicting the life of the commedia dell'arte character Punchinello.[1] Entitled by the artist *Divertimento per li ragazzi*, these drawings were executed around 1800, presumably as an amusement for neighborhood children.[2] Not based on a text or culled from a single narrative,[3] the series includes many episodes that are likely to be Domenico's own inventions, the artist drawing inspiration from a number of popular sources such as contemporary theater, carnival celebrations, scenes from everyday life, and the Bible.[4]

The subjects depicted in the *Divertimento*, which reprise and enlarge the imagery of the Punchinello frescoes from the Villa Tiepolo at Zianigo,[5] may be loosely classified according to five categories: Punchinello's Ancestry and Youth, his Labors and Occupations, his Adventures, his Social and Official Life, and his Last Illness and Death.[6] Our drawing belongs to the group illustrating Punchinello's adventures.

The theme of Punchinelli encountering centaurs was treated by Domenico in five of the *Divertimento* drawings.[7] Three of these, including the present sheet, depict a Punchinello apprehended by a centaur,[8] while the other two present Punchinelli as spectators to the amorous dalliances of centaurs and nymphs. As Marcia Vetrocq has noted, the encounter between the centaur and Punchinello portrayed in our drawing has a more playful character than the other two scenes, where the hapless Punchinello is actually abducted.[9] Here, the centaur does not attempt to flee with the young Punchinello—such action

would be prevented by the wall in any event—but appears to be playing with him, albeit in a less than gentle fashion.

It has been widely remarked that in the Punchinello drawings Domenico Tiepolo borrowed many motifs from his own earlier compositions—the scenes from contemporary life series of 1791, the satyrs and centaurs series, animal drawings, and biblical narratives—as well as from works of his father, Giambattista Tiepolo.[10] The Horvitz sheet epitomizes this practice of the elderly Domenico. The arrangement of the central group of the centaur and Punchinello repeats that of a centaur and a young satyr in a drawing by the artist in The Metropolitan Museum of Art, New York;[11] the garden setting of this scene finds close parallels in a sheet by Domenico in the Art Museum, Princeton University, which in turn may derive from a study by Giambattista in the Museum Boymans-van Beuningen, Rotterdam;[12] and the sleeping sow appeared in earlier drawings by the artist preserved in the Musée Bonnat, Bayonne,[13] and the Robert Lehman Collection of the Metropolitan Museum.[14]

Domenico Tiepolo was not the first artist to treat Punchinello's antics and foibles—Giambattista Tiepolo had portrayed this commedia dell'arte character in numerous sketches as well as two of his *Scherzi di fantasia* etchings[15]—but it is in the *Divertimento per li ragazzi* that the spirit of this comic hero is most memorably captured.

∎

1 On the Punchinello series, see Gealt, 1986; Gealt and Vetrocq, 1979; Byam Shaw, 1962, pp. 52-59; and the summary by James Byam Shaw in Byam Shaw and Knox, 1987, pp. 202-3.

2 This explanation of the Punchinello series proposed by Byam Shaw, 1962, p. 59, has been generally accepted. Domenico's frontispiece gives this title and records that the series was comprised of 104 sheets. This title page drawing is in the Nelson-Atkins Museum of Art, Kansas City (inv. 32-193/9). See Ward and Weil, 1989, p. 41, repr.

3 Byam Shaw, 1962, p. 54.

4 Gealt and Vetrocq, 1979, p. 28; Gealt, 1986, p. 18.

5 The frescoes have been detached and are now in the Ca' Rezzonico, Venice; see Pedrocco, 1988, pp. 48-57.

6 Byam Shaw, 1962, p. 56.

7 Gealt and Vetrocq, 1979, no. 39, repr.; S61-64, repr.

8 Ibid., under S61.

9 Ibid., under S61.

10 For a discussion of this point vis-à-vis the Punchinello series, see Gealt, 1986, p. 18. On this practice in Domenico's career in general, see the discussion by Byam Shaw in Byam Shaw and Knox, 1987, p. 136.

11 Inv. 37.165.54; see Bean and Griswold, 1990, no. 248, repr.

12 Art Museum, Princeton University, inv. 48.898; Museum Boymans-van Beuningen, Rotterdam, inv. I.45. These correspondences were noted by Gealt and Vetrocq, 1979, under S61. For the Princeton drawing, see Gibbons, 1977, no. 669, repr.

13 Inv. 1307; see Bean, 1960, no. 162, repr.

14 Inv. 1975.1.518; see Byam Shaw and Knox, 1987, no. 146, repr.

15 On these and other earlier depictions of the Punchinello theme, see Gealt and Vetrocq, 1979, pp. 26-28; Gealt, 1986, p. 14; and Knox, 1984, pp. 439-46. An example of Giambattista's treatment of the subject is a double-sided drawing in the Robert Lehman Collection, Metropolitan Museum of Art, depicting a group of Punchinelli seated (inv. 1975.1.438); Byam Shaw and Knox, 1987, no. 96, repr.

■

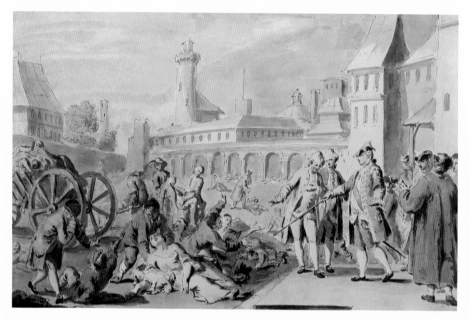

36

36. *A Group of Italian Physicians Escorted by Count Gregorii Orlov Visiting Plague Victims in Moscow*
Pen and black ink, watercolor; laid down,
32.1 x 49.4 cm. (12 5/8 x 19 7/16 in.).

Provenance: Trivulzio Collection Milan (according to label on old mount); [Colnaghi, New York, May–June 1990, no. 34, repr.].

A ccompanied by a retinue of Italian doctors garbed in aristocratic costume, Count Gregorii Orlov, distinguished by his blue sash of honor and sword, stands in the right foreground. He points his walking stick at a group of plague victims lying on the ground before him, some of whom have already succumbed to the pestilence. The middle ground is littered with the recumbent forms of other afflicted sufferers. To the left is a cart loaded with corpses, toward which two bodies are being transported. The arcade and dome glimpsed in the background are suggestive less of Moscow, where this episode took place, than of a generic Italian city, although a northern venue is perhaps signaled by the decidedly non-Italian structure rising behind the wall to the left.

Part of a series, of which two others have recently appeared on the art market, this drawing by Pietro Antonio Novelli illustrates the deeds of a group of Italian physicians whom Catherine the Great summoned to Moscow during a severe plague in 1770–71.[1] In all three sheets, the physicians are escorted by Catherine's favorite, Count Gregorii Orlov, wearing his sword and blue sash.[2] The two related compositions referred to above, which illustrate respectively the reunion of the physicians and surgeons before their return to Italy, and their taking leave of Moscow, include legends in Novelli's hand in the lower borders describing the events depicted, as well as the artist's initials, *PAN,* in the lower left corner. From this evidence, it may be inferred that the present drawing also originally carried an explanatory annotation in Novelli's hand together with the artist's monogram, and that the lower edge of the sheet has been trimmed. The imagery of the Horvitz drawing would be difficult to identify were it not for its obvious connection with the two other compositions whose subject matter is narrated in the respective inscriptions.

A compatriot and exact contemporary of Domenico Tiepolo, Novelli is a less familiar artist. The major source of information concerning his activity is Novelli's own account, published some thirty years after his death.[3] From his *Memorie,* we learn that the artist

was awarded an important commission in 1772 by Catherine the Great for a pendant to a painting by Pompeo Battoni, for which he chose the theme of Creusa and Aeneas.[4] Given the connection with the Russian empress, and the fact that the events illustrated in the drawings under discussion occurred the previous year, it is quite possible that this series was executed at about the same time.

Novelli, who was highly successful as a decorative painter, carried out a number of frescoes and ceiling paintings for wealthy private patrons in Venice and the Veneto. He was also active in the field of printmaking, providing an extensive series of designs for an illustrated edition of Tasso's *Gerusalemme liberata,* published in Venice in 1760. Throughout his life, the artist produced pen drawings, many of single figures, executed in a graceful, incisive line, often with even, parallel hatching. His elegant, linear style as a draftsman may reflect Novelli's role as a designer of prints. Particularly distinctive are his facial types, characterized by small and doll-like features with rosebud mouths and impassive expressions. Many of Novelli's drawings appear to be not connected with painted compositions but independent sketches, a number of these being loose copies of sculptural models.[5] Others were executed as designs for printed ephemera such as trade cards, a practice in which many eighteenth-century Venetian artists, Giovanni Battista Piazzetta among them, engaged.[6]

The function of the present drawing is unknown. Highly unusual in Novelli's graphic oeuvre are the striking use of watercolor, which invests the composition with a pictorial richness and finished quality, the large size of the sheet, and the treatment of a multifigured, narrative subject. While this drawing and the related compositions may have been executed as autonomous works, as has recently been suggested,[7] it is also possible that the series was intended to be engraved or etched, possibly for publication in a book. The accompanying inscriptions and artist's initials at the lower edge of the two related sheets conform to the conventional format for narrative prints, which typically contain text in a panel below the image. The fact that Novelli frequently provided designs for prints should also be taken into account when weighing this hypothesis. No images after these drawings are known, however; nor is the present sheet marked for transfer in any way. Thus, even if this were its intended function, the series appears never to have been reproduced.

In the depiction of events from contemporary history, the present study relates thematically to a group of drawings by the artist in the Pinacoteca del Seminario Patriarcale, Venice, entitled *Fasti del secolo;* perhaps our design and the other drawings of Russian subjects were originally produced as part of this or a similar series recording important events of Novelli's own day.[8]

■

1 Drouot-Richelieu, *Dessins Anciens,* Paris, March 14, 1990, nos. 120–21. I am grateful to Stephen Ongpin for this information.

2 The identification of the main figure as Count Gregorii Orlov was proposed in Colnaghi, *Master Drawings,* New York, May–June 1990, under no. 34.

3 Novelli, 1834. On Novelli, see also Voltolina, 1932, pp. 101–17.

4 Novelli, 1834, pp. 19–20. Earlier in his career, the artist had painted a ceiling for a Russian patron, Captain Sordikoff, which depicted *Nobility Protecting the Sciences* (ibid., p. 18).

5 On Novelli's drawings after sculptural models—a favorite source was Pietro Tacca's monument to the Medici grand duke Ferdinando I in Livorno, individual figures of which the artist evidently knew through casts—see the discussion of the sheet in The Metropolitan Museum of Art, New York, in Bean and Griswold, 1990, pp. 154–55, under no. 145.

6 Examples are in the Robert Lehman Collection of the Metropolitan Museum (inv. 1975.1.387), and the Frits Lugt Collection, Fondation Custodia, Paris (inv. 1981-T.10). See respectively Byam Shaw and Knox, 1987, no. 62, repr.; and Byam Shaw, 1983, vol. 1, no. 305; vol. 3, pl. 351.

7 Colnaghi, 1990, under no. 34.

8 This series, which I have been unable to find reproduced, is noted by Voltolina, 1932, p. 115.

■

PIETRO GIACOMO PALMIERI
(Bologna 1737–Turin 1804)

37. *Two Figures in a Landscape*
Red chalk, 45.8 x 60.9 cm. (18 x 23 15/16 in.).

Provenance: Sale, London, Christie's, July 5, 1983,
no. 239 (unattributed); [Paul J. Weis, New York, 1990].

Two figures, one lying on the ground, the other seated with a book, appear in a rocky landscape beside a lake. They are accompanied by a dog and two cows. A small boat with three figures is at the right; a castle looms in the distance. A monumental tree rises above the figures at the left, towering over a large broken branch and stump, and other trees dot the landscape.

Active in Bologna, Parma, Paris, and Turin, Pietro Palmieri is best known for his witty, inventive, and technically accomplished trompe-l'oeil drawings.[1] He evidently produced these in some number although relatively few survive, notable examples being preserved in the Biblioteca Reale, Turin,[2] and The Metropolitan Museum of Art, New York.[3] In these trompe-l'oeil compositions, Palmieri's relatively faithful copies of prints, drawings, and musical scores are enlivened by the whimsically curled edges and cast shadows of the feigned sheets. Some of the images recorded in these drawings are Palmieri's own inventions, while others are readily identifiable prints by Stefano della Bella, Jacques Callot, and several seventeenth-century Dutch artists. His familiarity with a broad range of graphic sources—Palmieri acted as an advisor in the collecting of prints and drawings at the Savoy court in Turin—is reflected in these studies.

Palmieri also executed landscape drawings—a number of these were reproduced in a volume of engravings entitled *Il Libro dei paessaggi,* published in 1760[4]—but, like his trompe-l'oeil studies, these are now relatively rare. Closely related in subject matter to our sheet is a pen and ink study in a private collection showing a horse, a shepherd, and a cow in an arcadian landscape;[5] indeed, the same cow appears in the Horvitz landscape but in reverse. Palmieri's interest in this genre is also witnessed in his trompe-l'oeil drawings, which include in their pictorial repertoire landscapes and pastoral images. With their quotations from etchings by Pieter van Laer and Jan van Aken, these compositions further attest to the artist's responsiveness to contemporary Dutch art—important collections of Dutch paintings formed part of the princely collections in Turin, where Palmieri worked from 1778 until his death—an influence that is also discerned in his landscape drawings. In the present example, this is evident particularly in the prominent, rather ponderous cows that recall drawings by Paulus Potter, an artist who exercised a particular appeal for Palmieri.[6]

Although he is a peripheral figure, Palmieri occupies a place in the pastoral landscape tradition. His highly finished red chalk drawings—depictions of bucolic themes revealing an obvious recourse to seventeenth-century Dutch sources—demonstrate a kinship with the more idealized, arcadian landscapes of his French contemporaries François Boucher, Jean-Honoré Fragonard, and Hubert Robert.

■

1 The artist has been little studied with the exception of the trompe-l'oeil drawings, for which see Dalmasso, 1972, pp. 131–38. A volume of these drawings was sold in Milan in 1925. Palmieri also designed trompe-l'oeil furniture inlay, which was executed by the cabinetmaker Giuseppe Maria Bonzanigo. A surviving example of their collaboration is in the Museo Civico, Turin (ibid., p. 134, fig. 4).

2 Inv. 16220 D.C.; see the entry by Nancy Ward Nielson in Turin, 1990, no. 127, repr.

3 Invs. 69.14.1 and 69.14.2; see Bean and Griswold, 1990, nos. 148 and 149, repr.

4 Dalmasso, 1972, p. 138, note 10.

5 See ibid., p. 135, fig. 5. Another pen and ink landscape by the artist was recently on the market (Christie's, London, July 4, 1984, no. 54, repr.).

6 See, for example, Potter's study of two cows in the Kunsthalle, Bremen (inv. 56/114), and the study of a bull in the Biblioteca Reale, Turin (inv. 16535 D.C.).

■

38

CARLO ALBERTO BARATTA (Genoa 1754–Genoa 1815)

38. *Adoration of the Shepherds*
Brush and gray, black, and light brown wash,
heightened with white,
43.6 x 30.2 cm. (17 1/8 x 11 7/8 in.).
Verso: Sketch for an *Adoration of the Magi,* black chalk,
lower right; study of a female head, red chalk.

Provenance: Sale, Venice, Semenzato, March 31, 1985,
no. 258, as circle of Carlo Maratti; [La Portantina, fall
1985]; [Colnaghi, New York, May 1989, no. 37, repr.].

T he Virgin appears at the center of the composition. Lying on a bale of hay before her is the radiant Christ Child, whom she tenderly embraces as she gazes down at him. Humble shepherds surround them, kneeling in adoration of the infant savior. A lamb, symbol of Christ's sacrifice, lies on the ground beside the kneeling shepherd at the left. Another lamb is borne on the shoulder of the shepherd standing before the open arch. An ecstatic choir of angels and putti hover above the manger, one waving a censer over the Christ Child and another strewing flowers. The makeshift manger has been built within a massive, crumbling classical architectural structure. A conventional setting for images of the Adoration, this edifice signifies the triumph of the New Law over the Old Dispensation.

A representative of the somewhat retardataire late baroque style in Genoa, Carlo Alberto Baratta was a proficient decorator and a talented draftsman.[1] Recent scholarship has served to define his style and clarify his graphic oeuvre, which consists largely of highly finished composition drawings such as a *Sack of Troy*[2] and a *Presentation of the Virgin,*[3] both in the Palazzo Rosso, Genoa; a *Judith with the Head of Holofernes* in the Schlossmuseum, Weimar;[4] and a *bozzetto* for a ceiling decoration recently acquired by The Metropolitan Museum of Art, New York.[5] A paradigmatic and singular example of his manner as a draftsman, the Horvitz drawing is characterized by a high degree of finish and fully resolved composition, as well as a dramatic chiaroscuro and rich combination of media. These are precisely the qualities of his graphic style remarked on by the Genoese chronicler Federigo Alizeri, who likened Baratta's drawings with their "diligenza" to easel paintings.[6] In its formal unity and brilliant, expressive luminosity, the *Adoration of the Shepherds* ranks among the artist's most accomplished inventions.

In addition to the sheets noted above, the present study compares closely with a drawing by Baratta of the *Assumption of the Virgin with Angels and a Bishop-Saint,*[7] where the morphologies of the figures—the round, cherubic faces, deeply shadowed, slightly slanted

157

eyes, and small mouths—are identical to those in the *Adoration of the Shepherds,* and with an *Adoration of the Magi* that recently appeared on the art market.[8] The latter shares with our drawing a predilection for dramatic light effects, achieved through the profuse use of heightening, a rich combination of media, and a fully worked-up composition. Moreover, the setting of the *Adoration of the Magi,* with the monumental arch and massive columns on tall plinths, is also similar to that of the *Adoration of the Shepherds,* and both drawings include a riotous choir of angelic beings, underscoring the divine nature of the epiphany. Finally, the two sheets are close in size.[9] These considerations suggest that the *Adoration of the Shepherds* and the *Adoration of the Magi,* frequently paired subjects, may have been executed as pendants.[10] That the verso of our drawing includes a hastily sketched *Adoration of the Magi,* whose composition resembles that of the other drawing but in reverse, further signals a kinship between the two studies.[11] This suggestion remains speculative, however, since neither sheet can be securely linked to a painting by the artist. Baratta executed a fresco of the *Adoration* in the Palazzo Rosso, Genoa,[12] but this work differs sufficiently enough from both the Horvitz drawing and the related *Adoration of the Magi* that a possible connection must remain hypothetical.

The composition of our drawing seems to have been inspired by G.B. Castiglione's *Adoration of the Shepherds* in the church of S. Luca, Genoa:[13] the large, animated angels, one of whom waves a censer over the Christ Child, in the upper zone; the monumental, antique architecture receding laterally from the right foreground; and the tender gesture of the kneeling Madonna who lifts a cloth from the radiant child lying on a bed of hay all find parallels in Baratta's design. This deliberate recourse to an important and well-known model by one of Genoa's most celebrated artists of an earlier generation signals Baratta's place at the end of the Genoese baroque tradition.

■

1 On this little studied artist, see *Pittura a Genova*, 1987, pp. 366–68; and Newcome, 1972, pp. 56–57.

2 *Pittura a Genova*, 1987, fig. 331.

3 Inv. 1669; see Newcome, 1972, no. 152, repr.

4 Inv. 293; see Newcome, 1989, p. 396 and fig. 12.

5 Inv. 1988.250; see Bean and Griswold, 1990, no. 4, repr.

6 Alizeri, 1865, vol. 2, p. 101, note 1: "Le carte del Baratta sono per lo più ombrate di bistro e lumeggiate di biacca in campo azzurro, con una forza di chiaroscuro ed una risolutezza di tocco che non lasciano desiderare ne le tinte ne la diligenza dei quadri ad olio."

7 See Mary Newcome and Silvana Bareggi, *Artisti a Genova, disegni dal XVI al XVIII secoli,* Stanza del Borgo, Milan, 1985, no. 31, repr.

8 Christie's, Rome, November 16, 1987, no. 33, repr., as Francesco Mancini; and *Antichi disegni dal XVI al XIX Secolo*, Stanza del Borgo, Milan, 1988, p. 68, repr., with the correct attribution to Baratta. The subject of this sheet was incorrectly identified in the Milan catalogue as the *Adoration of the Shepherds*.

9 The Horvitz sheet measures 436 x 302 mm. and the *Adoration of the Magi* 429 x 333 mm.

10 An example of this pairing of the *Adoration of the Shepherds* and the *Adoration of the Magi* is Cavedone's lateral paintings in S. Paolo Maggiore, Bologna discussed above (see cat. no. 18).

11 The red chalk study of a head on the verso, executed in a rather mechanical style, is not connected with any of the figures in the *Adoration* on the recto and may be by another hand.

12 The fresco in the Palazzo Rosso remains *in situ*. I am grateful to Mary Newcome Schleier for kindly bringing this work to my attention and pointing out its possible connection with the Horvitz drawing, and for providing the information recorded here on the provenance of the latter.

13 On Castiglione's *Adoration,* see Genoa, 1990, no. 14 and pl. 97.

■

BIBLIOGRAPHY
References abbreviated in footnotes

Alizeri, 1865
Federico Alizeri, *Notizie dei professori del disegno in Liguria dalla fondazione dell'accademia*, 2 volumes, Genoa, 1865.

Amato, 1971
Pietro Amato, "Disegni inediti di Corrado Giaquinto in Casa Spadavecchia," in *Atti convegno di studi su Corrado Giaquinto*, Mofetta, 1971, pp. 29-42.

Andrews, 1968
Keith Andrews, *National Gallery of Scotland, Catalogue of Italian Drawings*, 2 volumes, Cambridge, 1968.

Andrews, 1969
Italian Sixteenth-Century Drawings from British Collections, exhibition catalogue by Keith Andrews, The Merchant's Hall, Edinburgh, 1969.

Architettura a Verona, 1988
L'Architettura a Verona nell'età della Serenissima, Pierpaolo Brugnoli and Arturo Sandrini, eds., 2 volumes, Verona, 1988.

Baetjer and Links, 1989
Canaletto, exhibition catalogue by Katharine Baetjer and J.G. Links, The Metropolitan Museum of Art, New York, 1989.

Baglione, 1649
Giovanni Baglione, *Le vite de' pittori, scultori, et architetti*, Rome, 1649.

Bagni, 1988
Prisco Bagni, *Il Guercino e i suoi incisori*, Rome, 1988.

Bagnoli, 1978
Rutilio Manetti 1571-1639, exhibition catalogue by Alessandro Bagnoli, Palazzo Pubblico, Siena, 1978.

Baldinucci, 1845-47
Filippo Baldinucci, *Notizie dei Professori del disegno*, 5 volumes, ed. F. Ranalli, Florence, 1845-47.

Bean, 1960
Jacob Bean, *Bayonne, Musée Bonnat: Les dessins italiens de la collection Bonnat*, Paris, 1960.

Bean, 1966a
Jacob Bean, "Drawings by Giuseppe Maria Crespi," *Master Drawings*, volume 4, number 4, 1966, pp. 419-21.

Bean, 1966b
Jacob Bean, *Italian Drawings in the Art Museum, Princeton University*, Princeton, 1966.

Bean, 1979
Jacob Bean, *17th Century Italian Drawings in The Metropolitan Museum of Art*, New York, 1979.

Bean and Griswold, 1990
Jacob Bean and William Griswold, *18th Century Italian Drawings in The Metropolitan Museum of Art*, New York, 1990.

Bean and Stampfle, 1965
Drawings from New York Collections, I, The Italian Renaissance,
exhibition catalogue by Jacob Bean and Felice Stampfle, The
Metropolitan Museum of Art, New York, 1965.

Bean and Stampfle, 1971
*Drawings from New York Collections, III, The Eighteenth
Century,* exhibition catalogue by Jacob Bean and Felice
Stampfle, The Metropolitan Museum of Art, New York, 1971.

Bean and Turčić, 1982
Jacob Bean, with the assistance of Lawrence Turčić, *15th and
16th Century Italian Drawings in The Metropolitan Museum of
Art,* New York, 1982.

Bellini, 1985
Paolo Bellini, *The Illustrated Bartsch,* volume 46 (*Commentary*),
New York, 1985.

Bertelà, 1976
Artisti italiani dal XVI al XIX secolo: mostra di 200 disegni,
exhibition catalogue by Giovanna Gaeta Bertelà, Museo Civico,
Bologna, 1976.

Birke, 1979
Veronika Birke, "Neue Zeichnungen Donato Cretis," *Weiner
Jahrbuch für Kunstgeschichte,* volume 32, 1979, pp. 49-57.

Blunt, 1953
Anthony Blunt, *The Drawings of G.B. Castiglione and Stefano
della Bella in the Collection of Her Majesty the Queen at
Windsor Castle,* London, 1953.

Bober and Rubinstein, 1986
Phyllis Pray Bober and Ruth Rubinstein, *Renaissance Artists
and Antique Sculpture,* Oxford, 1986.

Bologna, 1959
Maestri della pittura del seicento emiliano, exhibition
catalogue, Palazzo dell'Archiginnasio, Bologna, 1959.

Bologna, 1990
Giuseppe Maria Crespi, 1665-1747, exhibition catalogue,
Pinacoteca Nazionale and Palazzo Pepoli Campogrande,
Bologna, 1990.

Byam Shaw, 1951
James Byam Shaw, *The Drawings of Francesco Guardi,* London,
1951.

Byam Shaw, 1954
James Byam Shaw, "The Drawings of Francesco Fontebasso,"
Arte veneta, volume 8, 1954, pp. 317-29.

Byam Shaw, 1962
James Byam Shaw, *The Drawings of Domenico Tiepolo,* London,
1962.

Byam Shaw, 1983
James Byam Shaw, *The Italian Drawings of the Frits Lugt
Collection,* 3 volumes, Paris, 1983.

Byam Shaw and Knox, 1987
James Byam Shaw and George Knox, *The Robert Lehman
Collection, VI, Italian Eighteenth-Century Drawings,* New York,
1987.

Canedy, 1970
Norman Canedy, "Some Preparatory Drawings by Girolamo da Carpi," *The Burlington Magazine*, volume 112, February 1970, pp. 86-94.

Cannata, 1982
Rilievi e placchette dal XV al XVII secolo, exhibition catalogue by Pietro Cannata, Palazzo Venezia, Rome, 1982.

Causa, 1957
Raffaello Causa, *Pittura napoletana dal XV al XIX secoli*, Bergamo, 1957.

Cazort, 1987
I Gandolfi, exhibition catalogue by Mimi Cazort, Fondazione Giorgio Cini, Venice, 1987.

Cazort Taylor, 1973
Mary Cazort Taylor, "Some Drawings by Francesco Monti and the Soft Chalk Style," *Master Drawings*, volume 11, number 2, 1973, pp. 161-63.

Cazort Taylor, 1974
Mary Cazort Taylor, *European Drawings from the Sonnenschein Collection and Related Drawings in the Collection of the University of Michigan Museum of Art*, Ann Arbor, 1974.

Cazort and Johnston, 1982
Bolognese Drawings in North American Collections, 1500-1800, exhibition catalogue by Mimi Cazort and Catherine Johnston, National Gallery of Canada, Ottawa, 1982.

Chicago, 1979
Roman Drawings of the Sixteenth Century from the Musée du Louvre, Paris, exhibition catalogue, Art Institute of Chicago, 1979.

Constable and Links, 1989
W.G. Constable, *Canaletto*, second edition, revised by J.G. Links, Oxford, 1976; reprinted with supplement, 1989.

Czère, 1988
Andrea Czère, "Five New Chalk Drawings by Aureliano Milani," *Master Drawings*, volume 26, number 2, 1988, pp. 133-37.

Dacos, 1986
Nicole Dacos, *Le Logge di Raffaello*, second edition, Rome, 1986.

Dalmasso, 1972
Franca Dalmasso, "Trompe-l'oeil di Pietro Palmieri e la cultura figurativa in Piemonte a fine `700," *Commentari*, volume 23, January-June 1972, pp. 131-38.

De Grazia, 1984
Corregio and his Legacy, exhibition catalogue by Diane De Grazia, National Gallery of Art, Washington, D.C., 1984.

De Grazia Bohlin, 1982
Diane De Grazia Bohlin, "Paolo Farinati in the Palazzo Giuliari: Frescoes and Preparatory Drawings," *Master Drawings*, volume 20, number 4, 1982, pp. 347-69.

Dillon, 1989
Gianvittorio Dillon, "Novità su Francesco Salviati disegnatore per orafi," *Antichità viva*, volume 28, numbers 2-3, 1989, pp. 45-49.

D'Orsi, 1958
Mario D'Orsi, *Corrado Giaquinto*, Rome, 1958.

Feinblatt, 1976
Old Master Drawings from American Collections, exhibition catalogue by Ebria Feinblatt, Los Angeles County Museum of Art, 1976.

Ferrari and Scavizzi, 1966
Oreste Ferrari and Giuseppe Scavizzi, *Luca Giordano*, 3 volumes, Naples, 1966.

Florence, 1980
Firenze e la Toscana dei Medici nell'Europa del cinquecento. Palazzo Vecchio: committenza e collezionismo medicei, exhibition catalogue, Palazzo Vecchio, Florence, 1980.

Florence, 1986
Il seicento fiorentino, 3 volumes, exhibition catalogue, Palazzo Strozzi, Florence, 1986.

Frerichs, 1981
Italiaanse Tekeningen II: de 15de en 16de Eeuw, exhibition catalogue by L.C.J. Frerichs, Rijksmuseum, Amsterdam, 1981.

Gaudioso, 1981
Gli affreschi di Paolo III a Castel Sant'Angelo, 1543-1548, 2 volumes, exhibition catalogue by Filippa M. Aliberti Gaudioso and Eraldo Gaudioso, Rome, 1981.

Gealt, 1986
Adelheid Gealt, *Domenico Tiepolo: The Punchinello Drawings*, New York, 1986.

Gealt and Vetrocq, 1979
Domenico Tiepolo's Punchinello Drawings, exhibition catalogue by Adelheid Gealt and Marcia E. Vetrocq, Indiana University Art Museum, Bloomington, Indiana, 1979.

Geiger, 1985
Gail Geiger, "Francesco Salviati e gli affreschi della cappella del cardinale di Brandeburgo a Roma," *Arte cristiana*, volume 73, May-June 1985, pp. 181-94.

Genoa, 1956
Luca Cambiaso e la sua fortuna, exhibition catalogue, Palazzo dell'Accademia, Genoa, 1956.

Genoa, 1990
Il Genio di G.B. Castiglione, Il Grechetto, exhibition catalogue, Accademia Ligustica di Belle Arti, Genoa, 1990.

Gere, 1963
J.A. Gere, "Drawings by Niccolò Martinelli, Il Trometta," *Master Drawings*, volume 1, number 4, 1963, pp. 3-18.

Gere, 1966
Mostra di disegni degli Zuccari, exhibition catalogue by John Gere, Gabinetto Disegni e Stampe degli Uffizi, Florence, 1966.

Gere, 1969
J.A. Gere, *Taddeo Zuccaro. His Development Studied in his Drawings*, Chicago, 1969.

Gere, 1971a
J.A. Gere, "Some Early Drawings by Pirro Ligorio," *Master Drawings*, volume 9, number 3, 1971, pp. 239-50.

Gere, 1971b
John Gere, *Il manierismo a Roma*, Milan, 1971.

Gere and Pouncey, 1983
J.A. Gere and Philip Pouncey, *Italian Drawings in the Department of Prints and Drawings in the British Museum, Artists Working in Rome, c.1550-c.1640*, 2 volumes, London, 1983.

Gerszi, 1958
T. Gerszi, "I disegni di Ventura Salimbeni per gli affreschi della chiesa di S. Maria in Portico a Fonte Giusta di Siena," *Acta Historiae Artium*, volume 5, numbers 3-4, 1958, pp. 359-63.

Gibbons, 1977
Felton Gibbons, *Italian Drawings in the Art Museum, Princeton University*, 2 volumes, Princeton, 1977.

Giles, 1986
Laura Giles, *Paintings and Related Drawings of Giacomo Cavedone: 1577-1660*, Ph.D. dissertation, Harvard University, 1986.

Giles, 1989
Laura Giles, "A Double-Sided Drawing by Giuseppe Maria Crespi," *Master Drawings*, volume 27, number 3, 1989, pp. 222-27.

Monbeig Goguel, 1971
Catherine Monbeig Goguel, *Il manierismo fiorentino*, Milan, 1971.

Monbeig Goguel, 1972
Catherine Monbeig Goguel, *Musée du Louvre, Cabinet des dessins, Inventaire général des dessins italiens: Vasari et son temps*, Paris, 1972.

Harprath, 1977
Italienische Zeichnungen des 16. Jahrhunderts aus eigenem Besitz, exhibition catalogue by Richard Harprath, Staatliche Graphische Sammlung, Munich, 1977.

Hartt, 1959
Frederick Hartt, *Giulio Romano*, 2 volumes, New Haven, 1959.

Hartt, 1970
Frederick Hartt, *Michelangelo Drawings*, New York, 1970.

Hirst, 1967
Michael Hirst, "Salviati's Two Apostles in the Oratory of San Giovanni Decollato," *Studies in Renaissance and Baroque Art Presented to Anthony Blunt on his 60th Birthday*, London and New York, 1967, pp. 34-36.

Hirst, 1988
Michael Hirst, *Michelangelo and his Drawings*, New Haven and London, 1988.

Jameson, 1866
Anna Jameson, *Legends of the Monastic Orders*, Boston, 1866.

Joachim and McCullagh, 1979
Harold Joachim and Suzanne Folds McCullagh, *Italian Drawings in the Art Institute of Chicago*, Chicago, 1979.

Knox, 1965
George Knox, "A Group of Tiepolo Drawings Owned and Engraved by Pietro Monaco," *Master Drawings*, volume 3, number 4, 1965, pp. 389-97.

Knox, 1970
Tiepolo: A Bicentenary Exhibition, 1770-1970, exhibition catalogue by George Knox, Fogg Art Museum, Cambridge, Mass., 1970.

Knox, 1971
Tiepolo: Drawings by Giambattista, Domenico and Lorenzo Tiepolo from the Graphische Sammlung Staatsgalerie Stuttgart, from Private Collections in Württemberg, and from The Martin von Wagner Museum of the University of Würzburg, exhibition catalogue by George Knox with Christel Thiem, International Exhibitions Foundation, Stuttgart, 1971.

Knox, 1975
George Knox, *Catalogue of the Tiepolo Drawings in the Victoria and Albert Museum*, second edition, London, 1975.

Knox, 1980
George Knox, *Giambattista and Domenico Tiepolo: A Study and Catalogue Raisonné of the Chalk Drawings*, 2 volumes, Oxford, 1980.

Knox, 1984
George Knox, "The Punchinello Drawings of Giambattista Tiepolo," in *Interpretazioni veneziane: studi di storia dell'arte in onore di Michelangelo Muraro*, ed. David Rosand, Venice, 1984, pp. 439-46.

Knox and Martin, 1987
George Knox and Thomas Martin, "Giambattista Tiepolo: A Series of Chalk Drawings after Alessandro Vittoria's Bust of Giulio Contarini," *Master Drawings*, volume 25, number 2, 1987, pp. 158-63.

Körte, 1932
Werner Körte, "Verlorene Frühwerke des Federico Zuccari in Rom," *Mitteilungen des Kunsthistorischen Institutes in Florenz*, volume 3, January 1932, pp. 518-29.

Kurz, 1955
Otto Kurz, *Bolognese Drawings of the XVII and XVIII Centuries in the Collection of Her Majesty the Queen*, London, 1955.

Leone de Castris, 1988
Polidoro da Caravaggio fra Napoli e Messina, exhibition catalogue by Pierluigi Leone de Castris, Museo Nazionale di Capodimonte, Naples, 1988.

Levey, 1986
Michael Levey, *Giambattista Tiepolo, His Life and Art*, New Haven and London, 1986.

London, 1962
Primitives to Picasso, exhibition catalogue, Royal Academy of Arts, London, 1962.

Lugt
Frits Lugt, *Les marques de collections de dessins et d'estampes*, Amsterdam, 1921; Supplement, The Hague, 1956.

Macandrew, 1983
Hugh Macandrew, *Italian Drawings in the Museum of Fine Arts, Boston*, Boston, 1983.

Macandrew, 1988
Hugh Macandrew, "Venetian Visions," *Times Literary Supplement*, number 4448, July 1-7, 1988, p. 741.

Magrini, 1988
Marina Magrini, *Francesco Fontebasso*, Vicenza, 1988.

Mahon, 1968
Il Guercino, catalogo critico dei dipinti, exhibition catalogue by Denis Mahon, Palazzo dell'Archiginnasio, Bologna, 1968.

Mahon, 1969
Il Guercino, catalogo critico dei disegni, exhibition catalogue by Denis Mahon, Palazzo dell'Archiginnasio, Bologna, 1969.

Mahon and Turner, 1989
Denis Mahon and Nicholas Turner, *The Drawings of Guercino in the Collection of Her Majesty the Queen at Windsor Castle*, Cambridge, 1989.

Maison, 1968
K.E. Maison, "The Tiepolo Drawings after the Portrait Bust of Palma Giovane by Alessandro Vittoria," *Master Drawings*, volume 6, number 4, 1968, pp. 392-94.

Malvasia, 1769
Carlo Cesare Malvasia, *Felsina pittrice: Vite de'pittori bolognesi*, ed. Luigi Crespi, 3 volumes, Rome, 1769.

Mandowsky and Mitchell, 1963
Erna Mandowsky and Charles Mitchell, *Pirro Ligorio's Roman Antiquities*, London, 1963.

Mantua, 1989
Giulio Romano, exhibition catalogue, Palazzo Te and Palazzo Ducale, Mantua, 1989.

Mariette, 1851-60
Abecedario de P. J. Mariette et autres notes inédites de cet amateur sur les arts et les artistes, annoted by Ph. de Chennevières and A. de Montaiglon, 6 volumes, Paris, 1851-60.

Marinelli, 1988
Veronese and Verona, exhibition catalogue by Sergio Marinelli, Museo di Castelvecchio, Verona, 1988.

Marini, 1980
Palladio e Verona, exhibition catalogue by Paolo Marini, Palazzo della Gran Guardia, Verona, 1980.

Meijer and van Tuyll, 1983
Disegni italiani del Teylers Museum Haarlem provenienti dalle collezioni di Cristina di Svezia e dei principi Odescalchi, exhibition catalogue by Bert Meijer and Carel van Tuyll, Istituto Universitario Olandese di Storia dell'Arte, Florence, 1983.

Méjanès, 1983
Les Collections du Comte d'Orsay: Dessins du Musée du Louvre, exhibition catalogue by Jean-François Méjanès, Musée du Louvre, Paris, 1983.

Merriman, 1980
Mira Pajes Merriman, *Giuseppe Maria Crespi*, Milan, 1980.

Miller, 1969
Dwight Miller, review of Renato Roli, *Donato Creti*, in *The Burlington Magazine*, volume 111, May 1969, p. 307.

Morassi, 1955
Antonio Morassi, *G.B. Tiepolo: His Life and Work*, London, 1955.

Morassi, 1962
Antonio Morassi, *A Complete Catalogue of the Paintings of G.B. Tiepolo*, London, 1962.

Morassi, 1975
Antonio Morassi, *Guardi. Tutti i disegni di Antonio, Francesco e Giacomo Guardi*, Venice, 1975.

Mundy, 1989
Renaissance into Baroque, Drawings of the Zuccari, 1550-1600, exhibition catalogue by James Mundy, Milwaukee Art Museum, 1989.

Munich, 1977
Stiftung Ratjen, Italienische Zeichnungen des 16.-18. Jahrhunderts, exhibition catalogue, Staatliche Graphische Sammlung, Munich, 1977.

Newcome, 1972
Genoese Baroque Drawings, exhibition catalogue by Mary Newcome, University Art Gallery, Binghamton, New York, 1972.

Newcome, 1989
Mary Newcome, "Genoese Drawings in Weimar," *Arte cristiana*, number 734, September-October 1989, pp. 385-96.

Newcome Schleier, 1985
Le dessin à Genes du XVIᵉ au XVIIIᵉ siècle, exhibition catalogue by Mary Newcome Schleier, Musée du Louvre, Paris, 1985.

New York, 1967
Drawings of Luca Cambiaso, exhibition catalogue, Finch College Museum of Art, New York, 1967.

New York, 1990
Woodner Collection, Master Drawings, exhibition catalogue, The Metropolitan Museum of Art, New York, 1990.

Notre Dame, 1984
Renaissance Drawings from the Ambrosiana, exhibition catalogue, Notre Dame, Indiana, 1984.

Nova, 1981
Alessandro Nova, "Francesco Salviati and the `Markgrafen' Chapel in S. Maria dell'Anima," *Mitteilungen des Kunsthistorischen Institutes in Florenz*, volume 25, number 3, 1981, pp. 355-72.

Novelli, 1834
Pietro Novelli, *Memorie della vita di Pietro Antonio Novelli, pittore veneto, scritte da lui medesimo*, ed. L. Maldura Rusconi, Padua, 1834.

Oberhuber, 1979
Konrad Oberhuber, ed., *Old Master Drawings, Selections from the Charles A. Loeser Bequest*, Cambridge, Mass., 1979.

Olszewski, 1979
Edward J. Olszewski with the assistance of Jane Glaubinger, *The Draftsman's Eye: Late Italian Renaissance Schools and Styles*, exhibition catalogue, The Cleveland Museum of Art, 1979.

Paris, 1971
Venise au dix-huitième siècle, exhibition catalogue, Orangerie des Tuileries, Paris, 1971.

Paris, 1983
Autour de Raphael, exhibition catalogue, Musée du Louvre, Paris, 1983.

Parker, 1948
K.T. Parker, *The Drawings of Antonio Canaletto in the Collection of His Majesty the King at Windsor Castle*, Oxford and London, 1948.

Parker, 1972
K.T. Parker, *Catalogue of the Collection of Drawings in the Ashmolean Museum, Volume II, Italian Schools*, 2 volumes, second edition, Oxford, 1972.

Parma Armani, 1986
Elena Parma Armani, *Perin del Vaga, l'anello mancante*, Genoa, 1986.

Pedrocco, 1988
Filippo Pedrocco, *Giandomenico Tiepolo a Zianigo*, Treviso, 1988.

Percy, 1971
Giovanni Benedetto Castiglione, Master Draughtsman of the Italian Baroque, exhibition catalogue by Ann Percy, Philadelphia Museum of Art, 1971.

Perez Sanchez, 1978
Alfonso E. Perez Sanchez, *I grandi disegni italiani nelle collezioni di Madrid*, Milan, 1978.

***Pittura a Genova*, 1987**
La pittura a Genova e in Liguria dal seicento al primo novecento, second edition, Genoa, 1987.

***Pittura Bolognese*, 1986**
Pittura Bolognese del '500, 2 volumes, ed. Vera Fortunati Pietrantonio, Bologna, 1986.

***Pittura in Italia*, 1987**
La pittura in Italia, Il cinquecento, ed. Giuliano Briganti, Milan, 1987.

Popham and Wilde, 1949
A.E. Popham and Johannes Wilde, *The Italian Drawings of the XV and XVI Centuries in the Collection of His Majesty the King at Windsor Castle*, London, 1949.

Pouncey and Gere, 1962
Philip Pouncey and J.A. Gere, *Italian Drawings in the Department of Prints and Drawings in the British Museum, Raphael and his Circle*, London, 1962.

Previtali, 1978
Giovanni Previtali, *La pittura del cinquecento a Napoli e nel vicereame*, Turin, 1978.

Pugliatti, 1984
Teresa Pugliatti, *Giulio Mazzoni e la decorazione a Roma nella cerchia di Daniele da Volterra*, Rome, 1984.

Quednau, 1981
Rolf Quednau, "Zeremonie und Festdekor. Ein Beispiel aus dem Pontifikat Leos X," in *Europäische Hofkultur in 16. und 17. Jahrhundert*, 1981, pp. 349-58.

***Raffaello in Vaticano*, 1984**
Raffaello in Vaticano, exhibition catalogue, Musei Vaticani, 1984.

Ragghianti Collobi, 1974
Licia Ragghianti Collobi, *Il libro de' disegni del Vasari*, 2 volumes, Florence, 1974.

Ravelli, 1978
Lanfranco Ravelli, *Polidoro Caldara da Caravaggio*, Be 1978.

Ravelli, 1988
Lanfranco Ravelli, *Un fregio di Polidoro a Palazzo Baldassin in Roma*, Bergamo, 1988.

Reggio Emilia, 1987
Lelio Orsi, exhibition catalogue, Reggio Emilia, 1987.

Ricci and Zucchini, 1968
Corrado Ricci and Guido Zucchini, *Guida di Bologna*, n.d. [ca. 1930]; reprint edition, Bologna, 1968.

Ridolfi, 1648
Carlo Ridolfi, *Maraviglie dell'arte ovvero le vite degli illustri pittori veneti e dello stato*, Venice, 1648; reprint edition, 2 volumes, ed. D. von Hadeln, Berlin, 1924.

Riedl, 1959
Peter Anselm Riedl, "Zu Francesco Vanni und Ventura Salimbeni,"*Mitteilungen des Kunsthistorischen Institutes in Florenz*, volume 9, number 1, August 1959, pp. 60-70.

Riedl, 1960
Peter Anselm Riedl, "Zum oeuvre des Ventura Salimbeni," *Mitteilungen des Kunsthistorischen Institutes in Florenz*, volume 9, numbers 3-4, November 1960, pp. 221-48.

Riedl, 1976
Disegni dei barocceschi senesi, exhibition catalogue by Peter Anselm Riedl, Gabinetto Disegni e Stampe degli Uffizi, Florence, 1976.

Rizzi, 1971
Aldo Rizzi, *The Etchings of the Tiepolos*, London, 1971.

Rodinò, 1977
Disegni Fiorentini, 1560-1640, exhibition catalogue by Simonetta Prosperi Valenti Rodinò, Gabinetto Nazionale della Stampe, Rome, 1977.

Roli, 1960
Renato Roli, "Qualche appunto per Aureliano Milani," *Arte antica e moderna*, number 10, April-June 1960, pp. 189-92.

Roli, 1962
Renato Roli, "Traccia per Francesco Monti, bolognese," *Arte antica e moderna*, number 17, January-March 1962, pp. 86-98.

Roli, 1967
Renato Roli, *Donato Creti*, Milan, 1967.

Roli, 1973
Renato Roli, "Drawings by Donato Creti: Notes for a
Chronology," *Master Drawings*, volume 11, number 1, 1973, pp.
25-32.

Roli, 1979
L'Arte del settecento emiliano, la pittura, exhibition catalogue
by Renato Roli, Bologna, 1979.

Rosand, 1966
David Rosand, "An Early Chiaroscuro Drawing by Paolo
Veronese," *The Burlington Magazine*, volume 108, August
1966, pp. 421-22.

Röttgen, 1973
Il Cavalier d'Arpino, exhibition catalogue by Herwarth
Röttgen, Palazzo Venezia, Rome, 1973.

Salerno, 1988
Luigi Salerno, *I dipinti del Guercino*, Naples, 1988.

Scavizzi, 1959
Giuseppe Scavizzi, "Su Ventura Salimbeni," *Commentari*,
volume 10, numbers 2-3, 1959, pp. 115-36.

Sciré and Valcanover, 1985
Giovanna Nepi Sciré and Francesco Valcanover, *Galleria
dell'Accaemia di Venezia*, Milan, 1985.

Shearman, 1983
John Shearman, *The Early Italian Pictures in the Collection of
Her Majesty the Queen*, Cambridge, 1983.

Shoemaker and Broun, 1981
The Engravings of Marcantonio Raimondi, exhibition catalogue
by Innis Shoemaker and Elizabeth Broun, Spencer Museum of
Art, Lawrence, Kansas, 1981.

Siena, 1980
L'Arte a Siena sotto i Medici, exhibition catalogue, Palazzo
Pubblico, Siena, 1980.

Siena, 1990
Domenico Beccafumi e il suo tempo, exhibition catalogue,
Chiesa di Sant'Agostino and Pinacoteca Nazionale, Siena, 1990.

Sopher, 1978
Seventeenth-Century Italian Prints, exhibition catalogue by
Marcus Sopher, Stanford University Art Gallery, Stanford,
California, 1978.

Soprani, 1768
Raffaello Soprani, *Vite de'pittori, scultori, ed architetti genovesi*,
2 volumes, ed. Carlo Giuseppe Ratti, Genoa, 1768.

Spike, 1986
*Giuseppe Maria Crespi and the Emergence of Genre Painting in
Italy*, exhibition catalogue by John T. Spike, Kimbell Art
Museum, Fort Worth, Texas, 1986.

Stuttgart, 1984
Zeichnungen des 15. bis 18. Jahrhunderts, exhibition catalogue,
Graphische Sammlung, Staatsgalerie Stuttgart, 1984.

Suida Manning, 1952
Bertina Suida Manning, "The Nocturnes of Luca Cambiaso," *Art Quarterly*, volume 15, number 3, 1952, pp. 197-220.

Suida Manning and Suida, 1958
Bertina Suida Manning and William Suida, *Luca Cambiaso, la vita e le opere*, Milan, 1958.

Thiem, 1969
Christel Thiem, "Fabrizio Boschi and Matteo Rosselli: D[...] Relating to the Theme of the `Martyrdom of St. Sebasti[...] *Master Drawings*, volume 7, number 2, 1969, pp. 148-5[...]

Thiem, 1983
Disegni di artisti bolognesi dal seicento all'ottocento della [...] Collezione Schloss Fachsenfeld e della Graphische Sammli[...] Staatsgalerie, Stuttgart, exhibition catalogue by Christ[...] Theim, Palazzo Pepoli Campogrande, Bologna, 1983[...]

Turin, 1990
Da Leonardo a Rembrandt: Disegni della Biblioteca Reale d[...] Torino, exhibition catalogue, Turin, 1990.

Turner, 1980
Nicholas Turner, *Italian Baroque Drawings*, London, 1980.

Turner, 1986
Florentine Drawings of the Sixteenth Century, exhibition catalogue by Nicholas Turner, British Museum, London, 1986.

Vasari-Milanesi, 1906
Giorgio Vasari, *Le vite de' più eccellenti pittori, scultori, ed architettori*, 9 volumes, ed. Gaetano Milanesi, Florence, 1906.

Venice, 1981
Da Tiziano a El Greco: Per la storia del manierismo a Venezia, exhibition catalogue, Palazzo Ducale, Venice, 1981.

Verona, 1974
Cinquant'anni di pittura veronese, 1580-1630, exhibition catalogue, Palazzo della Gran Guardia, Verona, 1974.

Viatte, 1988
Françoise Viatte, *Inventaire général des dessins italiens, III, Dessins toscans, XVIe-XVIIIe siècles, Tome 1, Musée du Louvre*, Paris, 1988.

Viatte and Monbeig Goguel, 1981
Dessins baroques florentins du Musée du Louvre, exhibition catalogue by Françoise Viatte and Catherine Monbeig Goguel, Musée du Louvre, Paris, 1981.

Videtta, 1962-67
Antonia Videtta, "Disegni di Corrado Giaquinto nel museo di San Martino," parts 1-4, *Napoli Nobilissima*, volume 2, 1962, pp. 13-28; volume 4, 1965, pp. 174-83; volume 5, 1966, pp. 3-18; volume 6, 1967, pp. 135-39.

Vitzhum, 1970
Walter Vitzhum, *Il barocco a Napoli e nell'Italia meriodionale*, Milan, 1970.

Voltolina, 1932
Maria Voltolina, "Il pittore P.A. Novelli," *Rivista di Venezia*, volume 11, March 1932, pp. 101-17.

Ward and Weil, 1989
Master Drawings from the Nelson-Atkins Museum of Art,
exhibition catalogue by Roger Ward and Mark S. Weil,
Washington University Gallery of Art, Saint Louis, 1989.

Washington, 1988
Master Drawings from the National Gallery, Canada, exhibition
catalogue, National Gallery of Art, Washington, D.C., 1988.

Washington, New York, and Bologna, 1986
The Age of Correggio and the Carracci, exhibition catalogue,
National Gallery of Art, Washington; The Metropolitan
Museum of Art, New York; Pinacoteca Nazionale, Bologna,
1986.

Weisz, 1984
Jean S. Weisz, *Pittura e Misericordia: The Oratory of S.
Giovanni Decollato in Rome*, Ann Arbor, 1984.

Zannini, 1974
Gian Ludovico Masetti Zannini, *Pittori della seconda metà del
cinquecento in Roma (documenti e regesti)*, Rome, 1974.

Zanotti, 1739
Giovanni Pietro Zanotti, *Storia dell'Accademia Clementina*,
2 volumes, Bologna, 1739.

PHOTOGRAPH CREDITS

Other than the Horvitz Collection

Fig. 1a	A. C. Cooper Limited, reproduced by gracious permission Her Majesty Queen Elizabeth II
Fig. 3a	Rijksmuseum-Stichting, Amsterdam
Fig. 5a	Trustees of the British Museum, London
Fig. 8a	The Metropolitan Museum of Art, The Elisha Whit. Collection, The Elisha Whittelsey Fund, 1951, 51.5(
Fig. 13a	The Metropolitan Museum of Art, The Harris Brisb Fund, 1953, 53.601.16(46)
Fig. 17a	Städelsches Kunstinstitut, Frankfurt
Fig. 18a	Ministero per i Beni Culturali e Ambientali, Soprinten i Beni Artistici e Storici, Bologna
Fig. 24a	Staatsgalerie, Stuttgart
Fig. 25a	Alinari/Art Resource
Fig. 29a	The Metropolitan Museum of Art, Robert Lehman Collection, 1975, 1975.1.441
Fig. 30a	National Gallery of Victoria, Melbourne
Fig. 33a	Christie's, London
Fig. 34a	The Pierpont Morgan Library, New York. Gift of Mr. Janos Scholz

INDEX OF ARTISTS

Number indicates first page of catalogue entry.

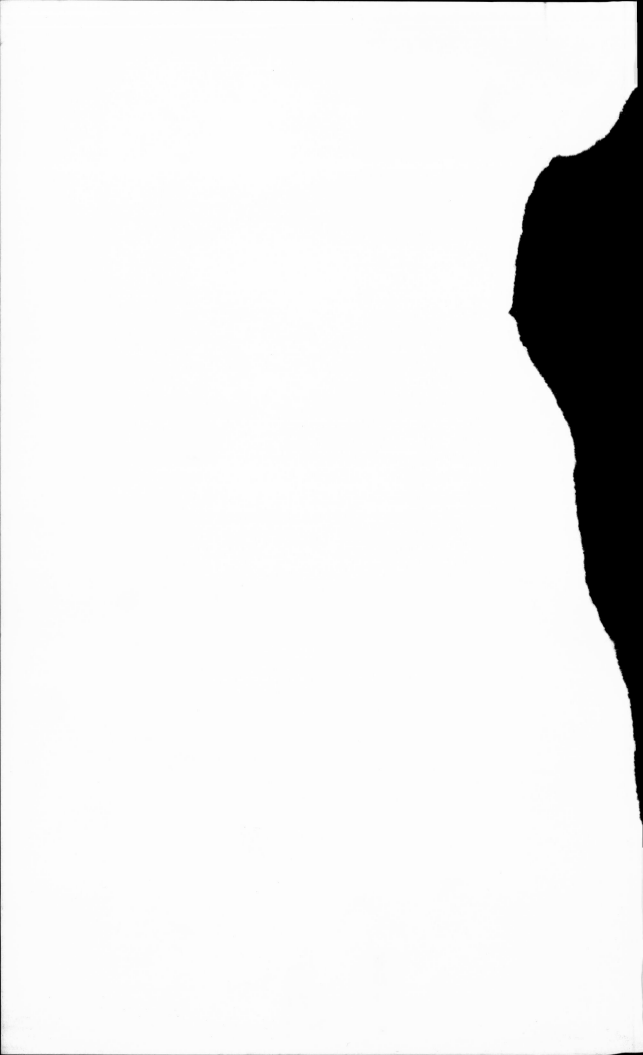